Artist-Teacher

Artist-Teacher:
A Philosophy for Creating and Teaching

by G. James Daichendt

intellect Bristol, UK / Chicago, USA

First published in the UK in 2010 by Intellect,
The Mill, Parnall Road, Fishponds, Bristol, BS16 3JG, UK

First published in the USA in 2010 by Intellect, The University of Chicago Press,
1427 E. 60th Street, Chicago, IL 60637, USA

A catalogue record for this book is available from
the British Library.

Cover design: Holly Rose
Copy-editor: Lesley Williams
Typesetting: John Teehan

ISBN 978-1-84150-408-7

Printed and bound by Hobbs the Printers Ltd, Totton, Hampshire, UK.

Contents

PART ONE

Teaching Artist or Artist-Teacher?

Chapter One
The Evolution of Teaching Art

Why Do We Teach?

To what end do we teach art? From a 21st-century perspective, it may be obvious in certain situations but ambiguous in others. For example, does the grade school art teacher purport different goals than the fine arts professor? The schoolteacher hopes to challenge, affirm, broaden horizons, inspire, share, and question students' understandings about themselves and the world. In contrast, the fine arts professor potentially hopes to critique, mentor, display, model, and instruct the student in the ways of being an artist, designer, or professional. At first glance, the two are very different. However, in many respects, the two art teachers share an ancestry and common pool of knowledge. Yet they differ in rationalism, education, and context. Or do they? I argue that the actions, philosophies, and contexts we work within as artists inform much of what we know and teach. Differentiating between grade school and college art teachers is not a concern. Rather, it is the way we see the world as artists and how that vision informs our teaching practice. This position is ever present in this introduction as we uncover various methods for teaching art. An awareness of the past brings to mind traditions, vocabulary, and forgotten aspects of our chosen profession as artists and teachers. Our contemporary perspective then allows us to reinvestigate these histories from particular perspectives—the artistic and educational perspectives being focal points. The following paragraphs thus introduce and engage several topics and trends used to understand the changing nature of teaching art.

The history of art is filled with artists of distinction who have contributed to progressing and questioning aesthetic sensibilities through their media of choice. The lives of these artists continue through their work recorded visually. The very best are represented in our history books, yet what do we make of the art teachers? The products of teachers are often much more fleeting. Although some permanent records exist of successful teaching, many of the records are forgotten. Yet education—formal or informal—is a necessary aspect of the struggle to achieve the position of the artist who

is heralded and is the precursor of great things to come. What then do we make of the art teacher? Often established artists in their own right, these folks have often dedicated their lives to teaching others. How then are we to begin an examination of the complex interrelationship between art making and teaching?

A significant contributor toward trends in art education is the preparation or education of future teachers. Educational institutions stress the importance of artistic study and pedagogical preparation in different combinations. Although there are many possibilities, the role of art making can be virtually nonexistent to encompassing the entire program. Students with a master of fine arts (MFA) degree know this well. The majority—if not all—of their education consists of art practice and art theory. These students graduate and enter the teaching field at the college or high school level without the educational theory art education students receive. Art education majors—at the undergraduate and graduate level—who study within a department of education are more likely to receive educational theory and less artistic development or art theory courses. This is not always the case, but it is a reasonable assumption. This is not meant to degrade art education or MFA programs but rather to highlight the differences in preparation.

It is important to understand there is not a correct method for preparing students to enter the art teaching field. Artists have taught successfully and unsuccessfully with different backgrounds for centuries. Certain regulations or degrees are required in different contexts; however, there are a wide variety of ways to earn an art degree or credential. To understand the 21st century, looking back at the past helps to situate our current time. I ultimately propose the importance of being an artist in our current educational context. However, the artist-teacher idea is not a new one and does not presuppose a particular degree. It is a way of thinking that can be accomplished regardless of context.

Academic Art

The development of art programs within institutional frameworks is important for understanding the complex nature of teaching art. Artists and teachers do not work in a vacuum; the circumstances—including tradition, culture, and context—play key roles in understanding art's place and importance. The Italian and French academies were among the first to professionalize the discipline of teaching art. By imbuing certain values and establishing charters regulating the practice and the organization of teaching, these academies formulated a professional atmosphere that was quite different from craftsmen workshops. The academy is typified by artistic guidelines that were often transformed into formulas, which privileged the notion of producing art. I put forward that this groundwork set by the academicians is important for understanding current schools of higher education. The philosophies have changed, but the infrastructure remains. Later in 19th-century England, John Ruskin's appointment as professor of art and subsequent

developments, including new art departments within liberal arts universities and the formation of art history as a discipline in the United States, established the fields of art history and studio art as legitimate areas of study at the college level (outside the art school or college). Prior to the 18th century, the academy was the professional standard. Potential artists must have enrolled in an academy to be successful. These developments over the past four hundred years did much for moving the field away from the workshop and toward a new way of understanding a professionalized field.

Although the 21st-century art world with its pluralistic or postmodern views differs greatly from early 19th-century philosophies involving Romanticism or idealism, the two are closely aligned in professionalizing their respective fields. During the 19th century, the French Academy established a strict set of rules and doctrine, which organized the field and established a paradigm for what constituted success and promotion. In comparison, the 21st-century art world shifted this paradigm yet successfully maintains a constant pluralistic view through education at all levels. Modern artists therefore rejected the traditions and professionalization of the academic art system and sought a new beginning without rules. The game pieces and traditions have changed in the contemporary; however, there is still a conceptual foundation that maintains order and common ground for hierarchy and success. As the arts transitioned into a subject of study within universities, the arts philosophically became a well-maintained machine that continually molded minds to enter the factory, where one must be a product to work within it. A debt is owed to Renaissance artists, who established the beginnings of the factory (metaphorically), a tradition continued in today's arts schools built on a conceptual set of doctrines that virtually every artist who enters must follow. The idea that there is no right way to teach or learn is, in a manner of speaking, the proper way to teach and learn in the visual arts today. The absence or rejection of a central philosophy *is* the philosophy. Art schools follow the academic and professionalized tradition as they teach and maintain a consistently inconsistent set of rules and guidelines.

Elkins (2001) posits a convincing argument that considers the question, what is academic art? In this respect, "academic" is referenced in a traditional sense, referring to art that is realistic, from a particular period, and influenced by an academy. The Italian and French art training systems responsible for many great artists of the 17th, 18th, and 19th centuries are often guilty of this association. The term "academic" has also become in some circles a negative or kitsch term that degrades the style and subject matter of 19th-century artists, adding a viral emphasis. Although the rules, traditions, and hierarchies of the French Academy are very different from contemporary schools such as Yale University or the Rhode Island School of Design, the infrastructure that sets rules, suggests practices, and influences the field are very similar.

However, the academic notion can be loosely understood as well. In this respect, it generally encompasses a professional infrastructure that supports the training and education of artists through a particular philosophy. Now, the art schools and art

departments working today would be aghast to be were compared to a dinosaur like the École des Beaux-Arts. The outdated model could not prepare artists to work in the highly conceptual and enlightened society that today's artists must navigate. After all, to become a successful artist like Jeff Koons, or to practice your craft and engage with the field like Rachel Whiteread, one does not enroll in a dated system of education. A budding artist must instead engage issues of the day at a top school to learn from masters and to establish a proper footing for entering this climb of success. Ironically, this is exactly what an aspiring 18th-century artist would have said about the academy. The French Academy had a core philosophy, as do all of today's art schools—whether they realize it or not.

The understanding that the academy was at its core an institution that set standards and enforced doctrine is eye-opening—it was not a particular style. Styles change constantly, even within the traditional academy. To this point, the 16th-century academy was very different from the 19th-century academy. The earliest records of the Florentine Academy do not display evidence of studying the nude, nor do they include the incredible number of guidelines the 19th-century academy maintained (Goldstein, 1996). The classical nude typifies the 19th century and is the central aspect of the traditional academy, and thus style and content change with culture and context.

The contemporary liberal arts schools and the fine arts schools preparing thousands of artists a year should be considered academic for the following reasons. Contemporary schools certainly maintain guidelines and bodies of knowledge considered sacred, exactly as the older art academies maintained. The philosophy that rules do not matter is an idea purported, thus a doctrine or rule defining contemporary art education. John Baldessari, Ed Ruscha, and other conceptual artists and professors of art are well known for teaching that artists turned their backs on rules, canons, and conventional techniques and materials during the late 20th century (Dannenmüller, 2006). Through these actions, future artists blaze new paths with a similar infrastructure guiding their decisions, thus establishing a doctrine of truth to follow. The pluralistic understanding of the art world, rules, and education used by modern academies are combined to form a new institution.

Perhaps one could argue that, yes, art schools seem to be teaching a new doctrine similar to rules. But does not having a faculty full of different ideas, aesthetics, and teaching practices contradict this doctrine? In fact, all the art schools in the world do not teach Baldessari's philosophy; many schools have different philosophies and even have philosophies that contradict one another. Are we not now breaking the rules and differentiating ourselves from the academy as an institutional governing system? Have we not moved beyond this? There are, after all, many different philosophies of art happening at the same time. The simple answer is no; this would be a micro perspective and not an all-encompassing understanding of what is happening outside particular schools. The mere fact that thousands of competing philosophies work concurrently

reinforces what today's academy teaches as a pluralistic attitude (from a macro view) toward understanding art education and the preparation of artists. The philosophy that there is no one right way agrees that turning your back on rules is in fact the right way to do things.

Harold Rosenberg, the prominent critic challenged mid-century artists who were enrolled in art schools and compared them indirectly to academies (Goldstein, 1996). Rosenberg doubted the university and its ability to prepare young people to become professional artists. He claimed that only one of the top ten abstract expressionists had a degree in the arts. The university degree was changing the nature of artistic expression and, according to the art field, true expression did not require schooling. Rosenberg's detrimental view of university art departments saw artists enrolled in art schools as part of an academy because he felt nothing exciting or new would come from practicing tradition and maintaining the status quo. The view of the art school was that students were compromising the studio for the classroom; the thinking that art cannot be taught is not a new idea and is part of the argument for the new academy.

Another tenet of academic art was the control the academy wielded over who was able to teach. These academicians were educated in a similar manner and thus continued the traditions and rules. To teach in a 21st-century university, it is required that professors attain a specific level of education, or they are not considered for employment. In doing this, the potential professor of art must walk through the gauntlet[1] of higher education before given a weapon and placed on the line. This system requires an MFA and in some situations a doctorate in philosophy (Ph.D.) or education (Ed.D)[2] before a teaching post can be secured in related fields such as art history and art education. This system of promotions requires future leaders to excel and succeed in the given system before teaching in it. This is similar to the process the academy used to advocate and maintain the educational infrastructure, and ensure the continuity of the goals of the culture. Only graduates who practiced acceptable methods would proceed and graduate.

Questioning art preparation or the correct art preparation is the subject of much debate as the philosophies of modern art making grew more and more fragmented during the post war period. Reinhardt (1957), an artist-teacher, wrote "The Twelve Rules (or How to Achieve the Twelve Things to Avoid)" for the New Academy. The abbreviated list is as follows:

No texture
No brushwork or calligraphy
No sketching or drawing
No forms
No design
No colors

No light
No space
No time
No size or scale
No movement
No object, no subject, no matter; no symbols, images, or signs;
 neither pleasure nor paint; no mindless working or mindless
 nonworking; no chess playing

Rules and traditions play a prominent role in art education, and Reinhardt understood this dilemma, because he forgoes many aspects of modern art education propagated during the 20th century. Similar to the art-making structures that formed modernist movements, the teaching styles and techniques subsequently try to answer similar problems in art education. The rejection of these systems and traditions in art education led to teaching philosophies linked to nothing nor to anything. The new academy is present at all levels of art education (elementary to higher education), and one must be a member to teach.

Professionalization of Art Education

Professionalization has also infiltrated what could be considered a subdiscipline (or in other cases, a larger and more encompassing discipline as it involves all subjects) of the arts, art education, and the separate yet related field of education. The fields of education and art education are robust areas of study. A quick glance at the *International Journal of Art & Design Education*, *Teaching Artists' Journal*, or *Studies in Art Education* displays a multitude of professionals who work to define and refine the process and knowledge base of art and design education. The advancement of art education is predicated on the growth of the discipline of education. The organization of national associations—National Art Education Association, College Art Association, and Association of Teaching Artists—and annual meetings and conventions continue to define the purposes of the field locally and nationally. This growth demonstrates and considers art education as a distinct discipline that combined two relatively young fields —art and education. This unusual relationship between two subjects generates confusion as to where the art education departments should be located within the university. Should they be in education or in art schools/departments? Both departments of education and art offer art education degrees. But which is apt to facilitate such learning? There is a similar problem with the subject of art history—that is, in the department of history or art.

The advent of the Normal School in the 19th century is important for the art teacher, because it was an institution that specifically prepared teachers to teach art (Efland,

1990). Prior to this school, students were trained or educated as artists or craftsmen, who then passed the tradition or skill on as teachers. Artist taught from necessity—not as a professional identity. There was no emphasis on the teaching process per se—just a continuation of effective methods. The act of teaching became a subject of study through the Normal Schools in England and the United States (Efland, 1990; Macdonald, 1970). This is where teaching preparation was noted as significantly important because of contrasting theories of art education. The fine arts and applied arts were divided, and each discipline required a specific type of training/education not available in the other's curriculum. The subjects of study, processes, and goals differed very much depending on context. Teaching thus became a subject of study (in select areas such as England and the United States) rather than the subject of art itself. This is significantly different from the two alternatives in teaching: artist preparation (academic goal) and general subject preparation (school teacher goal).

Masters, professors, and instructors from classical times to the 21st century have been educated formally and informally in the discipline of making art, learning a craft, or exploring the changing components that compose the discipline of art. In essence, they learned how to draw and then they taught drawing. This type of education is concerned with artist preparation first, with teaching considered a minor or unmentioned aspect of education. The style or philosophy of teaching art adopted in these cases is usually copied from successful instructors intentionally and unintentionally. Current MFA programs around the country still work within this paradigm, as artists potentially prepare for careers in teaching without the faintest idea they are purporting particular philosophies or sometimes contrasting ideas in their teaching—a particularly frightful notion, because many MFA graduates pursue teaching careers.

The alternative to a system or rules and traditions is an absence of art training. By not having this tradition of creating, one can still learn to teach it but must choose one—or most likely many—doctrines, methods, and philosophies. This is essentially what teacher preparation programs hope to accomplish. They do not refine drawing skills or challenge the artistic production of students; rather, they introduce pedagogy and the various aspects of teaching. Early art education proponents in the United States sought to prepare general subject teachers to teach drawing to their students in this manner (Smith, 1873). Graduates arm themselves with a theory or a system of art education without practicing many of the experiences of art making themselves. Harkening Shaw's (1903) Maxims for Revolutionists in *Man and Superman*:

He who can, does. He who cannot, teaches (line 36).

An idiom used to discourage teachers the quote is often repeated and used incorrectly but it is applicable for early teacher training programs that discounted the art-making abilities of teachers.

This is where many who study the subject of the artist-teacher get caught up. They feel that artistic training is what potentially makes an artist-teacher, in comparison to a background in art education or education (Zwirn, 2002). Although education in the visual arts or art education may contribute to an identity aligned with being an artist or teacher, I argue that being an artist is more than a degree or course of study; it is, rather, a way of seeing and living. Being an artist is fundamental to who you are, a way of knowing and being (Hickman, 2005). Artist-teachers are not just artists who teach; their artistic thinking process is imbedded within various elements of the teaching process. A conceptual understanding of the artist-teacher does not discriminate by degree or education; it is about applying the artistic stream of thinking within to teaching. This aesthetic perspective informs one's teaching pedagogy potentially on many levels. Through this understanding of the artist-teacher, it is synthetic and interwoven, not a combination of roles defined by institutions.

Relationship to the Field of Knowledge

I have found through relevant literature addressing issues related to the artist-teacher that the subject is best understood through five categories: education and the dual identity; partnerships; nontraditional artist-teachers; history; and studies of individual teachers. The five categories represent subtopics of the larger issues of the artist-teacher. These themes serve as a backdrop for understanding this text as historical scholarship yet also situates the thinking processes of many contemplating this topic. A plethora of research exists on the artist-teacher, yet none take a holistic perspective of the issue. The following figure represents the various perspectives researchers and authors use to understand the term or concept of the artist-teacher.

Artist-Teacher Research

- History
- Education and Dual Identity
- Partnerships
- Studies of Individual Teachers
- Nontraditional Artist-Teachers

Figure 1. Five categories of artist-teacher research.

Education and the Dual Identity

Identity is often an issue of importance for those using the term "artist-teacher" (Orsini, 1973). Artist-teacher as a title sounds good, plus it emphasizes the dual roles of being a practicing artist and teacher. However, there are many characteristics that researchers have used to define what an artist is. For example, does one need to exhibit, have gallery representation, or maintain an active studio practice to be an artist? Another identifier is the level of education or the quality of education one received. Holding a bachelor of fine arts (BFA) or an MFA degree contributes to many artist-teachers' identity as artists. Research demonstrates that the education (level and type) of art teachers has a profound effect on teaching based upon past studies (Hansel, 2005; Lund, 1993; Zwirn, 2002). The type of school they attend (art school versus school of education) and the classes (studio art versus art education) they choose to take have important ramifications on identity. Zwirn (2002) approached the artist-teacher relationship as a conundrum. In contrast, Weiss (2001) looked at the many interpretations that post-baccalaureate students had of former artist-teachers. In most circumstances, when identity is addressed, the artist-teacher is seen as a dilemma where one role does not support the goals or characteristics of the other. Stereotypical characteristics of artists include carefree attitudes, spontaneous activity, atypical working arrangements/conditions, and goals associated with exposure, exhibition, and galleries, or museums. In contrast, the teacher is often working in a regimented system that is systematic and highly structured. The goals are associated with student success and are less personal in nature. Thus an identity associated with both of these positions can be confusing and frustrating for those interested in maintaining both roles.

The role of the artist-teacher at the college level prompts a number of problems. Risenhoover & Blackburn (1976) write about artists and their difficulties with the constrained commitments that detract from creative output in college art teaching positions. The subjects interviewed were artist-teachers working within university/college contexts from across the United States. The authors documented uncomfortable relations as well as successful stories about coupling teaching with being an artist. Despite the successes, the authors acknowledge that the artist within the university setting is troublesome. The artistic products (painting, sculpture, film, among others) created by artists are often not recognized as scholarship. Coupled with different higher education credentials (Ph.D. versus MFA), the artists interviewed wrestle with this unusual position. Although many universities moved beyond recognizing artistic products as scholarship, they still wrestle with the significance of certain products and how to measure or evaluate such work.

Ritenbaugh's (1989) identity study examined art education professionals and their perceived roles and status as administrators, artists, collectors, organizational leaders, scholars, and teachers. The educators included in the study were of all levels of instruction, from elementary to higher education, and included those in administration. The findings from this study along with Dohm (2000) and Zwirn (2002) display evidence for art teacher complacency with their titles.

Authors such as Dohm (2000) have written about art career education, and the training and skills necessary for today's graduates. Identity is certainly tied to education, as art educators may be less likely to see themselves as artists. But is this what is best for art education? In the past, artist preparation always took center stage. Those roles are now being reversed through advances in educational pedagogy. Titles are important, and the artist-teacher has a significant presence when art teachers try to describe their role within educational institutions. Yet this is not the purpose of this text— the artist-teacher is more than a title.

Partnerships

Particular circumstances that bring the professional artist and educator together in the classroom are also an option in understanding the dual role. In these cases, the artist-teacher is used to describe the combination of two different persons (artist and teacher) or the visiting artist's role in the classroom. Douglass (2004) examines specific arts initiatives that facilitate a partnership between artists and educators in the classroom. These programs illustrate the dual role that exists in art education, and this partnership between two individuals is one solution for combining the dual roles of artist and teacher.

An understanding of the collaboration that takes place between artists and teachers has been studied to learn about the many benefits of such contributions (Douglass, 2004; Kinsey, 2001; Strokes, 2001). Douglass's (2004) artist-teacher collaborations are related to problems with at-risk youth, and the methods/strategies that artists serving as teachers use, including perceptions of their effectiveness. The partnership category brings to mind museums that recruit artists to visit public school classrooms. The artist-teacher partnerships when working perfectly call upon the desirable qualities of both the artist and teacher to meet the needs of a specific group of students.

The Solomon R. Guggenheim Museum's Learning Through Art (LTA) program uses the partnership arrangement by placing New York artists in New York City public school classrooms. The teaching artists collaborate with the classroom teachers to create art projects related to themes in the school curriculum. These partnerships have been very successful for both sides (museum and school), especially because findings display the importance of this program in developing literacy, critical thinking, and problem solving skills (Randi Korn & Associates, 2007).

Nontraditional Artist-Teachers

Artist-teacher professional positions typically include employment at the elementary, high school, or college level. However, more positions outside the classroom exist for teaching art. Opportunities exist in museums, galleries, art centers, private corporations, and nonprofits. Pujol (2001) approached the effectiveness of the artist-teacher within the museum setting, whereas Hanson (1971) investigated the effectiveness of museum teaching artists working with traditional classroom teachers. Who better to interpret

artwork in a museum or art center then a person with an active art practice? Studies using the term "artist-teacher" in nontraditional teaching contexts fall into this category. Typically the nontraditional artist-teacher uses his or her perspective as an artist to heighten the visitor's aesthetic experience.

History

The artist-teacher relationship has also been well documented in historical accounts Scholarship about a particular period is the most common type of historical work. The art education historian Efland (1990) writes about the artist-teacher at the beginning of the 20th century. These particular artist-teachers made a name for themselves between the 1920s and 1940s by developing a mode of teaching that encouraged self-expression. Other reconstructed histories of art educators have been written from past students' viewpoints and provide an alternative look at learning (Cheung, 1999). For example, Brown (1990) uses data on artist-teachers drawn from past student accounts using recorded lectures and teaching memorabilia to reconstruct their history.

Historical referrals to artist-teachers are abundant and the term is often used in history texts (Byrd, 1963; Efland, 1990; Elkins, 2001; Logan, 1955; Macdonald, 1970). However, it is usually used to heighten the importance of the teacher as an artist. Hans Hofmann and Georgia O'Keeffe are good examples for both are known for their teaching contributions but are called artist-teachers because of their significant contributions to 20th-century art. A surface level signifier, the artist-teacher in the historical vein is a decorative title.

Studies of Individual Teachers

Several authors have approached the artist-teacher relationship through case studies of individuals (Beer, 1999; Brown, 1990; Douglass, 2004; Kent, 2001; Tucker, 1998; Wolfe, 1995). By studying exceptional artist-teachers, researchers are able to write about characteristics that contribute to understanding their craft. Portraits of artist-teachers have also been studied to shed light on qualities they share with others (Brown, 1990; Campbell, 2003). Cho (1993) examined the combination of the artist-teacher role at the college level by studying two influential figures: Hans Hoffmann and Josef Albers. Her analysis focused on their teaching, art making, exhibiting, and writing. She simultaneously offered suggestions from this research for artist-teachers balancing their own dual careers. This type of research shares useful traits that serve as a model for teaching.

Qualitative research on effective teaching is important to the field of art education. Brown (1990) and Wolfe (1995) provide examples of teaching and learning in the classrooms of artist-teachers. Researchers like Tucker (1998) write to educate future artist-teachers in the hope that such studies can be used as a reference to improve practice. The use of critique and the encouragement of metacognitive thinking by students of the artist-teacher have been the subjects of study (Kent, 2001). Specific traits of artist-

teachers—such as spirituality by Campbell (2003) and the use of repetition— have also been studied to further the craft. Risenhoover & Blackburn (1976) have also provided a valuable primary source in a collection of interviews with artist-teachers. The artist-teachers chosen for the publication are limited to painters, sculptors, and musicians who address issues of being an artist and teacher at the university level. The study also addresses topics pertaining to creativity in relation to working in a bureaucratic institution. This resource is a good example of the conundrum addressed by Zwirn (2002) about the dual role artist-teachers must balance.

Although case studies provide exceptional records of individuals, a few artist-teachers have taken matters into their own hands by publishing advice or curricula to aid future art educators with their dual roles. Rockman (2000), a seasoned artist-teacher, wrote a book designed for artists to use when teaching art at the college level. She feels that most artists are not good teachers (possibly a symptom of MFA curricula). Her writing is designed to help future art educators in their teaching endeavors. Kellman (1999) writes to offer art educators valuable knowledge from the point of view of an elder art educator. Walker (2001) approaches artist-teacher education from the vantage point of an artist. Through interviews, the artist becomes an educator in the classroom, discussing difficult issues and unique methods for approaching them.

The majority of these case studies on the artist-teacher relationship dealt with issues pertaining to quality teaching. A very small amount addressed the issues of being a professional artist and only a select few studies commented on the need for additional research in the area of leadership and art education. John Steuart Curry was the first artist in residence at an American university—that is, the University of Wisconsin. During the mid-20th century, the artist-in-residence idea continued to develop after World War II because administrators felt that students would gain a better education in the arts from professional artists (Risenhoover & Blackburn, 1976). This tradition has continued, but under some confusion, in the field of art. Although the proper placement of the art education department may be debated, the artist-teacher will always share two areas of study.

Rationales and Changing Goals in American Art Education

The purpose of teaching art is important for understanding the term "artist-teacher." The choice to prepare artists or a host of assorted goals has changed our understanding of why we teach art. Efland (1990) provides an in-depth account of the various rationales for the teaching of art in the United States. Although he primarily focuses on the justifications of art education as a component of public schooling, the trends and values society has used to validate study in the arts are an eye-opener for those entering the field. Art has been taught for various reasons, including preparing artists, self-expression, therapy,

aesthetics, history, industrial training, nationalism, peace, among others. Siegesmund (1998) expresses frustration and anxiety with this sentiment that conflicting justifications rationalizing art education are not a positive aspect for the field.

> I am concerned that whatever current success art education has is based more on the politics of holding diverse conceptions of art together than on the strength of a clearly articulated, persuasive, and enduring educational rationale. I am concerned that the absence of a conceptual center in the eclectic approach to arts curriculum will ultimately prove problematic. My fear is that without a center, the historical pattern of educational cycles will continue, and the current curricular reforms will prove to be ephemeral as the curricular reforms of the past. (p. 198)

Siegesmund's fear is understandable, yet what he considers art education's weakness, Davis (2005) posits as its strength. The metaphor of constantly applying new lenses is used by Davis (2005) to translate the vocabulary of arts learning into other properties. Rethinking and pushing the boundaries of art education is certainly different from an absence of a center. In fact, the center of art education appears to get larger as we study the history of how art is taught. This unique debate, albeit discouraging to some, may serve as an example of the malleability of art teachers to adapt (artistically) and to continue to influence and transform our understanding in many different cultures and contexts. The advent of new styles and movements in art history from the dawn of the caveman to contemporary artists working in New York City has not weakened the significance of the visual arts but rather broadened our understanding of what is possible.

Art for Industrial Education

Prior to World War I, art education in the United States was associated with industrial design training. A system of education to prepare designers was adopted from the South Kensington system of art education in England. These art teachers hoped to instill proper drawing skills to advance the state of design for a young country. The United States realized that Great Britain had been losing rank in manufactures and commerce for at least the last twenty-five years of the second half of the 19th century (Chalmers, 2000). In comparison, the United States was behind Great Britain, so something had to be done to address this deficiency (Chalmers, 2000). The economic argument for better-designed products required higher artistic skill, which required an educational infrastructure for a technical art education.

Walter Smith (1836–1886), formerly the headmaster of the School of Art in Leeds, was the South Kensington–trained instructor hired by the state of Massachusetts to

introduce a system of design education in the Boston public schools (Chalmers, 2000). As a student in London's Marlborough House, Smith was a classmate of noted Victorian designer Christopher Dresser. George Wallis (discussed in Part II) lectured at their school a number of times during the 1840s when Dresser and Smith were students and had a strong influence on the student body (Halén, 1993). Because Smith was a graduate of South Kensington, there is a theoretical link between early art education initiatives in the United States and art education programs refined during the 19th century in Britain. Smith (1873, p. 42) states: "The kind of drawing which the State of Massachusetts requires that its citizens shall have an opportunity of studying, is called 'industrial drawing' … an important element in the success of trades and manufactures."

Within the larger context of the industrial revolution, these designers would create patterns, decoration, and ornamentation for items from wallpaper to chair backs and carpet designs. Public appreciation of design and craft were outcomes of proper education, thus raising the aesthetic awareness of the folks who produced and purchased such products (Smith, 1873). The education of students and an increase of good design in the market cultivated the public at large. Smith did not support drawing for aesthetic reasons. He instead thought, "It should be regarded as a servant, or vehicle, to assist expression in the study of other subjects, as it is in geography, by means of map drawing" (Smith, 1873, p. 10). A practical application of arts teaching, students learned a craft that was pragmatic. As an early American education initiative, art was taught for industrial purposes; however, as times changed, so did the way art was taught.

Art as Cultural Agent

After the 1920s, the industrial purpose of teaching art faded as a transition away from design opportunities took place. Art would now be taught for cultural purposes (Efland, 1990). The appreciation of art itself and the wonders of nature were sufficient justification for studying and teaching art. Ruskin (1971) advocated a similar view, in that the study of nature led one to understand God and morals. In fact, faith, morals, and empire were all related to art (Bell, 1978). Similar to art movements reacting to one another, educational philosophies build upon or reacted against prior theories. As the Slade Professor of Art at Oxford University and author of *Elements of Drawing*, Ruskin reacted to the industrial design movement by criticizing its factory approach and lack of artistic influence (Macdonald, 1970). In addition, many concurrent theories work and are practiced alongside one another rather than a progressive improvement or understanding of ideas. History tends to remember the dominant theory until recent critical histories. Interestingly, Ruskin's ideas had little influence on public education, because he was not politically involved and his writings were sometimes too vague and were misinterpreted (Macdonald, 1970). It was not until 1872 that Ruskin finally

opened the fledgling Ruskin Drawing School, practicing the South Kensington system mentioned earlier.

To understand the history of 20th-century art education in the United States, Efland (1990) categorizes the major areas in art instruction as Reconstructivist, Scientific Rationalist, and Expressionist. These categories were constructed to organize the diverse applications and theories, and to serve as a useful tool in comprehending the various rationales. Siegesmund (1998) also uses these categories for his purpose to express the absence of a center. Critically, they serve as markers in which the various and diverse theories of art education can be discussed outside a timeline or chronology.

Advocates of the expressionist stream maintain that teaching art facilitates the autonomous and imaginative abilities of the student, with expression as the main goal. Art as an expressive agent and source for teaching is a dominant theme throughout the 20th and 21st centuries, appearing in different forms. First, the Progressive movement advocated by John Dewey (1944) and Andreas Kazamias (1966) realized itself through a student-centered curriculum (Egan, 2002). This is significant in comparison to a subject-centered curriculum in which a defined list of objectives is produced and poured into every student. Herbert Spencer (1966) advocated progress as social Darwinism. As industrial society in the 19th century progressed, so should education, according to Spencer, which could be accomplished by pursuing scientific knowledge of most worth and not irrelevant information.

The work of Dewey is known more recognizable than Spencer's, but Dewey's ideas are built from the foundation laid by Spencer (Egan, 2002). The central belief behind Progressivism is that attending to the student's nature, his or her mode of learning, and stages of development is how they learn (Egan, 2002). The child-centered curriculum approaches each student as a unique being, and information should be provided only when the student is ready. This may occur through questioning, dialogue, or observing the student. For example, the instructor would present one perspective when the student's work could benefit from such instruction to express herself fully. In this situation, the student applies the newfound knowledge when he or she desires or needs it. An advancing stream of progressive thought continues contemporarily in all levels of education in the United States, with many educators hoping it will solve the educational struggles of the period. It is common to see individualistic attention like this at college campuses in addition to grade schools in many formats.

Expressionism is also aligned with the modern art movement and theories that developed during the 20th century. Self-expression was valued and represented a break from industry and commercialism. "[M]ost self-expressive art teaching, as they … advocated it, was by artists who were deeply imbued with the conviction that there is an affinity between the activity of the artist and the graphic expression of the child" (Efland, 1990, p. 196). Franz Cizek, an influential Viennese teacher, hoped to unleash creativity by advocating a "taking the lid off" approach similar to Rousseau's (1764/1979) *Emile*-based education—all natural and uninfluenced by society.

Siegesmund (1998, p. 200) claims that using "art as a vehicle to express emotions is posited as essential for release from burdensome cognitive concerns and access to the unconscious which together result in positive developmental growth." Art becomes a soft subject, according to Siegesmund, not purporting academic outcomes. It is a place to clear the mind and become a well-rounded individual. Although Siegesmund's conclusions are questionable, he raises an aspect of art education that has been criticized and misunderstood as a subject concerned with individual issues and not relevant to society. However, without the expressivist stream, the tenets of Progressivism would not have endured to become the dominant philosophy in the field of education (Egan, 2002). Expressivism represents an aspect and strength of the field of teaching that many continue to espouse.

A group of artist-teachers rooted in the expressivist tradition labeled themselves artist-teachers in the early 20th century while fulfilling many Progressive ideals (Efland, 1990). In essence, this group of teachers, including Victor D'Amico, felt the act of being artists placed them in a better position to unleash and facilitate the creative nature of the students, something non-art specialists could not do because they did not have the necessary experience of being an artist. Prior to this, it was not uncommon for the visual arts to be taught by non-art teachers. Calling upon the Progressive philosophies and the child art movement mentioned earlier, this child-centered curriculum met the needs of the individual student. This experience of being artists placed artist-teachers in a better position to recognize and work with students who were encountering similar artistic problems that the teachers had also encountered.

Reconstructivist

Through the reconstructivist stream, Efland (1990) writes how art has been used as an agent for social transformation. From personal investigations by single artists to organizational groups of art professionals concerned with changing the world, art is a powerful tool for provoking cultural change. Morals/values, democracy, and citizenship have all been popular topics within the paradigm, as one does not need to travel far to realize the power of the arts to change or challenge the thinking process and actions of the general public. Using art as a lens to engage critically with social conditions and values rather than seeing art as a subject area exudes this stream of thinking whose base may strive for various causes, including cleaner air, recycling, women's rights, gun control, changes in government, or saving an endangered species, to name a few.

Art for nationalism was a reaction to America's involvement in World War II. Efland (1990, p. 231) captures the essential aspect of this movement: "The war represented a special challenge to art educators, who had to demonstrate that art was ideologically committed to the struggle to preserve freedom and democracy, the very freedom that permitted self-

expression." Just as economies boomed to support the war effort, art education followed with projects to promote supportive messages for our troops abroad. Contemporary artists who teach or make art for social causes advocate similar ideologies.

The International Society for Education through Art (InSEA) was founded in 1951 with the purpose to exchange information regarding visual art in an art for peace movement (Efland, 1990). The arts have the ability to express difficult issues and serve as a mouthpiece for engagement. The art for peace movement is one example in which art making and appreciation instead has been used to promote awareness or raise money for important causes. Using art to promote peace continues to be a strategy for individuals and communities. In this tradition, InSEA continues the dialogue by facilitating debate through conferences, special projects, and publications. The reconstructivist stream further illustrates the malleability and all-encompassing strength of art education. In essence, the reconstructivist thinks that art education is about critical awareness rather than appreciation or expression. In this paradigm art becomes a tool for limitless purposes and disciplines.

Scientific Rationalism

Efland (1990) describes scientific rationalism as ideas that have roots in science and asserts that all philosophical problems can be solved through scientific methods. This movement or stream of influence has taken disciplines defined by science as a starting point for reform. It posits an objective perspective to observe empirically physical phenomena. Although scientific rationalism can tell us about physical conditions, it is impossible to have a truly objective view separate from the way we understand the world. As the philosopher Thomas Nagel (1986) acknowledges, we are the first obstacles in the way of objective reality. (Nagel does not think reality is just physical.)

The progress of science is not divided neatly from the reconstructivist and expressivist streams of influence; in reality, the scientific discoveries of the 19th century fueled early progressive thinking by folks such as Herbert Spencer, who used the findings of Charles Darwin and his theory of evolution (Efland, 1990; Egan, 2002). The separation and categorization serves as an organization tool to link ideas that contain similar conceptual foundations. The variety and difference of foundational doctrines weave a complex tapestry as ideas emerge and are woven into the art education landscape. In hindsight, some philosophies are less effective—or even detrimental (Herbert Spencer's concept of what knowledge is of most worth)—to art education, whereas others broaden horizons and continue to be researched and developed (theories of Progressivism). In light of these movements, the historical currents of art education are constantly moving.

Producing Artists or Producing Artistic People?

Given the many theories and ideologies practiced in the field of art education's past and present, what happened to preparing artists? An easy answer is to divide school teaching from academy teaching and to use the stereotypical divider that the schoolteacher prepares young children to learn about the arts (or possibly one of the many justifications previously mentioned), whereas the academic atmosphere prepares artists. However, I have also argued that academies practice a contradictory method of art education, so preparing artists is not a goal that is sufficient, consistent, or salient for being an artist-teacher.

If we accept Arthur Danto's (1992) strong case that the boundaries between high and low art have been broken in addition to the divide between fine art and industrial process, then is there also a blurring of the education one receives in grade school compared to the university? Neither of these two contexts has a constant curriculum, and the schoolteacher is a product of the university. Because of the close relationship between today's schoolteachers and their university peers, schoolteachers and professors adhere to similar structures. As someone who works in both worlds, I am often confused if there is a difference, or if it should matter.

Visual thinking is a term now used to justify art study on every level. Thus the recent developments of art education are making this divide very slight, which I believe is a great strength. As grade school students study art movements and drawing exercises, the teacher hopes these exercises prepare his or her students to be intelligent perceivers of the world. This is in the same vein of college-age art students. The growth of artistic practice is staggering, especially because there are more artists practicing today than all the Renaissance artists combined. Although there are currently flourishing aspects of arts industries, the majority of arts graduates from the nation's colleges will not support themselves as traditional artists. A similar situation exists with most majors. (All math majors do not become mathematicians.) This argument is made many times by grade school teachers (who realize that all their students will not become artists) in support of a curriculum that supports alternative educational philosophies, such as developing well-rounded students or critical thinkers. Thus becoming an artist is not always the goal of grade school, high school, or college educations. After all, college graduates are not limited to becoming mathematicians or historians when earning these degrees. Is the purpose of education not larger than job preparation?

Hetland, et al. (2007) hypothesize eight cognitive and attitudinal dispositions within serious art programs:

> Develop craft which includes learning to use tools
> Engage and persist through problems with focus
> Envision what cannot be observed

Express ideas through art
Observe and develop visual skills
Reflect, question, and evaluate one's work
Stretch and explore beyond one's capabilities
Understand art world and the context of art history

The dispositions combine to represent studio thinking processes facilitated by quality art programs. These goals combined could be considered an artistic way of thinking about teaching. Organizing and applying them in classrooms and studios could be similar to applying the elements and principles of design. Arthur Wesley Dow (1899/1926) organized a structural system for designing images in his text *Composition*. Elements such as notan,[3] line, and color were defined and demonstrated as a way of controlling aesthetic products. Knowing which combinations of elements to use—or just being aware what they are—awakens possibilities in creating compositions. Rather than produce the same image over and over, a set of guidelines is established (that contemporaries may follow or break) to organize their creations. The elements and principles of design through Dow become an aesthetic organizing tool. In the classroom, they become another language, including motivational techniques, inquiry, and exploration. Combining the right mixture of educational dispositions similar to Dow's principles stands to create a strong learning experience. The artist metaphor works nicely in this situation, as the artist-teacher molds and creates powerful learning environments.

Teaching art is a tradition that has been reorganized and redefined in numerous instances to adapt to cultural and contextual circumstances, and art educators readjust the composition of teaching to strengthen its effect. The aesthetic nature of teaching art is valuable to push as a metaphor. Similar to a painter reworking a canvas, new ideas emerge and different relationships become important in some instances rather than others. In a similar fashion, the art teacher also adjusts the composition of the classroom, changing rationales, philosophies, and sometimes preparation to better capture and communicate what is important.

* * *

The common ancestry of the art teaching profession lends itself to breaking the barriers between the levels of art instruction from kindergarten to graduate school. The current adaptation of the academy has contributed to this democratic understanding by reinforcing pluralistic ideals, which affirm multiple perspectives. Fortunately, the arts have the ability to shift and adjust to change, a great strength that ensures art practice, appreciation, and education will always be a service to society. Noticing these shifts and changes and how they are handled harkens to the many aesthetic decisions an artist makes when creating a piece of art.

Whereas an artist uses various lines to communicate particular emotions, the art teacher also manipulates tactile objects, noise/voice, and concepts to produce a learning environment that is conducive or sometimes obstructive for learning. Thus the reasons for teaching do not make the artist-teacher; in fact, the justifications for art education at all levels are closer then previously thought. In addition, education does not appear to make the artist-teacher, although it certainly contributes to one's self-esteem. The actual concept of applying an aesthetic way of seeing and understanding is the central factor that requires embracing thinking deeply about being an artist-teacher.

References

Beer, R. S. (1999), "Landscape and identity: three artist/teachers in British Columbia," Ph.D. dissertation, Vancouver: University of British Columbia.

Bell, Q. (1978), *Ruskin*, New York: George Braziller.

Brown, K. H. (1990), "Lotte Lehmann: artist teacher," Ph.D. dissertation, Kansas City: University of Missouri.

Byrd, G. (1963), "The Artist-Teacher in America: His Changing Role in Our Institutions," *Art Journal*, 23: 2, pp. 130–135.

Campbell, L. H. (2003), "Portraits of visual artist/teachers: spirituality in art education," Ph.D. dissertation, Urbana: University of Illinois at Urbana-Champaign.

Chalmers, F. G. (2000), *A 19th Century Government Drawing Master: The Walter Smith Reader*, Reston: National Art Education Association.

Cheung, M. G. (1999), "Pilgrimage of an artist-teacher: Cecile Staub Genhart as remembered by her students," Ph.D. dissertation, Tempe: Arizona State University.

Cho, J. M. (1993), "Hans Hofmann and Josef Albers: the significance of their examples as artist-teachers," Ed.D. dissertation, New York: Teachers College, Columbia University.

Dannenmüller, S. (2006), *Los Angeles 1955–1985: the birth of an art capital*, March 2006 ed. [Student guide], Paris: Centre Pompidou.

Danto, A. C. (1992), *Beyond the Brillo Box: The Visual Arts in Post-Historical Perspective*, Los Angeles: University of California Press.

Davis, J. H. (2005), *Framing Art as Education: The Octopus Has a Good Day*, New York: Teachers College Press.

Dewey, J. (1944), *Democracy and Education: An Introduction to the Philosophy of Education*, New York: Free Press.

Dohm, A. M. E. (2000), "Career skills needed to be a successful artist: finding links between art teachers' practices and artists' beliefs," MA thesis, Tempe: University of Arizona.

Douglass, M. B. (2004), "Professional artists as teachers with at-risk youth: a narrative case study," Ph.D. dissertation, Raleigh: North Carolina State University.

Dow, A. W. (1899/1926), *Composition: A Series of Exercises in Art Structure for the Use of Students and Teachers*, 13th ed., New York: Doubleday, Page and Co.

Efland, A. (1990), *A History of Art Education: Intellectual and Social Currents in Teaching the Visual Arts*, New York: Teachers College Press.

Egan, K. (2002), *Getting it Wrong from the Beginning: Our Progressivist Inheritance from Herbert Spencer, John Dewey, and Jean Piaget*, New Haven: Yale University Press.

Elkins, J. (2001), *Why Art Cannot be Taught*, Chicago: University of Illinois Press.

Goldstein, C. (1996), *Teaching Art: Academies and Schools from Vasari to Albers*, Cambridge: Cambridge University Press.

Halén, W. (1993), *Christopher Dresser: A Pioneer of Modern Design*, London: Phaidon Press.

Hansel, L. B. (2005), "An investigation into the role of the artist in secondary art education," MA thesis, Providence: Rhode Island School of Design.

Hanson, D. (1971), "The art masters," *British Journal of Educational Studies*, 19: 1, pp. 40–50.

Hetland, L., Winner, E., Veenema, S. & Sheridan, K. M. (2007), *Studio Thinking: The Real Benefits of Visual Arts Education*, New York: Teachers College Press.

Hickman, R. (2005), *Why We Make Art and Why It Is Taught*, Bristol: Intellect Books.

Kazamias, A. M. ed. (1966), *Herbert Spencer on Education*, New York: Teachers College Press.

Kellman, J. (1999, March). The voice of an elder: Jo Leeds, artist teacher, a personal perspective on teaching and learning. *Art Education*, 52 (2), 41-47.

Kent, L. A. (2001), "The case of Lucio Pozzi: an artist/teacher's studio critique method," Ed.D. dissertation, New York: Teachers College, Columbia University.

Kinsey, C. W. (2001), "The use of artists in the learning process: a collaboration with first-grade teachers," Ph.D. dissertation, Charlotte: University of North Carolina Charlotte.

Logan, F. M. (1955), *Growth of Art in American Schools*, New York: Harper and Brothers.

Lund, K. A. (1993), "Transition from artist to artist teacher: a case study of graduate student studio teaching," Master of Arts thesis, Tempe: University of Arizona.

Macdonald, S. (1970), *The History and Philosophy of Art Education*, London: University of London Press.

Nagel, T. (1986), *The View from Nowhere*, Oxford: Oxford University Press.

Orsini, N. (1973), "The Dilemma of the Artist-Teacher," *Art Journal*, 32: 3, pp. 299–300.

Pujol, E. (2001), "The Artist as Educator: Challenges in Museum-Based Residences," *Art Journal*, 60: 3, pp. 4–7.

Randi Korn & Associates (2007), *Teaching Literacy through Art. Final Report: Synthesis of 2004-05 and 2005-06 studies*, Alexandria: Randi Korn & Associates, Inc.

Reinhardt, A. (1957), "Twelve Rules for a New Academy," *Art News*, 56: 3, pp. 37-38.

Risenhoover, M. & Blackburn, R. T. (1976), *Artists as Professors: Conversations with Musicians, Painters, Sculptors*, Chicago: University of Illinois Press.

Ritenbaugh, T. D. (1989), "Artist, teacher, scholar, organizational leader, administrator, collector: art educators' beliefs about roles and status," Ph.D. dissertation, University Park: Pennsylvania State University.

Rockman, D. A. (2000). *The art of teaching art: A guide for teaching the foundations of drawing-based art*. New York: Oxford University Press.

Rousseau, J. (1979), *Emile, or on Education*, New York: Basic Books.

Ruskin, J. (1971), *The Elements of Drawings*, Mineola: Dover Publications.

Shaw, B. (1903), *Man and Superman: A Comedy and a Philosophy*, Westminster: Archibald Constable & Co.

Siegesmund, R. (1998), "Why Do We Teach Art Today? Conceptions of Art Education and their Justification," *Studies in Art Education*, 39: 3, pp. 197–214.

Smith, W. (1873), *Art Education: Scholastic and Industrial*, Boston: James R. Osgood and Co.

Strokes, K. J. (2001), "LEAPing toward change: a portrait of teacher-artist collaborative instructional practice in the elementary classroom," Ph.D. dissertation, Philadelphia: Temple University.

Tucker, E. H. (1998), "Janice Harsanyi: profile of an artist/teacher," Ph.D. dissertation, Columbus: The Ohio State University.

Walker, H. (2001 Spring). Interviewing local artists: A curriculum resource in art teaching. *Studies in Art Education*, 42(3) 249-266.

Weiss, C. J. (2001), "The evolution of post-baccalaureate students' conception of the artist-teacher role during a teacher certification program," Ph.D. dissertation, Minneapolis: University of Minnesota.

Wolfe, M. S. (1995), "A really good art teacher would be like you, Mrs. C: a qualitative study of an artist-teacher and her gifted middle school students," Ph.D. dissertation, West Lafayette: Purdue University.

Zwirn, S. G. (2002), "To be or not to be: the teacher-artist conundrum," Ed.D. dissertation, New York: Teachers College, Columbia University.

Endnotes

1. A punishment formerly used in the military in which an individual was forced to run between two lines of men armed with weapons, beating him as he passed.

2. Departments of art and art education often award the doctorate of education in art or art education. The doctorate of fine arts is also growing in popularity.

3. The Japanese term "Notan" is used by Dow to represent the quality of light and dark in the shading of tones. "Notan-beauty" is also used to represent the harmony resulting from dark and light spaces.

CHAPTER TWO
THE ARTIST-TEACHER: FROM THE
CLASSICAL ERA TO THE 21ST CENTURY

The Artist-Teacher History

History serves many purposes. Typically, we understand the visual arts of the past cultures and periods through the study of art history. Studying teaching methods, on the other hand, is a bit more elusive. Teaching records can be scarce, because the products of great teaching are not easily preserved. Even more complicated is the interchange and sometimes combination of teaching and making art. Given the influx and number of artists who teach contemporaneously, a record of this history can better inform us to help understand our traditions, struggles, origins, and triumphs through teaching art in various contexts. Through an investigation of primary and secondary sources, the conceptual origins of the term "artist-teacher" are presented in a revisionist tradition (Brundage, 1989). As our understanding of teaching pedagogy changes, so does our search for understanding the teaching processes of the past. The context surrounding uses of the terms "artist" and "teacher" and links between them are discussed to present a fresh perspective of art education history.

Although many teachers of the visual arts could be labeled artist-teachers, they are not included in this chapter. The history of how the arts were taught in various cultures is important for the context, but only teachers who were labeled within current historical literature as artist-teachers are acknowledged. The art education historians Stuart Macdonald (1970), Mary Ann Stankiewicz (2001), Frederick Logan (1955), and Arthur Efland (1990) single out particular educators as artist-teachers through their respected histories of art education.

Art education history has proven a valuable addition to historical inquiry (Efland, 1990). Erickson (1979) values art education histories to understand the origins of terms in art education and to set a foundation for future research questions. Erickson's (1979) four justifications for historical research in art education are cited by many practicing

scholarship in this area and include the following: initiation into the field of art education, creating a sense of belonging, clarifying ideas, and that knowledge of the past feeds our consciousness to formulate new questions about current and future practice. For if we do not know where we have been, how ought we to know where we are going? The use of the term "artist-teacher" serves both purposes—establishing the significance and understanding the origin. The history of the artist-teacher is thus presented chronologically, not as a progression of ideas, but rather as an organizational tool to better understand the use of the term in the field of art education (Erickson, 1979).

Classical Education in the Arts

Although the art of the Classical era is a major field of study, not much is known about the methods of instruction for training artists in ancient Greece. The early Greeks considered skill in painting, sculpting, or stone carving as inferior trades (Efland, 1990). The arts are likened to technology or craft and were a set of skills one could acquire.[1]

These skills were not part of the traditional education system but were offered sparingly in the formal education of aristocrats. Individuals who made their living in a crafts industry, such as potters or painters, more likely acquired their skill through a family workshop. An informal workshop was designed to pass on the family trade. It was understood that these processes were part of a discipline with rules that could be taught and learned (Kristeller, 1951). Given this crafts-based profession, creativity was not a major component compared to acquisition of technique. Efland (1990) emphasizes that the father would teach these skills to his sons or on occasion someone from outside the family interested in becoming an artisan. Through this dynamic, the profession continues, handed down generation to generation.

According to ancient writers, the work of painters and sculptors was associated with manual workers, giving them an unfavorable social status (Kristeller, 1951). Although contemporary artists enjoy an intellectual identity, the Greeks had a different concept of which subjects were valued. Our basic conception of what constitutes the liberal arts was loosely defined by ancient Greek and Latin writers (Capella, Varro, and Sextus Empiricus) and noticeably excluded was the field of visual arts (Kristeller, 1951). Craftsmen also accepted fees from their students, which, according to Plato, did not qualify them as educators; only philosophical or theoretical studies were worthy areas of study for general purposes to become a gentleman compared to the lower-class professional or skilled laborer (Macdonald, 1970).

These skilled workers took it upon themselves to teach their trades in, most likely, a practical way. The Greek craftsmen were first and foremost practitioners, and they taught to provide their offspring the necessary skills applicable to a trade. This domestic education model did not differ from the early family-based education that Greeks

received in Sparta or Athens before attending a state-supported school (Cordasco, 1963). Family education is a short way to describe how fathers and mothers passed on important family or cultural values within the context of the home. Although the various city–state goals differed, each culture in the Old Greek period took responsibility for its children's education until a certain age. Certain city–states valued warfare, whereas others maintained the importance of philosophy—these values were then emphasized in this atmosphere.

Cordasco (1963) organizes Greek educational history into two periods: old and new. The old period represented the Age of Pericles (the Golden Age, approximately 448–404 B.C.) and an emphasis on the individual, whereas the new period represented a concern for the citizen. The Sophists, philosophers, and teachers in the new period taught for a fee and regarded education as a means for success (Frost, 1989). The University of Athens was established in the New Greek period, and this institution and other universities of its kind owed a debt to earlier philosophical groups, such as Plato's Academy and Aristotle's Peripatetic School (Cordasco, 1963). The high regard for education among the Greeks led to the establishment of the early university system that laid the foundation for intellectual pursuits for hundreds of years. The University of Alexandria eventually surpassed the Greek university during the early Christian centuries (Cordasco, 1963).

In Roman education, the arts were also missing from the general education of men. Many Roman communities appropriated the Greek educational system after 146 B.C., including their framework for higher education (Cordasco, 1963). The uncomfortable relationship between the visual arts and the educational curriculum of the Greeks and Romans underscores the tremulous relationship that the arts have had throughout their history.

The educated Roman was someone who could express and sway others through speech with the qualities of logic, morals, local laws, and traditions. The Sophists developed this pattern of education that continued in Roman education. Men who demonstrated these skills possessed a power because of their ability to motivate the masses (Frost, 1989). The arts were a skill that did not contribute to lofty goals like these and thus remained a craft.

One could say that an embryonic model of the artist-teacher was already present within the classical apprentice model of the Greeks. Surely the craftsmen and sculptors who created artifacts sought to teach these skills to a younger generation for practical and economic means. However, the arts were not part of the academic disciplines of the day, and it appeared that the role of education was not emphasized highly in this apprenticeship process. Lack of sufficient data, however, limits our interpretations in this process, but the primary goal was to pass on a skill set for survival in an efficient manner. Our modern understanding of an artist also does not exist, so it is unfair to label these individuals artist-teachers, but it is valuable to recognize if their artistic perspectives influenced their teaching processes. The mode of creating sculptures in the

Greek or Roman eras was one of craft and discipline, something recognizable in their teaching as well—that being a craft discipline. Ancient manuscripts by Polykleitos and Vitruvius demonstrate the importance of symmetry, order, and distinctness in classical art (Williams, 2009). Given the context, period, and evidence, we can only draw surface interpretations that set a foundation for Renaissance education to draw upon and the Middle Ages to borrow and react against.

Middle Ages

The rise of Christianity in Europe had a profound effect on education and the arts after the fall of the Roman Empire. Catechumenal[2] schools were formed and taught the beliefs and rites of the Christian tradition (Frost, 1989). The purpose of this early education was to disseminate Christian doctrine throughout the world. During the course of the Middle Ages, the Catholic Church sought to suppress the surviving models of pagan art and culture that prospered in Greek and Roman times. The arts (painting and sculpture) and education during this time entered a period of decline because of the indifference medieval Christians held toward Greek and Roman art and education (Efland, 1990; Cordasco, 1963). Temples became monuments, and churches and cloisters were the new architectural innovations (Stalley, 1999). Athough Hauser (1951a) concurs the spiritual expression and religious character of art in the Middle Ages is continuous from the early Middles Ages (6th to 11th centuries) to the Romanesque and Gothic styles, it developed at first similarly to late Roman movements, adapting a common style. As with art production, education also took cues from pagan culture, because the classical education developed in Greek and Roman contexts was only available to the upper class as the early Christian church influenced general education.

The arts survived during the Middle Ages as a way to illustrate the messages of the Bible to the illiterate through the work of monasteries and were seen as a gift from God (Stalley, 1999). Scholarship, art, and literature were all affiliated with the work of monasteries, but "[t]he artisans, who, as the heirs of the old Roman craftsmen, were still plentiful enough in the towns, worked within very modest limits until the revival of urban economy." (Hauser, 1951a p. 175). The popularity of monastic life brought together people not usually associated with the arts and crafts, and it likely contributed to chipping away at the contempt usually reserved for manual labor. The universities of the 12th century inherited a similar adaptation of the liberal arts from antiquity. The seven liberal arts included grammar, rhetoric, dialectic, arithmetic, geometry, astronomy, and music (Kristeller, 1951). Although additional subjects of study were added over time (logic, ethics, and physics), the visual arts remained estranged from the general contemporary curriculum that includes the arts. The rise of Islam during the early 7th century also had an influence on European and African education during the late Middle Ages (11th to

13th centuries) as they moved their armies west and established universities that bore leading figures in science and mathematics (Cordasco, 1963).

The Middle Ages saw an emergence of craft guilds from an increased development of trade and a specialization of industry. Gombrich (1995) compared the guilds to trade unions, in that they monitored their members to ensure fair treatment in the market. For passing on techniques, the guilds used an apprentice system to teach young males specific trades. Students could spend several years as apprentices, eventually graduating to a higher rank within their specialization. The teacher was referred to as a master, and he was the only member of the guild that was able to take on the training of students (apprentices). A master first demonstrated his competence to open a workshop, and then he was able to accept commissions and take on apprentices. From an educator's perspective, the master was a craftsman first and viewed the role as a mentor or teacher as secondary. The master was a businessman, craftsman, teacher, and administrator, securing patrons while dividing the guild's workload among his apprentices.

Baxandall (1988) characterizes the 15th century with the relationship between the artist and the patron. In comparison, 21st-century contemporary buyers and connoisseurs purchase ready-made art objects, which are completed and acceptable for immediate display. During the late Medieval era, it was not uncommon for the artist and patron to sign a contract stipulating content (figures to be represented), materials to be used (including color), and payment structure (weekly, monthly, or a salary structure) before a project was begun. Some artists would be paid according to their time, whereas others could charge based on the size of the commission. Skill was also a bargaining chip—attaining the master's attention or work on significant aspects of the commission or just having him present could increase the cost. Indeed, all masters were not equal and were very much in competition with one another (Baxandall, 1988). This relationship of the 15th century demonstrates the mentality these artists held toward their craft and business.

The late Middle Ages were not without a formal education system. Students attended grammar schools to learn Latin, and they often attended a university that prepared them to become doctors, lawyers, clergymen, or officials (Elkins, 2001). In comparison, "the painters were sometimes associated with the druggists who prepared their paints, the sculptors with the goldsmiths, and the architects with the masons and carpenters" (Kristeller, 1951, p. 508). As a subdivision of the mechanical arts, painters and sculptors continued to work separate from the academic institutions of the period. There were no art schools, and a young man with artistic aspirations would have had to be apprenticed at an early age to one of the leading masters. The Medieval guild system was comparable to colleges of art in contemporary society, where students study only the fine arts, unlike their liberal arts counterparts. The guild apprenticeship most likely started by accomplishing small basic tasks—such as running errands and grinding pigments—that progressed to minor painting projects. This individualized education also may explain

why certain towns developed distinctive styles that are attributed to particular "schools of painting," such as 15th-century Florence, Bruges, or Vienna (Gombrich, 1995).

The Middle Ages also witnessed the growth of formalized education. Grammar schools and universities became firmly established as various disciplines were refined. The church, as well as secular powers, founded universities that were able to specialize their studies, resulting in more than 79 universities by A.D. 1500 (Cordasco, 1963). Parallel to the university, the apprentice system practiced by the craft guilds developed into a sophisticated and powerful political institution. The craftsman and artist of the Middle Ages progressed through a system that in theory prepared him to be a master himself. Likewise, the university sought to graduate experts in such fields as medicine, law, and religion. As the centuries progressed, the process for becoming a professional artist became institutionalized.

The artist or craftsman of the Middle Ages was recognized as a master but did not focus on the educational aspects of teaching. The goal may have been to learn a trade, but there was not an emphasis on the learning process. It is quite possible that an apprentice remained in that position a very long time without hope for advancement. Bell (1963) wrote that the young painter in a guild regarded himself as an artificer and manual laborer. The master of a craft guild balanced the many aspects of his position. Because of stiff competition, too many masters would be bad for business and trade. Therefore, promotion could be stifled. Attaining a glimpse of the master's thinking process regarding the production of art and objects, it is clear that it was systematic and hierarchical. It should not come as a surprise that the education process was organized in a similar fashion.

The Renaissance

The birth of the artist is a significant development for understanding the artist-teacher. It is during the Renaissance that this happens, but the transition from the workshop mentality is a slow process. Cordasco (1963) characterized Renaissance education as an enlightened society that began to question long-held beliefs. This thinking resulted in a revived interest in the ancient Greeks, emotions, and the natural world. Practical implications for schooling stirred a revival of liberal education and an emphasis on humanism. The liberal education of the Renaissance included the aesthetic, a notable addition to an education philosophy that had been absent from medieval education. The meaning of humanism in Renaissance education included "the language and literature of the ancient world in a grammatical and linguistic sense" (Cordasco, 1963, p. 43). Kristeller (1964) writes about the significant changes that took place between the Middle Ages and the Renaissance, including the invention of printing, the discovery of America, and the Reformation, but most important for this study is the development of intellectual

and cultural centers in Italy between 1350 and 1600. Yet, it is also important to consider the illusion of a dramatic turning point from the Middle Ages to the Renaissance.

It is also during this transitional era that the first modern art theory emerges (Williams, 2009). Alberti's (1435/1956) *On Painting* addresses the subject of art as a science yet to be fully explained. He writes about the technical aspects of painting, including composition, quality of line, and color. Alberti stresses the importance of the story or narrative in painting, alluding to the significant conceptual agenda of artworks—something that differs from art production in the guilds. Combining both technical and narrative interests, the artist intends to use these aspects of art education to demonstrate their knowledge of the world through their painting. Williams (2009) captures this early duality as fusing empiricism with idealism, a step in a new direction for art production and education.

The artistic training of the Renaissance developed over a length of time in company with the guilds. From the 14th to the 16th centuries, students continued to become professional artists under masters in the appropriate fields of sculpture or painting. However, new opportunities arose to gain artistic skills for those who sought an education beyond grinding the guild master's pigments. Artist clubs and academies were alternatives that appeared around this time. Painters, sculptors, and musicians frequented the artist clubs along with members of the upper class to discuss issues related to music and poetry (Goldstein, 1996).

Vasari (1965) wrote in the 16th century about Lorenzo Medici (the Magnificent), who set his sights to facilitate a school of first-rate painters and sculptors circa 1490. He enlisted Bertoldo, a pupil of Donatello, to teach and mentor these students. Among the many students were Michelangelo and Francesco Granacci. Not officially considered an academy historically, this early art school represents Renaissance advances in art education. Humanism parallels the surge of artistic growth and alternative education outside the workshop. The rediscovery of Greek texts authored by Plato and Aristotle allowed a new debate to arise between humanist thinking and traditional Christian values. The work of Thomas Aquinas, a 13th-century theologian and proponent of natural theology, was a major influence on the status quo, whose writings and teachings affected the thought of the church. However, faith was separated from reason because the humanists opposed many of the philosophers, including Aquinas and learned men of the period. Proponents of humanist thinking included Giovanni Pico della Mirandola (1486/1998), whose 15th-century text, *An Oration On the Dignity of Man*, became an early foundational text. Harkening ancient Greece as the pinnacle of human achievement, Europeans aimed to resurrect a lost era and use its great thinkers as models for living. The interest in and revival of classical ideals are ever present and progressive during the next few centuries, as the discovery of manuscripts by Vitruvius in the 15th century encouraged research and practice of proportion, an aspect of the early academy and the rediscovered work of Pythagoras, the great mathematician of the 6th century B.C who understood the world was ordered through geometry (Macdonald, 1970).

The art academy of 16th-century Florence was an informal beginning that characterized a style of painting. The Accademia del Disegno was founded in Florence in 1563 (Goldstein, 1996). Briefly mentioned in Chapter 1, the early academy is difficult to define compared to later versions. Working alongside the Florentine Academy were other academies, social groups, and artist clubs (Goldstein, 1996). From discussion groups to drawing circles, these informal meetings and schools eventually became more organized. The early academies stressed copying the works of masters, which helped to practice and refine drawing skills (Goldstein, 1996). Although apprentices could also draw from the masters, there were other responsibilities that competed for their attention. These meetings consisting of groups of artists in private established a new alternative. This 16th-century establishment provided new opportunities for aspiring artists.

Pevsner (1973) cites the years between 1530 and 1540 as significant because the unorganized academy was reshaped at this time. Regardless of who is responsible for the first academy, the change represents the formation of a new type of instruction. The workshop mentality is not the only option, and the new paradigm offered less technical and manual work and more intellectual items to ponder, including literature, music, and poetry (Goldstein, 1996). The notebooks of Leonardo da Vinci illustrate the advancements of the period, specifically a course of study he outlines for artists that includes light, shade, color, proportion, perspective, nature, movement, physiology, and anatomy (Richter, 1977).

Giorgio Vasari (1511–1574) is also credited with establishing an early academy, the Accademia del Disegno (Pevsner, 1973). Vasari was deliberate in his intentions during the 1560s, calling a meeting to organize the institution while recruiting instructors and the necessary political support. The foundation included electing members to the academy, for which the academy quickly found a place of importance and honor, pulling artistic influence and dependence away from the guilds. Pevsner (1973) wrote that all the leading painters applied for membership, including Titian, Tintoretto, Giuseppe Salviati, Zelotti, and Palladio.

The second half of the 16th century, as reported by Bell (1963), saw workshops that started to resemble educational institutions as they taught perspective and anatomy from models and casts.

> Artists meeting as a "school" for the purposes of copying works of art or otherwise engaging in the process of drawing from observation would not, however, have constituted an "academy": one thing an academy could not be until sometime late in the sixteenth century was a center for drawing, either from works of art or from the model. (Goldstein, 1996, p. 15)

The first Renaissance academies functioned like the early Greek workshops, except they taught the grammar, spelling, and philosophy not accepted by the system. Meetings were informal and similar to a study group. It also should not be surprising that the

arts were introduced along with other taboo academic subjects. Historian Thomas Hess (1967) wrote, "the new Renaissance ideas in the arts were controversial and aggressively supported—which inevitably led to those who championed them into teaching" (p. 9). These ideas were a strong contrast to the guild's regulations, apprenticeships, and monopolistic methods.

The art academies of the high Renaissance believed that the fine arts were foremost an intellectual discipline. Art and the curriculum of the Renaissance academy were thought to engage the intellect first, followed by method. Painting was thought and argued to be part of the liberal arts that included grammar, rhetoric, dialectics, arithmetic, geometry, astronomy, and music rather than a mechanical art (Stankiewicz 2001). Painting became separated from craft, whereas sculpture was slow to be accepted because it was physical labor that produced sweat and fatigue, which closely aligned itself with handicraft (Pevsner, 1973). Through this distinction, the painter practiced science, whereas the craftsman toiled in an unrespectable fashion (Pevsner, 1973).

The role of the artist was a significant turn of events during the Renaissance. The increased social standing and career of the artist in turn required a new type of education for the artist. Pevsner (1973) observes that during the time of Michelangelo, hopeful artists could still enter an artist's workshop as an apprentice. Then after a period ranging from six to twelve years, he would learn everything, from grinding colors to the fundamentals of painting. In contrast, Leonardo da Vinci advocated the study of perspective first, proportion second, followed by drawing from the master's work, on to studying reliefs, nature, and completed with the practice of individual interests and work (Pevsner, 1973).

Elkins (2001) concurs the 16th century was a significant transition period, one in which the idea of the academy morphed with the medieval university to become an official institution for art instruction. Training of the arts had evolved from a tutoring atmosphere into an organized curriculum by an official institution of higher learning. Macdonald (1970) writes about this status change of the arts within the community by referencing the artist's ability to conceive compositions with his imagination. Students studied geometry, anatomy, and mathematics at a Renaissance art academy and were well versed in proportion, perspective, harmony, and plane. This emphasis on theory was a change from the informal workshop education of the guilds. The new art academy was a strong contrast to the long history of informal education of the Greeks and displayed evidence of an increased stature of the arts in society. The Campanile of Florence, a bell tower designed by Giotto, lists the liberal arts and the mechanical arts, and includes an inscription of the visual arts (painting, sculpture, and architecture) as their own separate group (Kristeller, 1951). This inscription displays the clear separation the visual arts attained from a craft origin.

During the Renaissance, the idea of artist and education are fully realized as conjoined intellectual pursuits. Practicing artists emphasized the most important aspects of their discipline and taught these concepts through formal and informal educational institutions. The developments of the Renaissance are also important for the history of the artist-

teacher because they set the standard of the "Academic Idea," or the idealization of the human form in painting that is executed by 17th-century theorists and put into practice by the French (Bell, 1963). The center of the art educational influence thus transferred from Florence and Rome, Italy, to Paris, France (Pevsner, 1973).

Although the early art academies made strides in education, there was a divide in the schooling young people received. The schools intended for young children and adults of the Renaissance did not include the type of artistic training supported within the academies of art. A humanistic education was revived during this period for young people (Cordasco, 1963). The humanities were not a broad understanding but a narrow linguistic education. Cordasco mentions that the aesthetic only appeared through the teaching of rhetoric and that it was this type of education that was prevalent in Europe from the 16th to mid-19th centuries. The influence of the Reformation seemed to mold many of the educational beliefs previously held in the Classical era, as many reformers were humanists. Although art training prospered within the academy, it remained there as schools focused on other topics.

The French Academy

The French academies of the 17th, 18th, and 19th centuries sought to organize the theories and doctrines of the Italian academies into a set of rules for practicing and teaching. Bell (1963) believed that it was probably not until 1648 that the enforcement of the academic ideals came into effect with the establishment of the new French Academy, the Académie Royale de Peinture et de Sculpture. The French Academy was the most important art school of this period and the one that many other academies were modeled after (Goldstein, 1996). A young person during this time who wished to be an artist must have had plans to attend an academy. The influence strengthened as the 17th and 18th centuries saw academies established in Berlin, Copenhagen, Vienna, St. Petersburg, Madrid, Mexico City, and Buenos Aires (Goldstein, 1996).

The 17th-century curriculum, however, did not advance very far from the guild traditions, according to Pevsner (1973). The rules of the French Academy in 1663 allowed each academician to take on only six students, and these students could not be admitted unless they had a certificate from their master. Students still at this point in history worked for a master with whom they most likely lived and performed duties similar to an apprentice during the Middle Ages. Once accepted as students in the academy, students were either in a lower or higher class. The lower class studied master's drawings, whereas the higher class worked from the figure. In addition, students could look forward to lectures on perspective, geometry, and anatomy.

The fine arts experienced additional support for reclassification during the 18th century when they were separated from mechanical arts in Charles Batteux's (1746/1970) *Les beaux arts réduits à même principe* or *The Fine Arts Reduced to a Single Principle* (Stankiewicz,

2001). During the 17th century, informal art schools that followed craft guild methodology continued to exist. However, this time, labeled the Baroque period by art historians, they were quickly becoming outdated by several large academies of art (Elkins, 2001).

The curriculum of the French Academy consisted mainly of drawing from master artists, the antique (plaster casts), live models, and competitions that provided theoretical underpinnings for practical skills (Elkins, 2001; Goldstein, 1996). The influence of the outdated workshop atmosphere eventually faded as the academies grew in importance and the curriculum developed and became more rigid. The academy, however, did not abolish the apprentice tradition. Bell (1963) stated,

> the academician, like the Guild master, took apprentices into his studio; but the academy was there to instill good principles, to purify taste, to bring the youth into contact with the philosophy of painting which lay beyond the workshop, and to provide educational facilities such as models; casts . . . which would otherwise have been lacking. (p. 13)

Drawing was the main course of study in the academy from the 17th to the 19th centuries. The curriculum of the French Academy was progressive, in that students advanced from simple exercises to more complex study. Students learned from drawings first, plaster casts second, and finally the nude form. The study of classical work formed the foundation of the curriculum. A 19th-century drawing course by Charles Bargue is symbolic of the system. Bargue's book, reproduced by the historian Ackerman (2003), illustrates the entire learning process of the academy. These prints (intended to be copied) progressed from hands and ears to incorporate larger sections of the body, such as the torso and chest. The study culminates when the student reproduces the entire human figure from a two-dimensional image.

In theory, students progressed from two-dimensional images to copying plaster casts in the round. The academies housed a number of casts, including large courts filled with rows of casts after classical sculptures. These casts were part of the central philosophy of art academies and placing them in the central courts or halls reinforced this curriculum. Progress or promotion within the school was competitive, involving regular systems to measure the best works. A collaborative effort by the faculty kept the standards consistent. Bell (1963, p. 14) shares a poem by Hilaire Pader that addresses the strict curriculum of the academy:

> Heavens what pains to find the model's height.
> Oh what a bore to plot its width aright.
> And the task done, what profits all our skill?
> The figure's caged, yet eludes us still.

Progress could be slow because students might only advance if professors deemed their work worthy. A 19th-century example illustrates that each month, drawings could be submitted anonymously and if one qualified, the student was permitted to move up a level and study from the live model. Milner (1988, p. 18) describes this process: "In this way the tutor chose the preferred six works each month, ascribing a double first, marked with two figure ones, to a work on each occasion." In this way, the standards were kept in order and ensured reliability and consistency.

The French Academy became an institution in the French culture and other academies around the world were modeled after it. In fact, most of the French painters of importance passed through the academy between 1648 and 1789 (Bell, 1963). There is a decisive change in the academic tradition with the emergence of Jacques-Louis David (1748–1825), a French painter, a director of the arts under the French Republic, and an influential teacher. David's support of a classical style enforced the copying from casts mentality and a denial of new developments in the art world, including the new color theory proposed by the Impressionists (Macdonald, 1970). Ignoring science was not an aspect of the early academy, as it supported the use of perspective and studies of anatomy. Over time, education in this manner led to stiff compositions produced by 19th-century artists similar to the casts they worked from. The École des Beaux-Arts (renamed) began after this restructuring of the French Academy and continued to be the most venerable art-teaching academy in France during the 19th century (Milner, 1988). As an art school founded upon strict guidelines, the dedication to drawing the human form remained consistent (albeit with a new emphasis) to promote and train artists in a specific style.

Technical artistic standards were still of utmost importance, along with a strict hierarchy of themes including classical, religious, mythological, and allegorical subjects. Other genres, including landscape and still life, were considered less important. This controlled atmosphere extended beyond the classroom and into the administration of the academy as well. Milner (1988) provides an interesting vantage from the instructors of the academy:

> In this way the influence of the Institute was felt at every level, providing opportunities and preventing opportunities, preserving traditions of professionalism and manipulating the machinery of success. Its fourteen members, having themselves reached the pinnacle of recognition, elected compatible replacement members, and so endeavored to preserve a grip on the process of recognition for those who followed. (p.11)

The authority of the academy reigned supreme. They were artists first, achieving recognition, awards, and sales. After such achievements, they could be elected by their peers to continue the academic tradition of art education.

The modern concept of artist also contributes to the artist-teacher concept with the advent of aesthetics in 1735, coined as a new science of sensuous knowledge by the philosopher Alexander Baumgarten (Stankiewicz, 2001). The field of aesthetics has broadened our understanding of art by posing many questions, including what is art, how should we judge art, and topics related to beauty, history, and universals. Immanuel Kant furthered the concept of the modern artist as an endowed genius in *The Critique of Judgment* by challenging the educational tradition of preparing artists (Kant, 1790/2000). From Kant's perspective, imagination, taste, spirit and engaging the viewer intellectually become the important qualities of an artist (Wenzel, 2005).

19th-Century Teaching

A 19th-century instructor at the École des Beaux-Arts and a member for nearly forty years was Jean-Leon Gérôme. His works hang in many of the world's most prominent museums, and his art was continually exhibited in 19th-century Paris. His teaching methods, recounted by Milner (1988), were demanding and possessed an expectation that all student work would be completed in a similar vein. He scolded long and hard those who did not or could not follow his instructions; a man whose work was impeccable appeared to expect his students to follow the same guidelines that he mastered. Gérôme's responsibilities as an instructor came out of his success as a painter. His reputation and influence as an artist grew in the 1850s, as a result of his public and private commissions. The teaching appointments came as a result of these accomplishments and add an interesting dimension on the artist-teacher as a concept. Gérôme's primary profession was working as an artist and serving as an instructor only required two days of classroom critique. Gérôme used the same exacting procedures to complete canvases as the ones he applied in the teaching studio. Skillful and a precise craftsman, Jean-Leon Gérôme was part of the culture of academic art, creating and teaching from a rules-based discipline.

Titles for art teachers varied quite a bit during the 19th century. Teachers in European academies were called instructors, teachers, masters, professors, and tutors (Ackerman, 2003; Elkins, 2001; Efland, 1990; Hess, 1967; Pevsner, 1973; Macdonald, 1970; Milner, 1988). Officially, they held the title of membre or professeur at an institute or academy like the École des Beaux-Arts in Paris (Ackerman, 2003). The highest honor was a position called an académicien, an elected member of the academy comparable to the Medieval Guild Master. Additionally, the academicians of ateliers in the 19th century were referred to as master or patron (father). It was not until the late 18th century that the first academy of art featuring professors opened in the United States.

Another important feature of the 19th-century academy involved the emergence of preparatory schools for artists seeking admission to an academy. France had a great number of provincial schools that created a culture of art unparalleled in other European countries.

Napoleon's influence at the beginning of the 19th century saw several changes in education that had a lasting effect (Cordasco, 1963). The schools of France were organized under a ministry of education with allocated districts. Napoleon also arranged the beginnings of a Normal School for training teachers in 1808. France's effect on art training is significant, as schools in the United States and England modeled early attempts after their success.

The Victorian Era

The majority of the 19th century in England is referred to as the Victorian era. It marks the growth and height of the industrial revolution and the pinnacle of the British Empire. George Wallis came of age during this period, the dates of which correspond with the reign of Queen Victoria, 1837–1901. However, the Victorian era is defined by many factors, including the Reform Act of 1832. The Reform Act is significant to the industrial revolution because it allowed new and upcoming cities powered by industry to hold seats in the House of Commons. The Victorian era was preceded by the Regency period and followed by the Edwardian period, led by Victoria's son King Edward VII.

Cordasco (1963) characterized four social trends that influenced 19th-century educational development: nationalism, liberalism and democracy, industrialism, and capitalism. Two distinct types of education provided by churches and private funds were present in England at the beginning of the 19th century. Elementary schools were designed for the poor, and grammar schools or secondary schools were intended for the upper class (Cordasco, 1963). Picard (2003) condemns the unacceptable conditions yet applauds the mission of the elementary schools, or ragged schools, in their efforts to educate young people in reading, writing, arithmetic, religion, and social skills, students who might otherwise turn to crime or begging were it not for these opportunities. The desolate state of England's poor was a by-product of the industrial revolution and urbanization. The philanthropic effort arose to correct these injustices (Cordasco, 1963). However, until the year 1870, private and religious institutions provided elementary education for the majority of British children.

The Royal Academy

Early reports established a desire for an academy in 17th-century England, but it was not until 1711 that an informal group called an academy had begun (Bell, 1963). The Royal Academy was formed after the schism between two artist societies. Through this struggle, the academy inherited some older traditions while adopting some French rules in the establishment of this artistic institution in the late 18th century (Goldstein, 1996; Hutchison, 1968). The Royal Academy elected 40 academicians after the French system,

with lectures held on the subjects of anatomy, geometry, perspective, architecture, and painting (Goldstein, 1996).

Sir Joshua Reynolds, an influential 18th century English painter and eloquent spokesman for the academy, regarded painting in the academic tradition as a noble pursuit that would establish England as one of the "great civilized nations of the world" (Bell, 1963). As the most important arts institution in England, the Royal Academy and those associated with it had an influential role over how the provincial Schools of Design were to develop. At the founding of the academy, there was an opinion that no other art institutions could compete with the new Royal Academy. The molding of forthcoming government-sponsored national art education thus was subject to these worries in the mid-19th century. In fact, several members of the government committees formed to establish the new Schools of Design were members of the Royal Academy and did not wish to support a competing institution and reserved a general disdain for design training (Macdonald, 1970). These beliefs staggered the growth and early developments of design training in England.

The Hall at the Royal Academy, Somerset House, 1810
Artist: Unknown
Etching
© Victoria and Albert Museum, London

England's Schools of Design

The Royal Academy was an educational institution but did not cater to train students of design like other academies in Europe. The academy employed engravers and decorators in the early 19th century, but the school eventually evolved to become a high art club for painters, sculptors, and architects (Macdonald, 1970). The restriction of the academy in training only painters, sculptors, and architects was one reason a better education in the arts was needed. Without a proper design education, England lagged behind other countries. Public schools had existed in England that applied a humanistic education since the 14th and 15th centuries (Cordasco, 1963). The industry needs were not being met with the current art educational system, producing only fine artists (Savage, 1985).

Sproll (1994) investigates the intervention of the British government in the art education process in 1835. Art instruction existed prior to this date in England only within the academy and private instruction. Thistlewood (1986, p. 72) writes,

Student Work from British School of Design, 1840
R. W. Herman
Black and white chalk drawing
© Victoria and Albert Museum, London

The history of art and design education is really only as old as the state's intervention, because when elementary schooling became generally available to the children of ordinary working people, an entirely novel discipline called "Drawing Instruction" was devised for their compulsory benefit.

This intervention called for committees to explore the most appropriate means for the people of England to learn about the fine arts and the principles of design (Sproll, 1994). Without an organized approach to art education in Britain, the country lacked a system that created informed consumers and producers, such as neighboring France and Germany. The establishment of the Select Committee on Arts and Manufacturers was arranged to address concerns related to art, commerce, and education (Savage, 1995; Sproll, 1994).

The argument for public arts education thus could not have arisen without several key individuals promoting the advancement of Schools of Design. The most important advocate was the historical painter Benjamin Robert Haydon. Haydon traveled the country promoting the benefits of an art education for the public and argued for grants supporting civic paintings in government buildings. The context set by Haydon created an atmosphere with a need for art education (Macdonald, 1970).

England's Normal School

The committee prompted by the government put the establishment of a Normal School of Design into motion when they were allocated specified funds (Sproll, 1994). It was claimed that this establishment of a unified infrastructure of art education was primarily for commercial means and had lasting effects for decades in the British educational system (Thistlewood, 1986; Ashwin, 1985). Through these sessions and debates, the final recommendations were that a Normal School of Design be established in London and that provincial schools receive assistance (Macdonald, 1970). The branch/provincial schools were to be established in manufacturing towns throughout England to address the need for design training (Savage, 1995).

The Board of Trade, which established the Normal School, received a report on Schools of Design in France and Germany from William Dyce (Macdonald, 1970). Dyce, a Scottish artist born in the early 19th century, was a student at the School of the Royal Scottish Academy in Edinburgh with additional study in the Royal Academy of London. He developed a reputation as a portrait painter and became an accomplished artist before his death in 1864. As an educator, Dyce "regarded art as a severe and precise craftsmanship, in fact a science. He saw himself as a skilled practitioner who could inspire a workshop of hardworking artisans" (Macdonald, 1979, p. 78).

The new Schools of Design in Britain fell behind in comparison to the French and German schools of art, and Dyce intended to import a German system of art education into England. Dyce favored a particular system that used simple geometric forms and concluded with more sophisticated designs. A curriculum specifically for designers, it was drastically different from the training of academic artists. The study of the human figure was not included, as Dyce instituted what he felt was a practical education. In contrast, the original British proponent of art education, Haydon, was in favor of an education that followed in the French (figurative) tradition. He did not see a difference between the training of artists and designers, and he thought the curriculum of design schools should remain similar to artist training. However, politics led Dyce to gain influence as director of the Normal School and the provincial schools.

Dyce was particular about art education based upon his preference for the German art schools over the French schools, which were more popular, influential, and successful at that time. To institute the new curriculum, John Buonarotti Papworth was hired as director of the government-sponsored Normal School of Design. Papworth was a respected architect and designer responsible for designing the glass throne for the Shah of Persia. As an artist, he was hailed as a second Michelangelo for a "Tropheum" he designed. As the first director of the Normal School, he was hired to carry out Dyce's new curriculum for the schools. Papworth's tenure ended abruptly after a slow start. This departure set in place the eventual transition to Dyce overseeing the school directly.

Dyce's control and influence over Somerset House led to the establishment of a class to prepare teachers to carry on his philosophy of art education. He desperately needed additional masters to implement the curricula he saw fit for the provincial schools. The short tenure of Papworth was something Dyce wanted to avoid. In this manner, Dyce would train the teachers in the Normal School to institute his methods. Writing about the shortage of teachers, Hanson (1971, p. 41) commented, "in 1841 the Council of the Government School of Design announced its intention of educating a class of persons for the purpose of qualifying them to become TEACHERS in British Schools of Design." Prior to this, the primary purpose at schools of art and design had been to produce quality craftsmen, designers, or artists. This difference is highlighted in the author's emphasis on the word "teacher." This training course within an art school was a novel idea that continues today (similar to contemporary art education programs).

Dyce was unhappy with the educational system in place, the first of its kind, and felt that the establishment of a class intended for art teachers of design was necessary. These student-teachers were, in theory, to be trained to replace the older academic drawing masters who were present in British art schools (and the only available teachers to hire). The opening of this course for art teachers is significant because it introduced a different aspect of training and labeling in art education. Instead of training artists or designers, this class sought to prepare teachers. The students received hands-on training, yet the class design soon broke apart because the supply could not keep up with the demand

for teachers, which started to multiply in the 1840s with the opening of more schools (Macdonald, 1970). The first two classes experienced a quick dropout rate because the students accepted positions across the country as instructors. However, because of this shortage, prospective teachers at the Normal School were encouraged to enroll in this teacher preparation course even if for a short time.

The First Artist-Teacher?

A significant graduate of the course is George Wallis (1811–1891). Wallis was a student in the first course and left halfway through his second year for a teaching position. Macdonald (1970) noted that Wallis was the first head of a British School of Design to see his position as one of education. Trained under the direction of Dyce, Wallis was considered a rebel for his educational views and regarded himself as an artist-educator. This is a significant contrast to the views of the artist Richard Redgrave, a colleague and typical artist of his time. Redgrave was an artist and teacher, but he felt that the needs of the artists should come before the duties of teaching (Hanson, 1971). Hanson reported that Redgrave was someone who chronicled his own art education and training experience in the 19th century in his diary. These accounts thus give an interesting aspect of the superior and professional role of the artist compared to the lowly educator.

Wallis acted on this role in his first appointment when he was master at Spitalfields (Macdonald, 1970). Although he initially agreed with the programs Dyce had put into place, he felt that his design students needed more than the basic curriculum they were provided. Spitalfields was a center for silk weaving, and Wallis felt that the school could not accomplish what was required at the time based on the simple education students were receiving (Macdonald, 1970).

Bell (1963) claims Wallis must have been a man of some character based on his dealings. Originally trained as a painter, he embarked upon his teaching career very early. Although Wallis employed new methods for teaching design, he also introduced new tools in unusually creative ways. In 1839, he sought to open his own school of design. The main feature for the students to learn design was to copy the movements of the master artist as he drew the designs on a blackboard (Bell, 1963). It was shortly after this experience that Wallis joined the community and teaching class at the Normal School.

What separated Wallis from other instructors at the time was not simply a term but an overall philosophy about how design should be taught. His methods differed greatly from other methods practiced at that time. Originality was of great importance to him. He would demonstrate a principle and then request students create an original design based upon the principle modeled. The designs produced by the students had to be practical, in the form of a wall decoration or for furniture, and were subjected to critique when finished (Macdonald, 1970). Macdonald stresses, "Wallis always praised originality and fitness for purpose" (p. 91).

Even if students desired to reproduce a design, Wallis urged them to recreate it a different size. By making the image larger, they did not fall back into curriculum that was taught at the academies and schools of art. This instruction is evidence that Wallis was quite liberal in his educational views for the mid-19th century. His emphasis on originality was in stark contrast to the traditional curriculum of copying in design education.

The unique curriculum Wallis created at the Manchester School of Design did not go unnoticed. Manufacturers noticed and desired his students as apprentices in their factories. However, the Royal Academicians in power also noticed and had a different reaction. They were upset about Wallis's curriculum because it stressed originality rather than drawing two-dimensional reproductions of classical antique forms (Macdonald, 1970). Wallis believed so strongly in his course of design—featuring originality, critique, drawing plants, constructing the human figure, studying the anatomy of animals, and demonstrations of the principles of art—that he submitted a copy to the governing council of the school (Macdonald, 1970). The council disagreed with the submitted curriculum and ordered that the course be changed to the more traditional methods practiced in other schools or funding would be discontinued. Wallis eventually resigned as master and Henry Johnstone replaced him. In his introductory address in 1846, the new headmaster of Manchester condemned the originality that had been prevalent at the school and claimed that the school would follow the authorities of art, stating, 'The best means of teaching was to place before students exact imitations of Art, and the sooner that Schools of Design became "museums of Art," the better' (Macdonald, 1970, p. 95).

Reflecting on Wallis and the use of the term "artist-educator," it appeared to be a verbal expression for the emphasis he placed on the craft of teaching. This professional role emphasized by Wallis was a new concept for the culture in which he was engaged. Wallis was bred from an artist-as-profession culture that did not consider the idea of being a teacher on par with being an artist. The use of the word "educator" symbolized this liberal stance.

Romanticism and Idealism

The 19th century is characterized by the industrial revolution in Europe, political struggles in France and America, and a cultural influence called romanticism (Efland, 1990). In addition, other art and design educational philosophies existing prior to the 1830s also influenced the decisions made in Britain. Romanticism gained strength during the industrial revolution, representing a revolt against the intellectual and industrial changes of the time (Curtis, 1982). Unsatisfied with the conditions brought about through development, the romantics rejected rationalism, which they felt was foundational to social, economic, and religious thought. Passion, impulses of mankind, uniqueness, and aesthetic and artistic experiences were of great importance. Inundated by mediocrity,

Curtis (1982) communicates the frustration artists had with an environment they could not control or influence: "The romantics looked back to the past; in particular, they rediscovered the Middle Ages and Medieval Christianity, considering them the pinnacle of inspiration and beauty" (p. 76). This harkening back is illustrated by the arts and crafts movement of the 19th century to counter the loss of the handicraft and the quality of good design (espoused by William Morris, the English furniture and textile designer). The rapid growth of industry coupled with the advent of machinery replacing human hands led to the demise of the handcrafted object. Manufactured goods in this manner lost a quality of design, taste, or aesthetic. Although Britain noticed this lack of quality as early as 1835 with the Select Committee meeting and report, it became apparent on a larger scale with the Great Exhibition of 1851, an international exhibition that compared the products of design and industry with countries around the world.

Efland (1990) writes that every nation solved the growing problems of industrial art education in a different manner depending on the unique circumstances of context. France had combined the training of designers and artists, whereas other countries such as England and Germany separated the education of fine artists and artisans. The fall of the monarchy in France symbolized the new direction political thought was traveling. The arts were now viewed as important sources of knowledge and insight compared to the scientific rationale prevalent in the past during the Enlightenment. The arts were a unifying force in a chaotic world. Although artists could unify, the designer was thought to be elevating the taste of the public, thus bringing harmony to the masses (Efland, 1990).

Idealism, another philosophy of importance, has roots in Kant (Curtis, 1982). The goals sought for the Schools of Design in 1837 included a number of justifications, including economic, social, political, moral, and cultural (Bell, 1963; Macdonald, 1970; Romans, 2004). These goals are idealistic from our perspective, as the foundation of a new educational venture had little chance to solve moral, aesthetic, and political problems for a country. Idealism saw society as an organic growth and an inseparable whole that witnessed the state's will eclipsing the will of the individual. Through the turn of the 20th century, this philosophy underpinned the English-speaking world until World War I. Through idealism, "[t]he state is viewed as the sustainer of a moral world within which rights and obligations emanate from the community, and individuals are afforded the opportunity to achieve maximum potential" (Boucher, 1997, p. ix).

An optimism appears through the history texts as though the supporters of art and design education thought society would improve a great deal, especially when compared to other European countries. This ideal could never be reached in reality, thus the early Schools of Design were doomed to failure from this perspective. The individual appears to be lost in such idealism because the public or whole of society is often the one to which referred. Despite an agreement that design training would benefit a nation, there was much bickering over the philosophy to adhere and follow, as seen from Dyce and Haydon. If this ideal education were to work, how should we teach? Which way is the right way? As an ideal to improve

morals and taste, the Schools of Design made sense; in reality, they did not. The separation of artists and designers is also problematic, because the academies were in the best position to accomplish this ideal. If the Kantian idea of artist as genius were to unite society, separating the artisan, who potentially had the largest effect on society, is not logical (Wenzel, 2005). The public's improving taste and growing understanding of good design could only benefit artists in the long run, as their art would attract a more sophisticated society.

William Morris, John Ruskin, and Morals

Although the Schools of Design advocated education as the solution, Morris opened a workshop that favored handicraft over anything produced by machine. Morris is seen as the personification of many of Ruskin's theories on art and craft. Ruskin disagreed with the methods employed by the Schools of Design, but he did not disagree with the aspirations. Ruskin felt the craft of drawing could be taught, but design is inspired. His theories favored the hand, that anything made by machine would be mechanical and less desirable (Thompson, 1967).

Morris is Ruskin's saving grace. Applying many of the romantic notions expressed earlier, Morris actualized the expressions, taking inspiration from the craft guilds of the Middle Ages, in which he sought a unity of expression that was democratic and less like the lofty fine artist who was above the artisan. Morris co-founded Morris, Marshall, Faulkner and Co. (later Morris and Co.) in 1861, a workshop that harmonized and was sensitive to the craft and design of furniture, stained glass, tapestry, and wallpaper (Goldstein, 1996; Lethaby, 2007). In doing this he had no intention of being part of the intellectual class to which 19th-century artists aspired, he was an honest artisan craftsman, which was the common bond between the arts (Yeomans, 1987).

Henry Cole, an influential civil servant positioned himself to take over the schools of design and later served as the head of the schools of art and design in addition to being Director of the South Kensington Museum. In these positions he controlled the entire system of art and design education (in England) including the curriculum for the art schools, training teachers, prize systems, and the new elementary curriculum. Cole, along with Redgrave and Wallis promoted design education to raise the taste of nation by providing an education that prepared folks to create better design (most recently in the Great Exhibition of 1851). Morris's contribution, although different (production and sales rather than education or exhibition), can be seen as an extension of this re-invention of design. This new firm produced and expressed design by hand (similar to the Gothic cathedral builders mentioned in Ruskin's writing) for houses and churches, whereas Wallis, Cole, and Redgrave adapted to industrial progress as designers and artisans within the factory (Thompson, 1967).

Pre-Raphaelites

The Pre-Raphaelite Brotherhood formed in 1848 united to paint earnest, uplifting subject matter (Melville, 2006). William Dyce (Wallis's instructor) and William Morris (a conceptual descendent of Wallis and his colleagues) were greatly influenced by these painters (Melville, 2006; Thompson, 1967). They were essentially a group of British painters, poets, and critics (Ruskin was one of their greatest supporters) who sought to reject the classical compositions of Raphael and the subsequent negative influence he had on the academic painting. Instead, they painted in a style representative of the early Renaissance.

The idealism expressed by Wallis and founders of the government-sponsored Schools of Designs was a theory to improve taste and morals—an idealism that was good in theory and an earnest struggle to order the world in a particular way. Adamantly supported by Ruskin in his criticism, it was finally materialized in painting through the work of the Pre-Raphaelite Brotherhood and in craft through the products of Morris. The work of Morris and Ruskin eventually leads to Walter Gropius, who placed these two Englishmen as significant influences on the genealogy of the Bauhaus that attempted to combine artistic thought of expressionism with the craft of the Middle Ages (Cantz, 2000).

The Bauhaus

Gropius is referred to as one of the most important artist-teachers in history by the art education historian Fredrick Logan (1955) and is also referenced as having the most important influence on contemporary art instruction by the historian James Elkins (2001). Highlighted in Part II, he is most well known as founder of the Bauhaus, a school that integrated industrials and the fine arts. This school sought a return to standards of production before the academies popularized in Europe with the craftsman ideal of the Middle Ages. A goal of the Bauhaus included overcoming the division between art and craft as well as the growing schism between art and industry. These artist-designers produced practical new designs for the new era of mass-production (Gropius, 1965). The faculty of the Bauhaus consisted of some of the most influential artist-teachers ever assembled and contributed individually and collectively towards Gropius's vision.

The curriculum and faculty fluctuated but it was a practice-based course of study that had three progressive stages or courses of study a student could advance through to graduation. The educational structure was theoretical and a small number of the 1,250 students that attended the school stayed for one or two terms just for the experience (Bauman, 2007). The school maintained a high standard of education and enjoyed international recognition and support from the industry. The teachers were called masters

and the students were apprentices and they could advance during their education to the journeymen or young master status. The graduates (who considered themselves artists) were then charged with contributing (through teaching and craftsmanship) toward the cathedral of the future, which was part of the Bauhaus Manifesto that understood 'The ultimate aim of all creative activity is the building' (Droste, 2006).

The time was right for the achievements of the Bauhaus, as the academic painters of the late 19th century had less control over the art establishment at the turn of the 20th century. A growing disillusionment toward the current state of design also led to a desire for quality craftsmanship. Criticism appeared from many sources over the poor quality of mechanical reproductions, which was thought to effect the culture and taste of consumers and producers. A gap between the artist and craftsman roles also existed that had been growing since the Renaissance. Many solutions were attempted to rectify the issues, but the most important to the artist-teacher history was Gropius and his school. Operating from 1919 to 1933, many artist-teachers taught and studied at the Bauhaus, influencing much modern thought on art, architecture, graphic design, interior design, industrial design, and typography in the 20th century.

Thomas Eakins and the Academic Tradition in the United States

The late 18th and early 19th centuries marked the beginning of the American Art Academy. The foundation of the first academy of art (following the European tradition) in the United States was established in Pennsylvania. Academies continued to open in New York and other East Coast cities during the 19th century. The art education historian Frederick Logan (1955), in his text *Growth of Art in American Schools*, noted the difference between early art education in the United States and the establishment of the first art academies in cities such as Philadelphia, New York, Boston, and Cleveland. He stated: "Pioneer artist-teachers, including William Morris Hunt, Thomas Eakins, William Merritt Chase, and Frank Duveneck, were creating a more serious professional art education in these institutions" (pp. 54–55). Because these artists had been trained in Europe, Logan felt that their backgrounds were much sounder for teaching in America. He stated: "Their European training had been better, much broader, and at the same time sounder than the timid scholasticism" (p. 54). Eakins (2005) demonstrates many of these important facets in his unrealized drawing manual. A collection of letters and lectures intended for his students was never published because of his untimely resignation from the Pennsylvania Academy of Fine Arts. Eventually published after his death, the contents include chapters on linear perspective, mechanical drawing, isometric drawing, and sculptured relief and illustrate some American alterations to the academic curriculum established in Europe (Eakins, 2005). The turn toward European traditions in teaching was imported in the system of higher education through these individuals.

The university system also turned a corner during the latter half of the 19th century when the arts were introduced into curriculum and professorships at established schools such as Oxford and Harvard (Efland, 1990). Funk (1990) raised the issue that younger Americans at the beginning of the 19th century began to question what colleges should teach, and that the academic structure of the German universities provided a model for incorporating the liberal studies.

The 19th century also marks a trend in state-supported schooling and the argument for drawing as a necessary component of education (Efland, 1990). Although the institution of public or common schools became more popular, they differed greatly from how art had been taught in the past. Although artists from the time of the Greeks sought to teach their craft, the schools of America during the 19th century sought a sound moral education. Efland (1990, p. 74) writes, "Vocal music and drawing were prescribed as ways of elevating moral standards," which is a notion not very far removed from classical writers.

Normal Schools in the United States

The developments in England's government-sponsored art education had ramifications for art education in the United States. Sproll (1994) comments on Walter Smith's (a graduate of the British art education system) influence in the United States as a product of the South Kensington system. Smith's justification for adding a drawing curriculum in Massachusetts's public schools had similar incentives instituted for the Schools of Design in England in the mid-19th century. The public schools sought trained designers for industrial purposes. Thus, the development of designers for industry is well documented by historians as a cause for this new curriculum in America (Efland, 1990; Logan, 1955; Smith, 1996).

The time between 1870 and 1917 witnessed considerable growth for public schools in the United States (Logan, 1955). The population increased dramatically from the larger cities to the plains, where one-room schoolhouses were built. To combat this growth, teacher training schools also multiplied, as did respectable salaries to attract educated teachers. The professionalism of the educational discipline became more paramount as superintendents, principals, and directors attracted higher status and salaries (Logan, 1955). It was into this environment that Smith was recruited to administer his art educational methods. The commercial implications and pragmatic ends of art education justified its inclusion in Massachusetts's schools.

The training of quality artisans and designers was needed because American products were seen as inferior in design compared to the nations of Europe. The legislature of the Commonwealth of Massachusetts passed the act that enabled drawing as a subject of study in public schools. However, unlike its European counterparts, the subject was to be taught by the standard classroom teachers (Kern, 1985).

This lack of adequate teachers spawned the establishment of the Massachusetts State Normal Art School in Boston. This school differed greatly from the art academies already established in the United States. Rather than training artists, the Normal School prepared potential art teachers who were not specialists. The American system sought to change the tradition from classroom teachers who taught subjects to preparing a specialized community of art teachers. Efland (1990, p. 108) wrote, "The idea that an art teacher might require a different form of training than an artist was a radical notion… That art could be taught by anyone but an artist was a radical notion in the history of ideas."

The art education promoted by Smith was mechanical in nature. It was not interested in facilitating "child art" but rather in creating a "manufacturing state" (Chalmers, 2000). The goal was to teach children to be technically proficient in drawing for design, not to make good art. The curriculum included reproducing geometric designs and complex patterns. Through training programs, publications, and curriculum materials, Smith's influence reached from Boston to other major cities such as Chicago, Detroit, and Columbus.

As the 20th century approached, education in the United States witnessed a series of movements: the child study movement, the social efficiency movement, the nature movement, the progressive movement, and the manual training movement (Efland, 1990). All these beliefs were to become factors in the following decades. Using documents published by various states, Kern (1985) reconstructs the purposes of art education in the 1920s. A significant distinction arises, as the teaching of drawing and the teaching of art are listed as two different types of instruction. Since the 1870s, the teaching of art in the United States did not warrant the specialization or expertise of an artist. However, toward the end of the 1920s, a movement in art education that stressed creativity surfaced. Kern acknowledges this change, as public schools mentioned self-expression and creative thinking as goals and objectives of art education.

Art and Schooling

A direct connection between art education and economics has been a factor in weakening the place of art in schools (Smith, 1996). Although profits certainly have been connected to the arts role in society, other means, including self-expression, have been used. The supporters of the self-expressionist stream could be classified as Romantics, who allowed the students to express feelings in a constructive manner. Franz Cizek, an educator credited with administering this method and expanding the art experience of the child, profoundly influenced a particular set of artist-teachers. Cizek attracted the attention of many art teachers in the United States through journal articles and exhibitions of his students' work promoting his pedagogy.

The influence of this noninterventionist philosophy of Cizek had a lasting effect on American art educators of the early 20th century, who are labeled artist-teachers by Efland (1990). Cizek, often referred to as the father of creative art teaching, saw his methods as innovative and breaking away from the teaching-centered model of the past (Smith, 1996). Although scholars have questioned the freedom of Cizek's curriculum, his efforts compared to Viennese schooling are quite different (Efland, 1990). This self-expressive stream of child-centered teaching was in contrast to a curriculum that had been traditionally subject-centered in the United States and abroad.

The Progressive education movement is also felt strongly in American education at the turn of the 20th century. Bode (1921), in his text *Fundamentals of Education*, clearly articulates the intention of his text to be a pragmatic philosophy instituted in the school system. The influence of the philosopher John Dewey is evident in the work of Bode and in the American educational climate. Logan (1955) noted that by the middle of the 1920s, the uninhibited activity and interests of the student would come to influence teaching theory. Rather than following a text-heavy or teaching-centered curriculum, the shift to a child-centered curriculum was enabled. Individuals without a proper understanding of the learning process established the older curricula in place, whereas the new philosophies took into account recent scholarship. The years after the 1930s witnessed self-expression as a method for personal and social growth (Keel, 1963).

The Artist-Teacher in New York

During this period of change in education, a new philosophy of art education was adopted that increased the role of artists in the classroom. The artist-teachers in the United States believed that artists were the most appropriate persons to teach the subject of art in school (in contrast to the schoolteacher trained in art education methods). According to this specialized group of schoolteachers, artists were the most appropriate persons to foster the creative capacities of the child, developing creative self-expression and fostering the child as an artist (Efland, 1990). This group of teachers felt that the educational establishment/methods in effect stifled the natural expression of the student and only through their method could the child progress.

Efland (1990) provided a list of artist-teachers from this period that included Victor D'Amico, Natalie Robinson Cole, Florence Cane, Peppino Mangravite, and Marion Richardson (British). Efland stated that artist-teachers were convinced of the "affinity between the activity of the artist and the graphic expression of the child" (p. 196). D'Amico was a significant member of this artist-teacher group and had a lasting effect on art education in the United States through his various places of employment.

As art teacher, college professor, head of the fine arts department at the Ethical Culture School, and later director of the Department of Education at the Peoples Art Center in

the Museum of Modern Art, D'Amico held a strong belief that the child was an artist yet differed from an adult artist. According to Efland (1990), D'Amico's curriculum had two aspects to it. Initially, he sought for children to recognize and reflect on their own experiences as inspiration. Then, technique and instruction were introduced based upon the children's development and maturity according to their needs and interests. D'Amico's curriculum clearly demonstrated that he placed importance on the individual child. In the article titled "Art Education Today: Millennium or Mirage?," he stressed a concern for the dehumanizing of the child in the educational establishment in America (D'Amico, 1966).

D'Amico's writing and methods fit within the expressive stream, yet his lessons were structured in a coherent and logical fashion to achieve the goals of artist-teachers of the early 20th century. "The teacher motivates the children by stimulating their interests, probing for individual thinking and solutions. He adjusts the activity to their ability and experience and leads each child to rise above his last attempt, thus assuring growth and progress" (D'Amico, 1966, p. 29). This experience could be described as nurturing the child's artistic process. In D'Amico, et al.'s (1954) text *Art for the Family*, D'Amico along with his fellow authors urge readers to work at their own pace, using preferred methods with materials they enjoy. Growth can then be measured in a variety of ways, including aesthetic, technical, and self-confidence. D'Amico's method is structured to promote this growth and awareness that should continue regardless of age. It appears to differ from the criticism of "taking the lid off," of which many teachers of this era, along with Cizek, are accused. D'Amico placed an emphasis on proper teaching, and within this self-expressive stream, is a proper example of one of the American artist-teachers of the early 20th century.

Stankiewicz (2001) refers to the same group of art teachers (referenced by Efland) as artist-teachers in her review of progressive education. In this history, the importance of child art, the invention of finger paints by Ruth Faison Shaw, and the modernist movement all played factors in the self-expressive atmosphere. It was during the 1930s that the progressive movement hit its stride in New York City, specifically within private schools that allowed for the facilitation of such methods. Florence Cane, at this time one of the most well-known artist-teachers, had a similar philosophy to D'Amico but differed in application (Stankiewicz, 2001):

> All artist-teachers agreed that the subject matter for creative expression should come from the child's interest and need. Nonetheless, they differed on the source — the innate needs of the child or internalized experiences provided by the Progressive school in the urban environment. (p. 36)

Cane advocated creating from the imagination, whereas D'Amico pushed students to explore their environment. Cane asked students to visualize images and paint with their nondominant hand. D'Amico thought new materials would stimulate creativity and help students recall unusual or special events (Stankiewicz, 2001).

The artist-teachers of the early 20th century continued their work in American and British school systems into the 1950s and eventually into a new generation that still practices similar techniques or ideas today in schools (both university and grade school) across the country. Interestingly, the freedom associated with the progressive and self-expressionist movements that gave us these artist-teachers is reflected in their individual curricula. To facilitate the creative atmosphere they desired, each developed their own unique method. By doing this, the artist-teachers of this era did not follow one formula. Given that self-expression, with attention to recent developments in child psychology, the artist-teachers were united in a basic philosophy yet differed in application, similar to the methods each individual teacher used on each individual student. Different students required different questions and challenges, thus different teachers and schools required different methods.

<p style="text-align:center">* * *</p>

The focus on education as it relates to producing art began its transformation during the Renaissance era. The art education systems, including those at universities and grade schools of the 21st century, have roots in the mentorship atmosphere of the Classical era, yet the growth of education as a field of study and the acceptance of the visual arts into the liberal arts tradition itself has complicated the balance and is shifting the emphasis of study in art and education. Education as a subject of study is valuable, (historically emphasized by the early academies); however, too strong an emphasis on education can be a negative, as art education departments often are confused where they belong (in art or in education schools).

The argument for artistic identity established through studio experience versus education classes is valid through history, as an artist or craftsman for most of history could be a teacher without any formal education focused on preparing teachers. This idea begins in the Renaissance but is formalized a few hundred years later with teacher training courses, especially the training Wallis received in the 19th century. These courses, though practical for developing pedagogy, also appear to further separate or compartmentalize artistic practice from teaching as time progresses in the 20th century. As training courses by Smith in the early 20th century facilitated art teacher preparation for folks with no art background, the pendulum swung over to the other side and completely erased the need for an arts background, ironically the essential component for teaching art. The pendulum does swing back, as the 1950s witness art teachers transcending these barriers and re-owning their artistic heritage as they emphasize their artistic background as the central aspect informing their teaching. Going forward, education continues to be part of the discussion, and the term "artist-teacher" retains a powerful presence in the 21st century. Unaware of the rich history of teaching traditions, the term "artist-teacher" is often thought to be a surface-level descriptor elevating oneself above colleagues with weaker artistic experiences. History certainly does not agree.

References

Ackerman, G. M. (2003), *Charles Bargue: With the Collaboration of Jean-Léon Gérôme; Drawing Course*, Paris, ACR Edition.

Alberti, L. B. (1435/1956). *On Painting*. New Haven, CT: Yale University Press.

Ashwin, C. (1985), "The British Colleges of Art and Design: The end of an experiment," in B. Wilson and H. Hoffa (eds.), *The History of Art Education: Proceedings from the Penn State Conference*, Reston: National Art Education Association, pp. 76–79.

Batteux, C. (1746/1970). *Les beaux arts réduits à même principle*, New York, NY: Johnson Reprint Corporation.

Baumann, K. (2007). *Bauhaus Dessau: Architektur Gestaltung Idee*, Berlin: Jovis.

Baxandall, M. (1988), *Painting and Experience in Fifteenth-Century Italy*, Oxford: Oxford University Press.

Bell, Q. (1963), *The Schools of Design*, London: Routledge and Kegan Paul.

Bode, B. H. (1921), *Fundamentals of Education*, New York: The Macmillan Company.

Brundage, A. (1989), *Going to the Sources: A Guide to Historical Research and Writing*, Arlington Heights: Harlan Davidson.

Boucher, D. (1997). *The British Idealist*, Cambridge University Press.

Cantz, H. (2000), *Teaching at the Bauhaus*, Ostfildern-Ruit: Hatje Cantz Verlag.

Chalmers, F. G. (2000), *A 19th-Century Government Drawing Master: The Walter Smith Reader*, Reston: National Art Education Association.

Cordasco, F. (1963), *A Brief History of Education*, Totowa: Rowman and Littlefield.

Curtis, M. (1982), *The Great Political Theories, Volume 2: A Comprehensive Selection of the Crucial Ideas in Political Philosophy from Burke, Rousseau and Kant to Modern Times*, New York: Avon Books.

D'Amico, V. (1966), "Art Education Today: Millennium or Mirage?" *Art Education*, 19: 5, pp. 27–32.

D'Amico, V., Wilson, F., & Master, M. (1954), *Art for the Family*, Garden City: Museum of Modern Art.

Droste, M. (2006). *Bauhaus: 1919-1933*, Los Angeles: Taschen.

Eakins, T. (2005), *A Drawing Manual*, New Haven: Yale University Press.

Efland, A. (1990), *A History of Art Education: Intellectual and Social Currents in Teaching the Visual Arts*, New York: Teachers College Press.

Elkins, J. (2001), *Why Art Cannot be Taught*, Chicago: University of Illinois Press.

Erickson, M. (1979), "An Historical Explanation of the Schism between Research and Practice in Art Education," *Studies in Art Education*, 20: 2, pp. 5–13.

Funk, C. B. (1990), "The development of professional studio art training in American higher education, 1860–1960," Ph.D. dissertation, New York: Teachers College, Columbia University.

Frost, S. E. (1989), *Basic Teachings of the Great Philosophers*, New York: Anchor Books.

Goldstein, C. (1996), *Teaching Art: Academies and Schools from Vasari to Albers*, Cambridge: Cambridge University Press.

Gombrich, E. H. (1995), *The Story of Art*, London: Phaidon Press.

Gropius, W. (1965), *The New Architecture and the Bauhaus*, Cambridge: MIT Press.

Hanson, D. (1971), "The Art Masters," *British Journal of Educational Studies*, 19: 1, pp. 40–50.

Hauser, A. (1951a), *The Social History of Art, Volume 1: Prehistoric, Ancient-Oriental, Greece and Rome, Middle Ages*, New York: Alfred A Knopf.

Hauser, A. (1951b), *The Social History of Art, Volume 2: Renaissance, Mannerism, Baroque*, New York, Alfred A Knopf.

Hess, T. B. (1967), "Some academic questions," in T. B. Hess and J. Ashbery (eds.), *The Academy: Five Centuries of Grandeur and Misery, from the Carracci to Mao Tse-Tung*, New York: Macmillan, pp. 8–18.

Hutchinson, S. C. (1968). *The History of the Royal Academy*, New York, NY: Taplinger Publishing.

Kant, I. (1790/2000), *The Critique of Judgment*, New York: Prometheus Books.

Keel, J. S. (1963), "Research Review: The History of Art Education," *Studies in Art Education*, 4: 2, pp. 45–51.

Kern, E. J. (1985), "The purposes of art education in the United States from 1870 to 1980," in B. Wilson and H. Hoffa (eds.), *The History of Art Education: Proceedings from the Penn State Conference*, Reston: National Art Education Association, pp. 40–52.

Kristeller, P. O. (1951), "The Modern System of the Arts: A Study in the History of Aesthetics, Part I," *Journal of the History of Ideas*, 12: 4, pp. 496–527.

Kristeller, P. O. (1964). *Eight philosophers of the Italian renaissance*, Stanford, CA: Stanford University Press.

Lethaby, W. (2007), *William Morris as Artist: A Lecture Delivered at the South Kensington Museum on 4th March 1926*, London: Godfrey Rubens.

Logan, F. M. (1955), *Growth of Art in American Schools*, New York: Harper and Brothers.

Macdonald, S. (1970), *The History and Philosophy of Art Education*, London: University of London Press.

McNally, J. R. (1971), "Characteristics of Art in the Text of Aristotle," *Journal of Aesthetics and Art Criticism*, 29: 4, pp. 507–514.

Melville, J. (2006), "Faith, fact, family, and friends in the art of William Dyce," in J. Melville (ed.), *William Dyce and the Pre-Raphaelite Vision*, Aberdeen: Aberdeen City Council, pp. 38–46.

Milner, J. (1988), *The Studios of Paris: The Capital of Art in the Late Nineteenth Century*, New Haven: Yale University Press.

Mirandola, G. P. (1486/1998), *An Oration On the Dignity of Man*, Indianapolis, IN: Hackett Publishing Company.

Pevsner, N. (1973), *Academies of Art Past and Present*, New York: Da Capo Press.

Picard, L. (2003). *Elizabeth's London: Everyday Life in Elizabethan London*, New York, NY: St. Martin's Press.

Richter, I. A. ed., (1977), *Selections from the Notebooks of Leonardo da Vinci*, Oxford: Oxford University Press.

Romans, M. (2004), "Living in the Past: Some Revisionist Thoughts on the Historiography of Art and Design Education," *International Journal of Art and Design Education*, 23: 3, pp. 270–277.

Savage, L. (1985), "The history of art education and social history: text and context in a british case of art school history," in B. Wilson and H. Hoffa (eds.), *The History of Art Education: Proceedings from the Penn State Conference*, Reston: National Art Education Association, pp. 94–98.

Smith, P. (1996), *The History of American Art Education: Learning about Art in American Schools*, Westport: Greenwood Press.

Sproll, P. A. C. (1994), "Matters of Taste and Matters of Commerce: British Government Intervention in Art Education in 1835," *Studies in Art Education*, 35: 2, pp. 105–113.

Stalley, R. (1999), *Early Medieval Architecture*, Oxford: Oxford University Press.

Stankiewicz, M. A. (1995), "So what: interpretation in art education history," in P. Smith, (ed.), *Art Education Historical Methodology: An Insider's Guide to Doing and Using*, Reston: Seminar for Research in Art Education, pp. 53–61.

Stankiewicz, M. A. (2001), *Roots of Art Education*, Worcester, MA: Davis.

Thistlewood, D. (1986), "Social Significance in British Art Education 1850–1950," *Journal of Aesthetic Education*, 20: 1, pp. 71–83.

Thompson, P. (1967), *The Work of William Morris*, Oxford: Oxford University Press.

Vasari, G. (1965), *Lives of the Artists, Volume 1* (trans. G. Bull), London: Penguin.

Wenzel, C. H. (2005), *An Introduction to Kant's Aesthetics*, Malden: Blackwell Publishing.

Williams, R. (2009), *Art Theory: An Historical Introduction*, 2nd ed., Oxford: Wiley-Blackwell.

Yeomans, R. (1987), "The foundation course of Victor Pasmore and Richard Hamilton 1954–1966," Ph.D. dissertation, London: Institute of Education, University of London.

Endnotes

1. Aristotle defines art (tekne) as a productive disposition of the correctly ordered practical intellect (McNally, 1971).

2. One who is being taught orally the elementary facts or principles in any subject. In the context of the early church, however, it was a person learning the rudiments of Christianity.

Chapter Three:
The Artist-Teacher:
Just Another Title or a Distinctive Notion?

A Way of Seeing

"Artist-teacher" is a powerful and prevalently used term in the field of art and art education. In fact, "artist-teacher" rivals the traditional title of "art teacher" or "art instructor" by many working in the fields related to the visual arts. The largest museums and the smallest community art centers advocate its use to describe employees who are both artists and teachers. Graduate programs use it to attract potential students, whereas teachers from grade school to university campuses adapt its use for identity purposes. The term "artist" (in all of these contexts) becomes a commodity to heighten standing and represent knowledge or education distinguishing oneself as a true combination of artist and teacher. Since the 19th century, many other artists and educators have been designated or referred to themselves as artist-teachers. Most recently a series of conferences and a journal use a variation of the term "artist-teacher" to differentiate themselves from other art education programs. Despite the wide use of the term, I purport a much different understanding. Artist-teacher, when used properly, is actually a philosophy for teaching. It does not presuppose an artistic lifestyle but uses the individual talents and learned skills or techniques of the artist and circumvents them into the teaching profession.

My thesis presupposes there are two distinct fields coming together in the term "artist-teacher" (art and education). The field of education has left a very strong mark on the subfield of art education that makes the term "artist-teacher" controversial. Artist-teacher reinvigorates the role of the artist in education, which causes insecurity among those invested heavily in art education field. Art teachers are proud of their traditions, but I think the pendulum has swung too far in support of schools of education, and the art traditions have been forgotten in many circumstance (or just neglected). However, I think the term "artist-teacher" is an important concept that illustrates the essential aspect of art education. It is not just a focus on arts or art making but the application

of those ideas in the classroom. When the artistic thinking process really enters the classroom context, there is a wealth of opportunities.

Given the complex history of teaching art and the professional nature of teaching, is artist-teacher just another title or is it something else, perhaps a bit more profound? Artists certainly have a particular way of seeing and understanding experiences. Through history they have created particular perspectives for understanding various cultures and contexts in visual form. We understand past civilizations through their art. In this text I argue that artist-teachers attempt the same idea (in their particular systems for seeing and understanding the world) in education through their teaching. For example, art teachers of the Renaissance brought their unique philosophies of making art to their teaching practices. In other instances, such as the 19th-century academy, the instruction was closely aligned with the production of art as whole, yet contemporary teachers in the 21st century work in a pluralistic environment wherein individual taste, expressions, and philosophies have the potential to transfer to the teaching enterprise. I further argue that artistic knowing and thinking is important for the concept of artist-teacher and that each artist incorporates this in some manner. This aesthetic thinking process is a method that teachers call on to work through problems.

The artist-teacher is thus a philosophy for teaching and not a simple title or dual role. The artist-teacher may not be a famous artist and may not create much artwork at all! However, artist-teachers do have experience working visually. Sometimes this experience comes through their education but most likely it is practiced in their daily lives. Similar to the relationship between grammar and language, being an artist is not simply the ability to follow a set of rules or the ability to practice learned techniques. Just as a young child learns to speak without understanding the rules of grammar, the artist can develop his or her eye without formal training. Albeit Art classes like English classes are a positive force, the argument situates artful knowing as a type of unspoken knowledge combined with learned habits, techniques, and philosophies. Combining informal (intuitive) and formal knowledge (facts and figures) into learning situations can be valuable if the artist realizes and understands how he thinks. Not every art teacher is an artist-teacher, but rather it is the one who understands his or her art making and thinking processes. This requires reflection, study, and engagement with art making and teaching. Only through these experiences can one begin to pull apart what makes his or her art making successful and incorporate it into the classroom context.

An artistic way of knowing can be developed and refined just as apprentices learned the craft of their masters in medieval craft guilds. Imitation, observation, and practice are the mainstays of such an education; however, the initial talent or knowledge exists in the artist to develop. Rather than mystify this gift, understanding it as a disposition for thinking a particular way makes the artistic perspective less illusive. Thinking like an artist is not formal but rather a talent. It is a thinking process that is intuitive and difficult to develop. Difficult to codify, it is an illusive talent that collates our understanding of

artistic personalities. It can be developed and refined through education and practice. Thus the artist-teacher thinking process is a combination of knowledge, tradition, and a disposition that is applied in an individual manner to unique educational contexts.

Encountering the Term "Artist-Teacher"

The term "artist-teacher" is fascinating. I first encountered it while studying art in a school of education. Particular folks used the term to describe themselves and their commitment to art production and teaching. I encountered it on more then one occasion when master's and doctoral degree students studying art education used it to describe themselves. These were career art teachers who taught in wonderful schools yet continued to pursue their artistic calling. One particular student created huge abstract expressionistic paintings. He had the demeanor of gruff and deep thinking artist. Paint was always on his jeans and his beard was just antiestablishment enough to communicate he was quite different from other folks. Although teaching encompassed the majority of his week, the artistic personality was very important to him and seemed to take center stage. It was at an opening reception for his paintings where I read his artist statement. He referred to himself as an artist-teacher and claimed that teaching was important to his work. I thought it was a wonderful idea when I first heard it used. It sounded smart and refreshing compared to the title of art teacher, and it made sense that one field would affect the other. However, I wondered how the two fields really interacted in the lives of individuals and whether this term had a longer history or if it was a trendy idea. This prompted a short historical investigation. Where has this term been used and how? What is the earliest dates and have there been multiple understandings? A surface-level descriptor was my initial assumption, and I did not presuppose there would be much on the subject. I was wrong on both accounts, as this term appears in many decades as art teachers at all levels attempt to define themselves and their field.

The Debate

The term "artist-teacher" received a healthy amount of attention during the 1950s in American art education literature regarding whether it was an appropriate term for art teachers to use. One set of educators argued that the creative nature of the artist was essential to being an art teacher (McCracken, 1959). The other side described it as a superficial term and a distraction to the work of teaching, which had nothing to do with the work of the professional artist (Lanier, 1959). These issues surrounding the artist-teacher surfaced in an *Art Education* article by Lanier (1959). Lanier, a professor at the University of Southern California in the 1950s, condemned the new term. He claimed it

did not have a place in the field of art education, that being an artist was quite different from being an art teacher, and worried the term would carry negative implications. Artists' and teachers' professional lives are very different. Artists live in a relatively open world, combining professional goals—including gallery exhibitions with generating income or engagement—with their work. This negative view represents a struggle to combine two disciplines (art and education) that have different values. The artist is a free spirit and unconstrained, whereas the teacher lives in a world of accountability. In addition, the art teacher may possibly feel inferior to the artist-teacher if he or she is not involved in both professions. Lanier appears to have constructed a straw man in his argument defining the professional characteristics of what an artist should be doing. Artists throughout history have redefined themselves; a 19th-century artist was very different from the artist of the 1950s (Lanier's period) and now the 21st century. Should we limit our understanding to professional activities, or is there something else within that makes an artist?

In contrast to Lanier's view, two months later a rebuttal was published suggesting that the artist-teacher was a concept and evolutionary change rather than a descriptive term (McCracken, 1959). Willard McCracken feels the emergence of the "artist-teacher" term was based on artistic activity and its positive effects on the educational experience. The activity and processes the artist engages in are useful and essential to understanding what students are encountering in the classroom. Without such knowledge, art teachers are missing an essential aspect of being an art teacher. Through this understanding, there is not a professional obligation to show in galleries or live the stereotypical artist's life that Lanier seems about which to worry. The artist-teacher is rather actively engaging in the central aspect of being an artist. I concur that McCracken is on to something in his thinking. If one idea ties all artists of all periods together, it is that artists produce objects/concepts and in doing so use a particular way of thinking that aided their production process. This production and thinking process is a central tenet to being an artist, and this aspect (artistic thinking) is what many art teachers hope their students experience. However, if the art teacher does not engage in such thinking, how can one expect the art teacher to facilitate such thinking in the classroom?

Problems

The "artist-teacher" as a term is problematic because it assumes that art teachers cannot do what they teach (as opposed to an artist-teacher who can). The "artist" in this case is added to "teacher" to emphasize the special qualities the art teacher gained as a result of superficial variables. The aspect of the artist-teacher terminology I believe most educators react negatively to is primarily a self-esteem problem on behalf of art teachers everywhere. The individual determines success. There is not a mysterious line one crosses to rightfully claim the title artist-teacher. It is not reserved for painters exhibited in the

Metropolitan Museum of Art or regular exhibitors in the gallery district. It is rather a descriptor of what you do. Are you an artist? It does not matter how big your reputation is or if you sell it. It just matters that you make it, experience it, and engage it.

Lanier (1959) bemoans the artist-teacher label as defining someone who could not make it as an artist. He says that if one creates art and teaches, just call them an "artist and teacher." Together they have no part in education. Primary and secondary school art curricula are broad in scope, and there are no expectations regarding art production for art teachers at this level compared with colleagues at the postsecondary level (Anderson, 1981; Day, 1986; Szekely, 1978). According to Lanier, one does not need to be an artist, and it appears he worries about the allegiances one has as an artist and a teacher. This concern is weak, because art education and certification programs require competency in studio art rather than art history, aesthetics, or criticism. (Although art education preparation includes these disciplines, they are not a central aspect). Newly appointed art teachers do not come from art history, philosophy, or creative writing programs; they graduate from studio art programs or art education programs that emphasize studio practice. Often, I encounter students who want to be art teachers from alternative programs in which they must complete a required amount of studio courses before being considered for a state credential program. The idea that studio art takes the central role appears to be a dated concern harking back to the Discipline-Based Art Education (DBAE) curriculum that saw the visual arts as a composite of four equal subjects. The Getty Center for Education in the Arts sponsored by the J. Paul Getty Trust introduced the curriculum with instruction encompassing areas of aesthetics, art criticism, art history, and studio production (Hamblen, 1988). Designed to provide consistency among art teachers nationwide, the emphasis on art content and less on artistic development or conveying original ideas was prescriptive in nature and raised many questions among educators and scholars (Muth, 1988).

At the foundation of the artist-teacher debate is whether an ongoing creative practice by the art teacher contributes or detracts from the curriculum, priorities, identity, values, and processes of teaching art organized neatly in the past by DBAE. McCracken's (1959) argument posits the beneficial processes artists progress through, which, having accomplished or struggled in these developments, places art teachers in a better position to provide encouragement, challenges, and questions to facilitate young artists through similar situations. The concept of the artist-teacher has less to do with the professional activities of an artist and more to do with an active thinking process applied to educational situations. The argument boils down to the question, what is an artist? Is it someone who shows in galleries, or is it someone working through various types of artistic issues? The concept values the production and the method of thinking about artistic problems over distinctive roles. The teacher of art is more than a specialist but also a manipulator and creative agent who adapts, reacts, and creates environments to promote students to think through concepts and visual issues. Artist-teacher as a concept becomes an adaptation of two fields: artistic ingenuity uniquely applied to the puzzle of teaching.

I would further argue that as artists, artist-teachers see the world differently and understand educational problems aesthetically because of their artistic activity. Given the influx of arts-based research (Cahnmann-Taylor & Siegesmund, 2008; Macleod, 2005; McNiff, 1998; Sullivan, 2005), an artistic way of thinking is knowable and a reasonable method for addressing complex problems. The thinking process an artist may use to divide or explore subject matter on canvas may follow suit in the organization of curriculum or a subject of study. Many combinations are possible depending on the variables. Through this line of thinking, an artist-teacher incorporates a visual or conceptual lens or perspective and applies it to education. Because artists are unique, their modes of thinking are different but likely identifiable if closely examined as individuals. Artists apply visual thinking to their art production, but it also carries over to curriculum problems, lesson planning, and organization. In fact, it most likely applies to a unique perspective on all visual aspects of their lives. It is a hunch that other subject-area specialists apply a similar mode of thinking to their teaching as well. It would be worthy to investigate how scientist-teachers apply their methods in the laboratory in the classroom. Although scientists share the scientific method, the diversity of artistic production and theory leads me to believe artist-teachers are more diverse in their applications, a potential strength with the diversity of educational contexts and issues (a great strength of art education programming).

The debate continues in current literature, and it is usually based on the two different understandings of the artist-teacher already outlined. As a term, it generally assumes that professional teachers must also be professional artists. As a concept, it reinforces the importance of creative activity by the teacher for his or her profession. I believe the root of McCracken's argument is that through art making and production, we engage emotionally and cognitively with ideas and objects. Artist-teachers do not differentiate between artistic and education problems, they only require different media.

Artistic Qualities

Contemporary literature and research regarding the artist-teacher views this dual identity as a crisis, each with a different spin yet linked by the common denominator of education received (Risenhoover & Blackburn, 1976; Zwirn, 2002). Anderson (1981) argues that the roles of professional artist and educator are established and previously defined by mentors in the same field. Mentors have a large effect on students, and it is not far-fetched to think that these relationships have a powerful influence on future artists and teachers. Anderson (1981) explains that these professions (artist and teacher) are separated via different educations, technical training, philosophical approaches, and professional prerequisites. Education makes a difference, as each school or department propagates different theories of art making and teaching. However, today's art and education schools are not always divided

into neat categories. Teachers College at Columbia University, one of the largest graduate schools of education in the United States, offers studio art courses within its art education program, whereas Pratt Institute in Brooklyn, which has a reputation as a studio school and a technical fine-arts college, offers courses in teacher preparation. Teachers College, the more conservative institution, is distinguishing itself as a place for critical thought in the arts based on course offerings, whereas Pratt Institute adds educational theory to a school founded on artistic thought. These two colleges and art education departments, though different in theory, are slowly separating the traditions in art preparation and teacher preparation. The academic divide between art and education departments is slowly crumbling in certain situations, making the artist-teacher concept a true philosophical combination.

Hickman (2005) furthers the notion of instilling artistic qualities into teaching practice when he writes, "[S]chools, should in my view be modeled on the best practice of successful art and design teachers" (p. 145). His argument values aesthetic experiences, and he sees a similarity between the aesthetic concerns artists have in the studio as a proper model for learning in the classroom. Both making and engaging works of art are essential human qualities, according to Hickman, and part of creating aesthetic significance. Constructing learning environments and practicing them is an art that requires some thinking about the aspects of schools and classrooms. Hickman (2005) feels everyone has this ability, but that art making has certain effects on the producer, including the development of sensitivity to relationships both personal and inanimate. Hickman (2005) calls the process "creating aesthetic significance," and it aligns itself with the tendencies artists exude to create something that looks good and feels right. Rather than learn about art, Hickman hopes students can learn through art. He sees learning in art as developmental and unique to every individual. In reviewing this text, Baldacchino (2008), an artist, teacher, and scholar, identifies with Hickman's fundamental feeling of art making as a way of understanding life and one's identity as an artist. Baldacchino (2008) thinks Hickman's artistic experiences "cannot be simply pinned down to a holistically defined experience or simply a fuzzy horizon of aspects and possibilities." Although Hickman (2005) sees aesthetic experience democratically and shared by everyone, some individuals—artists such as Hickman and Baldacchino—accept, develop, and engage in aesthetic significance in a deeper fashion and reflect on these experiences.

Teaching Art as an Aesthetic Process

In a classic essay, historian Horne (1916) foresees much of the arbitrary bickering by positing teaching art as an aesthetic process rather than a terminological issue. He describes teaching as an activity that involves intelligence, skillful work, rules, and procedures, which is then applied through intelligence and skill. His understanding of teaching is arguably made up of components similar to the production of art. Careful not to reduce teaching

or the arts to a recipe, the same ingredients can produce a variety of products. Applying these characteristics can produce poor teaching as well as poor art. To push the initial comparison further beyond making art, the aesthetic nature of art and teaching is used, in a broad form, to differentiate successful teaching as an aesthetic process or activity.

Teaching as an aesthetic activity has six characteristics, including spontaneity, self-expression, imagination, imitation, love, and self-relief (Horne, 1916). Spontaneity is free, natural, playful, and inspired, not mechanical. Horner understands that beauty creates a demand for itself and that it cannot be ordered. Interestingly, the school environment is not seen as freely inspired but rather as a highly structured environment. Self-expression defines the artist, thus content is supplied by ideas and experiences of the artist. Imagination is productive and recombines these experiences in new, fresh, or unfamiliar ways. Whether harmonious or chaotic, the artist constantly recreates perspectives not seen before. Imitation according to Horne owes an intellectual nod to Plato, yet represents the artist's use of realistic imagery. Imitation is not merely copying, but rather it is faithful to certain characteristics in producing products of art. Love characterizes the intense connection an artist has with producing work. Whether it is the concept, the ideal, or the process, an artist has emotional connections when making art. Finally, self-relief is the sigh of relief when the work is finished and the burden has been lifted. The emotions are loosened and relaxation is possible before the process repeats itself as each new project is begun (Horne, 1916).

To bring the aesthetic activity of the art applied to teachers together, Horne (1916) expresses the previously mentioned characteristics in the following statement:

> The teacher is like the artist, the pupils are his material through whom he is expressing his ideals. Such an artist teacher is spontaneous and free in his methods, knowing the rules of the technique of teaching but subordinating them to his own purposes. He is self-expressive in letting his pupils fully into the secrets of his ambition for them as individuals and in showing the ideals regnant in his own life. He is imaginative in handling the familiar material of instruction in new and unfamiliar ways, making contrasts and suggesting comparisons. He is imitative of the great masters of teaching Socrates, Jesus, Pestolozzi, and Froebel, but in his own independent way. He is animated by his love of teaching, by the love of his pupils, and by the joy he finds in making ideals take root in human lives. And at the end of each day's work, each week's, each year's, there is the sense of having emptied himself, the demand for quiet and rest till the burden of fullness is again present. In this cycle of self-expression and assimilation, of giving forth and taking in of transferring personality and re-gaining personality, the teacher finds that he too may be an artist in his work... (pp. 22–23).

The artist makes the difference, according to Horne (1916). Materials and technique do not make the artist. The artist-teacher works with young minds and truth rather than materials. The artist-teacher thus works in an aesthetic manner and produces aesthetic products similar to the visual artist. The message does not include a subject-based requirement (producing artists), nor does it state a requirement to produce and sell art professionally. The artist-teacher moves far beyond the terminology issue and pushes conceptual understanding. Horne would concur that artistic activity contributes to the teacher's role. Without understanding this activity, the artist would not have this particular perspective of aesthetic activity on which to draw.

Felix Gonzalez-Torres, the 2007 United States' artist representative at the Venice Biennale touches upon the close relationship of art making and teaching when asked why he never shared examples of his work with students (Slonium, 1994). His response was that his teaching is his work and that there should not be a distinction between the two. Joseph Beuys, one of the most influential artists of the 20th century, also felt his most important function was as a teacher (Beuys, 1990). His role as an instructor at the Düsseldorf Art Academy was influential on his art and vice versa. In regard to his teaching being of most importance, he states, "Objects aren't important for me anymore. I want to get to the origin of the matter, to the thought behind it" (Beuys, 1990, p 85). Beuys's teaching process intended to push thinking and experience further. Although his artwork enacted an experience, Beuys seems to value the intellectual atmosphere of the classroom and what he could provoke. The classroom became a context for art-making experiences. Through discussion and performance, Beuys' classroom became an art experience meant to educate and transform. Similar to his art making, teaching was an extension or perhaps the tip of his conceptual agenda. For both Gonzalez-Torres and Beuys, a slide presentation followed by a technical demonstration would not be true to their individual thinking processes. In their artwork, we can see the types of thought they valued. The same is true in their teaching. Not all art teachers should approach their craft like these artists, but they should consider and reflect upon why they are interested in the arts.

Art and Design

The importance of design theory is critical to many of the earliest artist-teachers, in addition to understanding how one can think artistically. The general difference between art and design is important to clarify, especially in the context of this text. Design education often refers to a formalistic art education that focuses on visual relationships. Brady (1988) separates the two in terms of purpose: he sees art as being closely aligned with philosophy, whereas design is similar to the work of illustration, which is made for a purpose and an intended audience. However, this understanding of design is also similar to craft. Hickman (2005) agrees that the differences between art and design are similar

to the differences between art and craft. Craft is generally concerned with a product that is utilitarian and uses particular materials. Design follows a similar distinction with an emphasis on technical qualities rather than philosophical issues.

The distinction between design and fine art has roots in the 19th century. Design or practical art schools were established that were quite different from fine arts academies. This separation caused the design schools to adapt a substandard reputation. However, this text highlights the importance of design philosophies not usually associated with a common definition of design. In fact the 19th-century schools of design are much closer in their understanding. Frayling (1987) states,

> Design was popularly viewed to be a kind of visual language which could be taught entirely through drawing: as a training in the mechanical accuracy of hand and eye. If students spent several years learning and practicing the grammar of that language, then one day they might be able to go into the world and improve the quality of everyday products . . . (p. 8)

Because of these philosophies, design education has many overlapping qualities in contemporary and historical literature (Hickman, 2005). Readers will find that the history of design education is closely related to the history of abstract art and affects the thinking of many who call themselves artist-teachers. Design education in England is much more open-ended when historically compared to how visual arts education is concerned with technique (Yeomans 1987, 2005).

> Art I believe to be expressive of the human condition; it provides clues to what cannot be explained in rationale terms . . . Design is a problem solving activity concerned with intervention and with formal relationships which are at least partially definable in terms of day-to-day practicability. (Black, 1973, p. 43)

Design can be understood as practical and theoretical. As a theory for organizing and thinking about the arts, it is a philosophical method for understanding art. To think philosophically about the arts is a distinctive mark the Renaissance artist established from the craftsman. The unity of design has the potential to bring together all the arts because it is an intellectual process, not a medium or technique. Michelangelo's importance, according to Vasari (1550/1965), was his ability to bring together painting, sculpture, and architecture through the principle of design (Williams, 2009). Vasari felt design was the father of the arts. It originates from the intellect and is an organizational theory when artists think deeply about their creations. Design in the modern era is also understood in a similar fashion. As an organizational structure developed by the artist, it is a visual representation of his or her worldview or how he or she understands the world and human experience. Design in this

manner is an intellectual activity developed in the Renaissance and thoroughly explored in subsequent centuries—one that corresponds to solving both art and educational problems.

This problem-solving aspect of design is closely related to the work of abstract artists and is a key developmental issue in subsequent art education theories in the 19th and 20th centuries. The search to understand abstraction is a modern dilemma that that raised issues similar to applied design. The fragmentation of the arts began in the 19th century as design schools sought to study this problem. Abstraction is often defined as form, expression, or symbol (Yeomans, 1987). In fact, many have posited formalism as the resolution as the basis of art education (Bell, 1963). James McNeil Whistler attempted to break from the academic traditions of painting with images that border on complete abstraction. Rather than viewing art as visual literature or history, he sought formal aspects of his work (Yeomans, 1987). In fact, Whistler brought a lawsuit in 1877–78 against the critic, John Ruskin, because he felt his reputation as an artist was hurt by Ruskin's criticism (Efland, 1990). Ruskin felt the time spent on this painting was not equivalent to the price Whistler was asking. In response, Whistler felt it was the experience that allowed him to arrange his compositions. His use of musical terms (harmony) emphasizes formal properties and not objective truths. The jury ultimately found in favor of Whistler but only awarded a farthing[1] in damages. The case represents a distinct change in art as a transition from concrete to abstract. From this point, abstract and eventually nonobjective works are analyzed using strategies once set aside for design.

The formal nature of work is emphasized in Whistler's compositions, drawing similarities to Kandinsky's comparisons of visual form and sound (Kandinsky, 1979). Essentially a form of demystification, a language is needed for understanding form. Nineteenth-century artists and designers attempted to render art making as a scientific process by singling out the elements of art compositions. As artists such as Cézanne, Picasso, or Modrian order the world through abstraction, a formal language becomes increasingly important. Many of these artist-teachers acknowledged the formal elements that were essential to their own artistic practice and subsequently taught it in the classroom. This formal language would then be the means for transcending the separate categories of art (Yeomans, 1987): "This search for a common core, for an underlying essence which could unite all the branches of the visual arts, was a reaction to the fragmentation which occurred in the fine and applied arts throughout the nineteenth century" (Yeomans, 1987, p. 15).

* * *

The staying power of the term "artist-teacher" is apparent in the ongoing dialogue in the 21st century. From Horne's (1916) essay calling for an aesthetic way of teaching to the debate midcentury between Lanier (1959) and McCracken (1959) and recent studies concerned with artistic identity (Zwirn, 2002), the subject of the artist-teacher has a full

body of literature. The individuals who use the term to describe themselves along with the larger corporate uses, each group manipulates it to its intended goals. However, through the writing of Hickman (2005), we see that teaching art can be much more than providing information about art, and that the experiences of learning through art are much deeper. Because design is usually related to craft, we see that this is not the case: the Basic Design Movement, along with other design-run initiatives, were able to deeply engage with artistic issues related to design, and apply them as artists and in the classroom (Yeomans, 1987). Through these curricula, the barriers between studio and classroom became less apparent.

References

Anderson, C. H. (1981), "The Identity Crisis of the Art Educator: Artist? Teacher? Both?" *Art Education*, 34: 4, pp. 45–46.

Baldacchino, J. (2008), Book review: *Why We Make Art and Why It Is Taught*, http://www.tcrecord.org/content.asp?contentid=15272. Accessed 19 November 2008.

Bell, Q. (1963), *The Schools of Design*, London: Routledge and Kegan Paul.

Beuys, J. (1990), *Energy Plan for the Western Man: Joseph Beuys in America*, New York: Four Wall Eight Windows.

Black, M. (1973), "Notes on design education in Great Britain," in D. W. Piper (ed.), *Readings in Art and Design Education*, London: Davis-Poynter.

Brady, M. (1998), Art and design: what's the big difference?, http://www.unc.edu/~jbrady/Essays/Art_Design.html. Accessed 10 June 2008.

Cahnmann-Taylor, M., & Siegesmund, R. eds. (2008), *Arts-Based Research in Education: Foundations for Practice*, New York: Routledge.

Day, M. D. (1986), "Artist-Teacher: A Problematic Model for Art Education," *Journal of Aesthetic Education,* 20: 4, pp. 38–42.

Efland, A. (1990), *A History of Art Education: Intellectual and Social Currents in Teaching the Visual Arts*, New York: Teachers College Press.

Frayling, C. (1987), *The Royal College of Art: 150 Years of Art and Design*, London: Barrie and Jankins.

Hamblen, K. A. (1988), "What Does DBAE Teach?" *Art Education*, 41: 2, pp. 23–25.

Hickman, R. (2005), *Why We Make Art and Why It Is Taught*, Bristol: Intellect Books.

Horne, H. H. (1916), *The Teacher as Artist: An Essay in Education as an Aesthetic Process*, New York: Houghton Mifflin.

Kandinsky, W. (1979), *Point and Line to Plane*, New York: Dover Publications. First published 1947.

Lanier, V. (1959), "Affectation and Art Education," *Art Education*, 12: 7, pp.10, 21.

Macleod, K. (2005), *Thinking Through Art: Reflections on Art as Research*, New York: Routledge.

McCracken, W. (1959), "Artist-Teacher: A Symptom of Growth in Art Education," *Art Education*, 12: 9, pp. 4–5.

McNiff, S. (1988), *Arts-Based Research*, London: Jessica Kingsley Publishers.

Muth, H. A. (1988), "Commentary on DBAE," *Art Education*, 41: 2, pp. 19–22.

Risenhoover, M. & Blackburn R. T. (1976), *Artists as Professors: Conversations with Musicians, Painters, Sculptors*, Chicago: University of Illinois Press.

Sullivan, G. (2005), *Art Practice as Research: Inquiry in the Visual Arts*, Thousand Oaks: Sage.

Szekely, G. (1978), "Uniting the Roles of Artist and Teacher," *Art Education*, 31: 1, pp. 17–20.

Vasari, G. (1550/1965). *Lives of the artists, volume I* (G. Bull, Trans.). London: Penguin. (Original work published 1568).

Williams, R. (2009), *Art Theory: An Historical Introduction*, 2nd ed., Oxford: Wiley-Blackwell.

Yeomans, R. (1987), "The foundation course of Victor Pasmore and Richard Hamilton 1954–1966," Ph.D. dissertation, London: Institute of Education, University of London.

Yeomans, R. (2005), "Basic design and the pedagogy of Richard Hamilton," in M. Romans (ed.), *Histories of Art and Design Education: Collected Essays*, Bristol: Intellect Books, pp. 195–210.

Zwirn, S. G. (2002), "To be or not to be: the teacher-artist conundrum," Ed.D. dissertation, New York: Teachers College, Columbia University.

Endnotes
1. Farthing (or fourth part) was an English coin worth one quarter of a penny and 1/960 of a pound sterling.

PART TWO

Artist-Teachers

George Wallis

George Wallis (1811–1891), in addition to being an artist and teacher, was an arts advocate, lecturer, inventor, author, historian, critic, and curator. Acting through these various roles, he had a significant effect on the art educational landscape of 19th-century England (Daichendt, 2009a; Wallis, 1859). Wallis posed ideas and methods unique for his time that resulted in new systems and devices for educating designers. His later accomplishments include inventing a printing press for reproducing artists' drawings, creating an original design curriculum for industrial artists, founding an art school, and garnering a reputation for systematizing complex situations (such as organizing a disorganized school, or authoring a practical drawing publication intended for home use). However, it was Wallis's role as an artist-teacher in England's Schools of Design that provoked an interest in a life forgotten by many in the art field. As the earliest known person to use the term "artist-teacher," his understanding is crucial in properly understanding the concept of artist-teacher.

Early Artistic Experiences

From an early interest in art as a child to his professional responsibilities as an artist and teacher, Wallis, the first self-described artist-teacher, was involved with art education his entire life. However, obstacles in the beginning of his journey represent the lack of adequate art education opportunities in 19th-century England. Wolverhampton's (Wallis's birthplace and residence) remoteness and absence of artistic resources caused Wallis to move and pursue artistic training in a larger city. This dilemma foreshadows one of the major concerns in implementing the government Schools of Design that Wallis championed. England, unlike France, did not maintain a large number of art and design schools, museums, and galleries for students to pursue artistic studies. Despite

such setbacks, Wallis prevailed and managed to continue his sketching and painting throughout his long career. Late in life, Wallis championed progressive art educational initiatives in many cities, and an art school eventually opened in Wolverhampton during Wallis's lifetime

Wallis suffered through the tragedy of losing his father at an early age. This misfortune also served as an impetus for arts exposure. Wallis's uncle (a designer himself) subsequently adopted Wallis, introducing him to world that changed his life. Wallis was thankful and recognized his uncle Worrallow's influence on him as a child and credited these early experiences with his own appreciation of the arts and design (Anon, 1879). There is always an influential moment or person behind success stories and Wallis' uncle was that critical figure for him.

Wallis's early talent led him to painting and designing tea trays for a local designer in his hometown. Developing artistically during this time, the artistic identity of Wallis was developed long before his teaching career. His professional role as an artist matured formally during his tenure in Manchester. Studying from plaster casts and taking part in a semitraditional academic education, Wallis honed his craft. It is during this time (1832–1837) that Wallis produced several of his major paintings, including *Wolverhampton Race Course* and *Fall of Napoleon.*

During the 1820s, England did not have the facilities or resources in small towns, such as Wolverhampton, to educate a prospective artist. Thus an aggressive and motivated individual would move to a larger town to pursue artistic training. In 1832 Wallis relocated to Manchester to pursue such a goal (Anon, 1879). The Royal Manchester Institution (now the Manchester Art Gallery), a collection founded in 1823, was accessible to students interested in studying from casts. Wallis pursued this museum as a place of study. It was not uncommon for students in the 19th century to study from collections like Manchester's. The Royal Manchester Institute boasted a healthy supply of antique models, and studying the antique was a proper form of education in the 19th century, similar to the curriculum advocated at the Royal Academy. Unfortunately, the conditions were not ideal in Manchester, and Wallis's early educational experiences could be described as an "every man his own teacher" atmosphere (Anon, 1879). It is worth noting Wallis's employment as an artist during this time in Manchester, from 1832 to 1837. According to biographer George Clement Boase (1899), Wallis came to take in interest in art as it was applied to design during this time.

A trip in 1836 to view a design exhibition in London significantly affected Wallis. The exhibition highlighted the lack of adequately trained designers in England and possibly brought together his dual interest as an artist and designer in relation to education. In other words, Wallis started thinking (artistically) about a method (education) to improve the skill level of designers in England. An early exposure to design, a young career as artist, and disappointment in his own art education in Manchester (and possibly the lack of education in arts) combined to lead him back to his hometown to establish an

experimental art school. Wallis saw a chance to pursue his passions and at the same time provide art educational opportunities where none had existed.

The official impetus to found the experimental art school was the lack of design training in England. Wallis noticed the absence of design education during his trip to London in 1836 to the exhibition of design work. Acting partially from his desire to advance art in England, he felt art education was the best means to do so. Without this awareness, Wallis would have been unable to comprehend the visual differences. In addition, without the physical skills, he would not be able to teach them.

Through Wallis's experimental art school, he created opportunities where there were none. Wallis's methods involved a unique system of instruction that differed from copying examples of ornaments (the typical art and design school curriculum). In his new school, Wallis expected students to learn from the instructor drawing on a blackboard. Through observation of arm gestures, students could see a design develop. Wallis referred to his blackboard method on several accounts. Using the blackboard, his strategy involved students copying the motions of the instructor rather than the actual lines (Macdonald, 1970; Wallis, 1885). This practice, although short-lived (the art school did not continue), constituted a new art teaching technique later adopted into the Government Schools of Art curriculum for elementary education during the 1850s. The process deserves mention because of the contrast with academic methods and the early impetus. The exercises were also done on a large scale compared to the smaller examples provided in Schools of Art. These early educational theories were most likely born out of the frustration he experienced in realizing the poor conditions of art and design teaching. Interestingly, Victor Pasmore (another artist-teacher discussed later) from the Basic Design movement also used demonstrations via blackboard as a central aspect of his teaching (Yeomans, 1987).

Portrait of George Wallis, 1843-1845
Courtesy of Manchester Metropolitan University

Wallis also held a lifelong concern and admiration for his hometown combined with his own frustrations in learning to draw, thus the school served many purposes (Daichendt, 2009b; Jones, 1897; Wallis, 1885). On the basis of the vastly different philosophy practiced by Wallis, the self-taught education process is a powerful example informing the experimental art school. Reflecting on these learning processes as an artist in Manchester, Wallis developed a new method for teaching and learning born from his frustration and successes. Wallis (1885) reflects on this aspect of his life:

> Prior to seeking official connection with the Government School of Design in 1841, I had, as a young artist, devoted considerable attention to the question of art as applied to manufactures. Having seen during a residence in Manchester, 1832 to 1837, and in the Staffordshire Potteries, Wolverhampton, and Birmingham, from 1837 to 1841, the utter neglect of everything like artistic principles in the various industries of those places, in 1839–40, I publicly lectured on the subject; and subsequently formed an experimental class at Wolverhampton to test certain methods of teaching elementary drawing by black board illustrations on a large scale, thus satisfying myself of the value of such a method of instruction. (p.3)

Although Wallis adopts new methods after his time in London, these early experimental teaching methods stayed with him and became a controversial subject in his appointment as master of the Manchester School of Design a few years later because they were different. It was shortly after this experience in Wolverhampton that Wallis joined the community at the Normal School (a teacher training school specifically created for the Schools of Design in England) in 1841 (Dixon, 1970; Anon, 1891). This opportunity was formal training in the art of teaching.

Bell (1963) feels Wallis was a man of some character based on his dealings. This is evident in his ability to overcome many obstacles in his own education as an artist. Originally thought to be a history painter, his background is more nuanced, shifting between design work and artistic aspirations (mainly landscape painting) as he simultaneously embarked on his teaching career. Although Wallis may be credited by Bell (1963) as a painter, he did not receive the type of training that 19th-century painters usually did, which typically included enrollment in an academy or an atelier. Wallis was a self-taught artist for the most part, although he did enroll in classes while he resided in Manchester. His only official training for a substantial period of time, outside grammar school, was tenure at Somerset House in 1841, which prepared him as a drawing master. To be accepted, however, Wallis displayed an extraordinary talent in drawing. How much time Wallis committed to his own art education is unknown, but it is likely it was substantial. Boase (1899) claimed Wallis won one of six exhibitions offered by the government in 1841 that led to eventual admission at Somerset House.

Despite Wallis's successful role as an artist, designer, and educator for the majority of his life, he gave up on the idea of a full-time career in painting because of his design and teaching responsibilities. He writes, "The career of the mediocre artist must be one of poverty and disappointment" (Bell, 1963, p. 116), compared with the career of a designer, which is more comfortable, respectful, and profitable. This suggestion delivered to students is particularly telling of his own choice to be an advocate in design training for a large portion of his career. A common frustration to artist-teachers is the success rate of artists who must supplement their income by teaching. This is not a failure but a success to be able to continue with both aspirations.

The director of the Schools of Design, William Dyce, also struggled to balance his career and commitment to administering the Schools of Design and his painting. Dyce was an associate of the Royal Scottish Academy and an accomplished portrait painter who toiled over his professional commitments and the little time they allowed him to be a painter (Bell, 1963). The time commitment required to teach in the 19th century was a common obstacle for anyone pursuing dual professions, and it is likely Wallis's educational dedication affected his output. Wallis and Dyce presumably faced frustration in balancing two identities and careers, similar to issues contemporary artist-teachers face (Anderson, 1981; Lanier, 1959; McCracken, 1959; Zwirn, 2002). However, Wallis continued throughout his life to create new works of art despite professional obstacles.

The 19th-Century Artist-Teacher

The thought patterns become visual as Wallis's background as a landscape painter significantly appears to influence his organizational strategies. Despite the variety of strategies used in Wallis's pedagogy, a common theme is current. Wallis's use and reflection on his artistic enterprise informs all aspects of his teaching. This is apparent as he incorporates the critique process of the artist in the classroom and brings originality back into education for designers.

Wallis's horizontal and grid formations used in the organization of his painted landscapes are similar to the organizational patterns he used when creating plans or drafts for curriculum. Numbering his actions (e.g., 1, 2, 3) to explain issues or ideas, Wallis was a systematic thinker. However, these ideas were multilayered in his graphic organizers. When Wallis's thoughts are laid out visually, we are in a position to understand the depth and richness involved in his educational theories. A foundational knowledge is obviously important to Wallis, yet he still leaves room for variation in a course of study.

Wallis adhered to a basic curriculum in line within his context. However, he modified it, based on the peculiarities of the various industries (Wallis, 1846). The tailored curriculum of Wallis is evident in Select Committee (Anon, 1849) discussions. Regarding the qualifications of school inspectors, Wallis felt that an artist alone could

The Old Plane Tree, 1887
George Wallis (1811-1891)
Oil on Canvas
© Victoria and Albert Museum, London

not understand the dynamics of an educational institution. To properly understand the curriculum at the Manchester School of Design, knowledge of the particular industry was necessary. One generic system of education could not serve all students. Therefore, the curriculum must be tailored to a particular area and the needs of the students.

Similarly, selection of appropriate materials and designs must work in concert with one another. Forms should be considered in relation to the use of the object, whereas decorative details should embellish but not interfere with form or surface (Wallis, 1880). Paying special attention to the material, the design should consider the variables of the object; for example, carpets and wooden benches are used to communicate different messages and should not exhibit similar designs. In the end, Wallis aims for his students to look closely and balance these variables aesthetically.

In tailoring the curriculum, the selection of appropriate projects illustrated by samples becomes a central issue. Wallis was particular about the types of design and ornament he placed before his students. His objection to teaching from the figure at Manchester and his disappointment with the changes in the elementary curriculum are examples of this aspect of selection (Anon, 1849; Wallis, 1845).

Holding a pragmatic philosophy, Wallis saw no reason to fill students' minds with useless exercises that did not contribute toward their profession. In the following statement, we see the heritage of how design schools would relate to technical colleges in the coming

decades. Wallis stated, "[T]he primary purpose of the schools of design is to teach art as applied to the manufacture" (Anon, 1849, p. 279). In fact, the design education should be suited for the particular manufacture or specialty that would employ the student. If an understanding of industry were not studied, their energy would be fruitless. According to Wallis, "A man may be a very excellent draughtsman, and a very excellent artist, and yet know nothing of designing for calico printing" (Anon, 1849, p. 279). The practicality of Wallis comes through, as it is apparent that selection is a key aspect of his curriculum. However, selection is measured by the benefit it has on the student. Knowledge of the field is fundamental in this respect. Wallis draws on a practical background as an artist and designer and imparts this knowledge to the students through the design of the course. The problem Wallis seems to hint at is that nobody would recognize these nuances without a proper background. Contemporary college art instructors wrestle with similar situations when supervisors or administrators come from different careers or are specialists in different areas of study. Recognizing unique contributions becomes difficult outside expertise. Selection is also an essential aspect of being an artist. Artist-teachers are constantly selecting imagery, colors, and media, and arranging compositions, and they continue this decision-making process in the classroom.

Wallis's emphasis on originality was in stark contrast to the government's curriculum employed in elementary courses, which consisted of copying hundreds of designs. However, to educate designers for industry, teaching only imitation was insufficient. The leaders in the field of art education recognized this, yet the schools were young and their strategy not yet realized. In response, Wallis states,

> Merely learning imitation will not cultivate the mind of a student in the highest sense. I mean to say that if you get a student of average power, you may give him such rules and principles as will enable him to go with the intention of making a design for a special manufacture, but mind is required to produce an original design. (Anon, 1849, p. 280)

Wallis approached his original course by demonstrating a principle of design, followed by a request that students create an original design based on the same principle demonstrated (Macdonald, 1970; Wallis, 1845). Using his artistic enterprise, Wallis practiced his expertise. The design produced by the students had to be practical in the form of a wall decoration or a chair back and then subjected to critique when finished. Macdonald (1970, p. 91) stressed that, "Wallis always praised originality and fitness for purpose." Even if students desired to reproduce a design, Wallis urged them to recreate it in a different size. By making the image larger, they did not fall back into the curriculum taught at the Schools of Art and academies.

Constructive criticism was another aspect of the Wallis pedagogy. After receiving original designs and work from students, Wallis would critique their attempts and

promote critical reflections and formal analysis regarding practical application. In discussing these aspects of teaching the principles of design, Wallis states,

> I will suppose that a student brought me that trail on paper as a design for a common trail for a garment; I should at once take that design and redraw it for him upon the blackboard, and show him where I believed it to be wrong; I should show him that the design did not cover so well as it might do; that there was a great degree of angularity in it, and that he had violated some of the first principles of natural form in producing such a design; and in short, impress upon his mind as much as possible to avoid committing such errors in future. (Anon, 1849, p. 282)

As an artist-teacher, Wallis used his own practical drawing skills to demonstrate errors or alternative applications of the design element proposed by students. The use of the blackboard, on-the-spot criticism, and practical advice demonstrate the feedback that Wallis found useful for his students. The use of the blackboard originally instituted during the experimental art school in Wolverhampton continued, becoming a mainstay in British Art Education in the Schools of Art. In addition, the instruction involving formal analysis of design places Wallis as an educator in the mid-19th century using an early design curriculum.

Prizes were occasionally awarded to students at the Schools of Design, and Wallis appeared to have had mixed feelings on the subject. These feelings are highlighted in the 1849 Select Committee Report, in which he supported more prizes throughout the year rather than at the end. Although his comments demonstrated his interest and support of the students pursuing prizes, he also let it be known that these competitions possessed the capability to distract students from their work and could have a negative effect. In contrast, Wallis opted for prizes to serve as standards of accomplishment. Later in his career at Birmingham, Wallis was able to reorganize the prize distribution system, allowing for more prizes based on work accomplished rather than awarding a few select individuals. He wanted to reward hard work and progress for many rather than honor a few. He envisioned that the curriculum outlined be a four-year course of study. Thus, when students completed a stage, they would earn a certificate of completion rather than continue to compete for prizes against one another, an unusual philosophy within this context. A certificate represented an accomplishment, something attained by diligent students.

In correlation to Wallis's teaching strategies, writings, and artistic practice, the inferred pedagogy—including the categories' selection, originality, constructive criticism, taste and morals, intrinsic/extrinsic motivation, and practical experience/mentorship—were governed by Wallis's background and history. Wallis's own experience as a professional designer combined with an artistic background molded a unique individual who brought both an art and a design background to the classroom. An artist early in his life, his

identity was cemented with the facilitation he received as a young boy from his uncle. The importance of attending a teacher training school was essential in Wallis's becoming a reflective teacher, prompting him to think deeply about educational problems.

The implied use of the term "artist-teacher" demonstrates Wallis's commitment to the educational aspect of art and design education. Wallis was considered a rebel for his educational views and moved ahead of his colleagues on more than one occasion (Macdonald, 1970). Combining various roles and applying artistic ingenuity ahead of his time defined Wallis's career. In a statement, Wallis emphasized the importance of being an artist:

> An individual merely having a knowledge of manufacturer without the knowledge of art, or an individual having a knowledge of art without a knowledge of manufacture, would be equally unfit. It is knowledge of the two that would be the best qualification. (Anon, 1849, p. 284)

Wallis used his artistic nature to inform his teaching methods. The historian Stuart Macdonald (1970) noted that Wallis was the first head of a British School of Design to see his position as one of education. The statement supports reading Wallis's philosophy as one that balanced artistic and educational goals or more likely emphasized the educational aspects of teaching design. Understanding this balance is essential. Knowing oneself and the subject of study allows one to truly take advantage of educational thought.

* * *

Bringing artistic thinking processes into the classroom is a personal procedure that depends on many factors. An all-encompassing formula is not appropriate, as many artists practice in many variations of media and concepts. Equally valuing teaching and art making, Wallis embraced spontaneity in art making and teaching. Although many artists use critique in the classroom, understanding its importance as an artist is necessary before students engage in the activity. Understanding your own artistic enterprise before applying it in the classroom is a good way to facilitate this continuation. Wallis used critique for a particular aim, to fine-tune the original creations of students. He asked students to step back and allow for critique, so they could understand what their designs were communicating to their audience. In this situation, Wallis understood the purpose of good design and hoped to facilitate this revelation in the classroom. From facilitating original designs to tailoring curriculum, Wallis's pedagogy and use of his artistic enterprises in the classroom was a direct extension of his studio practice. A pragmatic thinker, he desired results and formulated his classroom to achieve them. Often swimming against the stream, his ideas were controversial in the conservative context but effective. Embracing what he knew about art and design was Wallis's great strength as an artist-teacher.

References

Anderson, C. H. (1981), "The Identity Crisis of the Art Educator: Artist? Teacher? Both?" *Art Education*, 34: 4, pp. 45–46.

Anon (1849), *Report of the Select Committee Appointed to Inquire into Schools of Design*. Unpublished document.

Anon (1879), "George Wallis, F.S.A," in *The Biograph, and Review*, pp. 177–182.

Bell, Q. (1963), *The Schools of Design*, London: Routledge and Kegan Paul.

Boase, G. C. (1899), "Wallis, George (1811–1891)," in *Oxford Dictionary of National Biography*, Oxford: Oxford University Press.

Daichendt, G. J. (2009a), "George Wallis: The Original Artist-Teacher." *Teaching Artist Journal*, 7: 4, pp. 219-226.

Daichendt, G. J. (2009b), "Artist-Teacher George Wallis: Redefining the Concept through History," Ed.D. Dissertation, New York: Teachers College, Columbia University.

Dixon, K. (1970), "George Wallis, Master of the Manchester School of Design, 1844–46," *Journal of Education Administration and History*, 2: 2, pp. 1–8.

Jones, J., (1897), *Historical Sketch of the Art and Literary Institutions of Wolverhampton, from the Year 1794 to 1897*, London: Alexander and Shepheard.

Lanier, V. (1959), "Affectation and Art Education," *Art Education*, 12: 7, pp.10, 21.

Macdonald, S. (1970), *The History and Philosophy of Art Education*, London: University of London Press.

McCracken, W. (1959), "Artist-Teacher: A Symptom of Growth in Art Education," *Art Education*, 12: 9, pp. 4–5.

Wallis, G., (1845), *A Letter to the Council of the Manchester School of Design on the System of Instruction Pursued in that School*, London, Council of the Manchester School of Design.

Wallis, G., (1846), *A Farewell Letter to the Council, Subscribers, Friends, and Students of the Manchester School of Design*, London: Simpkin, Marshall and Co.

Wallis, G., (1859), *Wallis's Drawing Book, for the Use of Artisans and Others Learning Drawing for Useful and Practical Purposes*, 2nd ed., London: Department of Science and Art.

Wallis, G., (1880), "Original Designs for Art Manufacture, Introduction," in *The Art Journal, Volume 19*, London: Virtue and Co.

Wallis, G., (1885), *Memorandum on Official and Public Services Connected with the Promotion of Art Education in Great Britain and Ireland, from 1839 to 1885.* Unpublished document.

Yeomans, R., (1987), "The foundation course of Victor Pasmore and Richard Hamilton 1954–1966," Ph.D. dissertation, London: Institute of Education, University of London.

Zwirn, S. G., (2002), "To be or not to be: the teacher-artist conundrum," Ed.D. dissertation, New York: Teachers College, Columbia University.

CHAPTER FIVE:
A SYSTEMATIC GRAMMAR

Arthur Wesley Dow

The arts and crafts movement is well documented in art history texts, especially the influence William Morris had in Great Britain. Arthur Wesley Dow (1857–1922) holds a similar position within the United States. However, he is little known outside specialist circles despite being highly influential for a large number of painters, printmakers, designers, potters, furniture makers, and metalsmiths in the United States (Sokol, 2000). A painter, printmaker, photographer, and designer, Dow's influence extended beyond craft and design to education as well. A founding faculty member of Brooklyn's Pratt Institute, Dow spent the majority of his career as a professor at Teachers College, Columbia University, in New York (Sokol, 2000). Concerned with the universal principles of art making, he devised an argument that a successful composition contains harmony of three elements. Line, notan (Japanese term noting value or dark against light), and color—if displayed harmoniously along with opposition, transition, subordination, repetition, and symmetry—could systematically be applied in art making and through teaching. The publication of his text *Composition: A Series of Exercises in Art Structure for the Use of Students and Teachers* (Dow, 1899) forever changed the teaching of art (Enyeart, 2001). Dow was the first artist or teacher to identify and classify the elements and principles of design (Mock-Morgan, 1976). Despite the progression and increased study of the elements of design, they are still taught in a similar manner in the 21st century.

> Elements of Design
> Line with spacing
> Line with character
> Line with expression

Principles of Design
 Composition of line
 Representation with line
 Dark and light (notan)
 Quality of tones
 Composition of dark and light
 Light and shadow in representation
 Color as hue
 Value
 Intensity color harmony
 Color composition

Principles of Composition
 Opposition
 Transition
 Subordination
 Repetition
 Symmetry (Dow 1899, 1926)

Born in Massachusetts, educated in France, and breaking through as a teacher in New York City, Dow's philosophy of art education was infused by his curiosity in art making and research. This notable philosophy emerges because he was an artist-teacher with a passion for making and teaching art.

Education

Dow's educational background started young. Growing up in Ipswich, Massachusetts, he spent much of his time sketching and researching historical houses (Mock-Morgan, 1976). His early attempts at drawing were supported locally in publications, such as the *Antiquarian Papers*. Consisting of basic outlines/contours, the sketches held an admirable quality lacking in-depth detail. This progress and support led to local art educational opportunities that encouraged his growth as a knowledgeable artist. Studying the writings of John Ruskin and William Morris Hunt, it became clear that Dow was interested in improving his own artistic technique in addition to better understanding the different processes of teaching these ideas (Mock-Morgan, 1976). In 1884, despite studying art technique locally, Dow eventual set forth to continue his art education in France. Described as a shy yet determined individual, he held deeply religious convictions about human nature (Enyeart, 2001). Smart and determined, Dow graduated as high school valedictorian, which followed with an offer to teach locally because of his academic

aptitude (Enyeart, 2001). Studying with many local artists, Dow progressed with zeal, learning Greek and becoming a teacher of distinction locally.

Dow's eventual education in the arts is similar to many young artists around the world in the 19th century. The center of the art world was Paris and Dow made his pilgrimage, enrolling in the École Nationale des Arts Décoratifs and studying under Francis D. Millet. Customary painting excursions to Brittany during the summer months fell between his courses of study before enrolling in the Académie Julian in 1884 (Ollman, 2000). Julian's school offered foreigners an alternative to the Ecole des Beaux-Arts, the most important art academy in Paris despite the improving stature of the Académie Julian. Participating in a number of salon exhibitions (1887, 1889) in addition to a solo show (1888) back in his home state of Massachusetts illustrates the early success of Dow's academic training and his stature as an artist (Ollman, 2000). Dow even saw his work exhibited "on the line" or at eye level, a noteworthy accomplishment, as a highly hung painting was hard to appreciate and to some considered unworthy (Mock-Morgan, 1976). His work as a student painter was of primary importance, and his early career suggests an individual entering the competitive art world. The time spent in France coincides with many significant happenings in modern art history. In 1886 the Salon des Independents, the Exposition Internationale, and the Impressionists held exhibitions providing exposure to the avant-garde (Moffatt, 1972). Dow even had the opportunity to meet Paul Gauguin. A relationship that some speculate led to Dow's initial mistrust of the academic system (Enyeart, 2001). It is likely that the entire group of artists in Pont-Aven contributed toward this growing disillusionment (Mock-Morgan, 1976; Moffatt, 1972). In fact, Moffatt (1972) feels this air of rebellion and questioning is as responsible for Dow's reaction against the academy as his eventual discovery of Japanese design.

Mock-Morgan (1976) notices the unique approach Dow set for himself as a student in France. Concentrating on one phase of painting at a time, he singled out particular aspects he sought to master. The representation of sunsets was one of these subjects, Dow desired to understand. Constantly experimenting with color, Dow refined his understanding of materials. Concentrating on one aspect is an interesting approach that foreshadows his thinking process applied to understanding abstract imagery.

The curriculum of the Académie Julian was similar to most academies in the strict observance of studying the human form. The body was measured in head lengths and representing the three-dimensional aspect of the figure was of prime importance. After four years of study, Dow felt compelled to return to the United States and to continue his education where he painted American motifs. However, his growing cynicism with the academic system plagued Dow (Moffatt, 1972).

Despite the strong foundation in technique Dow received from his academic training, he was frustrated upon his return the United States at the age of thirty-three. Ollman (2000) describes Dow as beleaguered with disappointment over the shortcoming of such an education. The study of plaster casts was simply imitation. He sarcastically called the academic process that of making maps of the human figure. These experiences had brought success to

the young Dow, but they appeared inadequate for the type of work Dow aimed to accomplish. Perfectly replicating the human form was not the truth he was after. Instead beauty was the prize he sought, and it could only be achieved through expression (Ollman, 2000). The academic education therefore became influential for Dow's progression as an artist-teacher. Although the frustration was negative, it served as a stimulus for going forward.

Within Dow, art production and a zeal for learning seem to coincide naturally. Upon his return, he continued to produce and set high expectations from his studio practice. Despite producing and exhibiting in a healthy number of Boston-based exhibitions, Dow experienced frustration with slow sales and negative criticism (Moffatt, 1972). The art world was far from objective, according to Moffatt (1972), because good reviews could be bought or possibly influenced by pandering the public with French titles. Dow did not appear to be interested in this avenue. And it was at this venture when the role of education was brought to the forefront. Many artists have taken to a teaching career or stint to support their practice; however, Dow's journey saw the two intertwine, making this decision to enter the field more than a job. Whether it was for reform or funds that initially started Dow on the teaching track, the longevity of his career was built on art educational reform.

The influence of Japanese prints from his time in France in addition to a growing interest in other cultural art products led Dow's study in a new direction. Dow was a long proponent of art from other cultures, including Greek classicism, Native American, Aztec, and African art (Green, 1999). This willingness to experiment and constantly grow is a state of mind that set Dow apart from other academic artists who were willing to follow the status quo. The Boston Museum of Fine Arts (MFA) and the Boston Public Library played crucial roles in facilitating much of the information that transformed his understanding of aesthetics. In an attempt to study arts of other cultures, Dow sought to find the best examples (Green, 1999). It was at the library where Dow discovered the prints of Hokusai, whereas the museum allowed him access to Japanese art among a host of other cultural artifacts of interest (Ollman, 2000). Dow writes, "One evening with Hokusai gave me more light on composition and decorative effect than years of study of pictures. I surely ought to compose in an entirely different manner and paint better" (Chisolm, 1963, p. 181).

Soon after the infatuation with Hokusai, Dow began intense study of design from other cultures. It is likely Dow was familiar with Japanese design before 1890, but this study marks an important transition for Dow, as it propelled him to learn more. Dow is not alone; many post-Impressionists were influenced by Japanese prints, notably Vincent van Gough and Paul Gauguin. However, Dow instantly took friendship with Ernest Fenollosa, who recently returned from studying in Japan and served as the Boston MFA curator of Oriental art. Dow studied Japanese grammar and practiced with Japanese block printing, brushes, ink, and rice paper. Dow became incredibly knowledgeable on the subject and eventually served at the Boston MFA as the assistant curator of Oriental art.

Dow the teacher presumable emerged from his relationship with Fenollosa (Mock-Morgan, 1976). Dow's friendship and working relationship with him changed his approach

and understanding of art practice and appreciation. Fenollosa believed the forms of Eastern art far surpassed the traditional aesthetics of the West. The lyrical forms of the East, according to Fenollosa, could successfully communicate unique emotional experiences (Hook, 1985).

Turning from an artist who taught to someone who deeply cared about learning, Fenollosa opened Dow's eyes to possibilities in art education. In fact, many of Dow's early ideas on art education should be credited to both Dow and Fenollosa. The 1920 forward of the text *Composition: A Series of Exercises in Art Structure for the Use of Students and Teachers* credits Fenollosa as the originator of the pure design Dow advocates, from which something Dow did not shy away. Fenollosa's influence cannot be understated, as Dow followed in his footsteps from the Boston MFA to Pratt Institute. When Fenollosa did not continue as a professor at Pratt, Dow took over his position.

The ongoing relationship Dow held with American philosopher John Dewey paralleled the development of his teaching theories (Mock-Morgan, 1976). Dewey (1934) the pragmatist is most well known for his aesthetics text, *Art as Experience*. Dewy taught in the Philosophy Department at Teachers College, Columbia University and was hired around the same time as Dow. The child-centered curriculum is often associated with facilitating the individual learning of students. However, Dow disapproved of the "free" use of materials in the art classroom (Mock-Morgan, 1976).

Dow the Artist

As an artist, Dow's work is classified as American Arts and Crafts. Initially labeled an Impressionist by the press, Dow saw himself reflecting his New England heritage more than any aesthetic (Mock-Morgan, 1976). Dow's work was obviously influenced by Japanese design, but it would be difficult to categorize him within "the Japanese School." He sought the essence of Japanese design and his professional work within the field both contribute toward visual ramifications. Dow held the position of artist with great esteem and sought this throughout his career

Dow's study of Japanese design was for his own personal art making (Watanabe, 1997). This interest was personal, as he sought the essence his paintings were missing. The refinement and powerful compositions he studied in Japanese art was unmistakable. He felt the influence in great works of art everywhere. However, like any great educator, once Dow felt he understood the art of design, he was compelled to share it with others.

Dow's artwork exudes the same characteristics he taught. Ollman (2000) explains:

> "They (Dow's artwork) encompass seamlessly Dow-the-teacher's most fundamental lessons regarding the dynamism of line, the arrangement of tonal masses and the subtle spark ignited by asymmetrical composition. The prints exude a sense of serenity in keeping with Dow's larger

philosophical agenda of educating the public to make choices, in life as in art, that deliver harmonious results." (Ollman, 2000, p. 63)

The systematic procedure of adding a line step by step was a Japanese trait that Dow later incorporated in his teaching. The common elements of line, mass, and color could be used in another fashion different from his own education.

"His evaluation was that each of the methods properly used produced valid results within the limitations of its geography. His preference became that of the formation of the whole composition, whereas the Western method of imitative representation, started with drawing and moved the whole composition in the end." (Mock-Morgan, 1976, p.128)

Arthur Wesley Dow in his studio, ca. 1900
1 photographic print on board: sepia; 27 x 36 cm.
Arthur Wesley Dow papers, circa 1826-1978
Archives of American Art, Smithsonian Institution

Late in his career, Dow could compare himself with many of the leading New York artists in the early 20th century. Childe Hassam and Willard L. Metcalf were both American landscape artists who held similar backgrounds to Dow and aggressively exhibiting in New York. Occasionally exhibiting alongside them, Dow rarely received one-man shows, and they did not demand similar prices for his work (Moffatt, 1972).

Dow the Teacher

Dow began teaching just after graduating from high school. This stint started before beginning a serious course of art training, Dow was thus able to reflect on the process of teaching art. Experiencing the practical implications in a one-room ungraded classroom, Dow taught two terms before enrolling in a local art education track. As an art student, Dow continued to teach during the summers. The teaching opportunities ended as a student in France but resumed after his tenure overseas.

Dow experienced early success as a painter and took part in a number of exhibitions upon his return to America. Despite this schedule, he founded the Ipswich Art School (later called the Ipswich Summer School of Art) in Ipswich, Massachusetts. Ipswich is also the location where Dow set up his studio. Both the roles of artist and teacher converged in Ipswich, as each developed over time. The early exposure to teaching most likely eased this transition to holding a dual role as an artist-teacher. Mock-Morgan (1976) emphasizes the struggle Dow encountered with the two roles. He considered the choice of becoming one or the other—either becoming a landscape painter or an art educator. Because of his disillusionment, he continued on his own self-education. This period of study thus informed his eventual teaching methods as well as his artwork. Teaching himself the art of the Egyptians, the design likely fascinated Dow, as he continued to thirst for more information. The decision to forgo realistic imagery for stylized figures and abstract imagery was quite different from the academic methods he embraced. This study did not vanish and eventually surfaced in Dow's classroom and his textbook *Composition* (Dow, 1920; Mock-Morgan, 1976). Teaching oneself is a powerful learning device and Dow's subsequent studies of Aztec art and American Indian design contributed toward his own understanding of abstract imagery and his teaching regarding the elements and principles of design. The quality of line and the combination of various lines and movements impressed Dow that he felt they could be captured in art and design.

Dow used words such as "experiment" when using many of his methods for the first time in the classroom (Mock-Morgan, 1976). A type of empirical research, Dow played with the various aspects of his study in the classroom to justify their inclusion. Handicrafts were used in Dow's classes to explore principles applied to the decorative arts (Meyer, 1999). Lecturing on his progress in Boston and the subsequent publication of *Composition* (Dow 1899) in 1899 opened up an opportunity for him to teach at Pratt Institute and offer his theories on a larger stage. It was a position Dow appreciated,

because it offered him a chance to work with students who would then disseminate his theories on art education across the country as they continued to teach. Dow continued at Pratt from 1895 to 1904 (along with teaching at the Arts Students League), during which his theories were accepted and esteemed in art and art education circles.

Dow eventually left his teaching post at Pratt and accepted an invitation to direct the Department of Fine and Industrial Arts at Teachers College, Columbia University in New York City. There were few art education programs in the United States at the beginning of the 20th century, and the program at Teachers College was quite different from traditional art academies (such as the Art Students League). The program offered both art education and fine arts courses, which was unusual. Dow taught his philosophy of art education and hired many new staff members that were sympathetic towards his ideas during his first two years (beginning in 1904) and retained many of his instructors from his school in Massachusetts in addition to retaining several graduates from Teachers College.

The field of art education during Dow's tenure as a professor was primarily industrial art education adopted from the former Schools of Design in England. Dow's concepts were thus a transition to many who embraced these ideas in modern abstraction. Dow's influence from his textbook, the absence of a coherent art educational philosophy for school children, his positions at Pratt and Teachers College, Columbia University, and the many students he taught helped to solidify his influence of change on the art education landscape in the United States (Mock-Morgan, 1985).

The American Artist-Teacher

Dow is remembered for his significant contribution to the field of art and design with the 1899 textbook *Composition: A Series of Exercises Selected from a New System of Art Education*. A development and advancement of the elements and principles of design, Dow mentored and educated hundreds of schoolteachers in New York, who then spread his philosophy of teaching across the United States. Significant students of Dow include Max Weber, Georgia O'Keeffe, and Alvin L. Coburn (Enyeart, 2001; Sokol, 2000). His teaching methods were a combination of advocacy and aesthetic education. Teaching his students to understand composition was important, yet the education of the whole person is emphasized in his writing (Dow, ca. 1826–1978).

> Fine art, by its very nature, implies fine relations. Art study is the attempt to perceive and to create fine relations of line, mass and color . . . Artistic skill cannot be given by dictation or acquired by reading. It does not come by merely learning to draw, by imitating nature, or by any process of storing the mind with facts. The power is within—the question is how to reach it and use it. (Dow 1899, 1926, p. 21)

Art training essentially involved a series of choices, and this thinking prepared students for modern life. Already confident in his approach to art education, Dow changed the nature of the program from a drawing and painting school to one that reflected his philosophy. "Painting is a space art. It is concerned with the breaking up of a space into parts which vary in shape, tone and color" (Dow, 1899, p.16). Placing equal emphasis on design and painting/drawing, the synthetic system was in place (Mock-Morgan, 1976). Achieving great success as the director of the Department of Fine and Industrial Arts, Dow witnessed the growth of the department.

Dow's organized teaching methods into two categories: the academic and the structural (ca. 1826–1978). The academic method of teaching, according to Dow, was in line with his own education. The student learns to draw in a scientific manner but

Student Works from the Courses of Arthur Wesley Dow
Opposition And Other Works
Artist: Unknown
1904 – 1922
Courtesy of Teachers College, Columbia University

proficiency and mastery of the subject matter is of primary importance before any expression can be explored. It is an analytic method that recognized the acquiring of skills and the gathering of knowledge. The structural method of teaching art, according to Dow (ca. 1826–1978), is concerned with developing the student's ability to build harmonies of shape, tone, and color. This was a return in Dow's reasoning to pre-academic days and is present in the arts of the East. In Dow's own words, "Self expression begins at once, involving all forms of drawing, and leading to appreciation. The process is creative and the standard is individual judgment as to fine relations" (Dow ca. 1826–1978:1).

A great example of Dow's teaching method is provided by Moffatt (1977, p. 82). A former student of Dow states:

> [Dow] would come into class and make an unbounded drawing of trees and hills, or perhaps a winding road against the sky. Then he would ask the class to copy the drawing freely and enclose it in a rectangle, to make a horizontal picture or a vertical, as they chose, and to make whatever changes necessary to fit the drawing to the frame which they had selected, to balance the drawing by making less foreground, or more sky, to change the masses and what not. He would then criticize the studies, emphasizing good design. Later the student would make similar studies in several colors, always giving first consideration to splendid organization and distribution of light and dark masses.

A lesson like this would most likely be followed by examples of good design. Critique, discussion, and analysis of objects, paintings, prints from a variety of cultures and forms would remind students of the universal principles imbedded in all art forms (Moffatt, 1977).

Leonardo da Vinci, despite being associated with early academies, was educated in the apprenticeship system during the 15th century. Dow (ca. 1826–1978) emphasized his education must have been structural enabling him to build harmonies of shape, tone, and color. Dow assumed this because Leonardo strove for quality, mystery, and power in his work. The study of the figure augmented rather than controlled his art practice. In this comparison Dow appears to admire and possibly see a bit of himself in the success of Leonardo overcoming his academic training. He saw Leonardo as a genius.

The role of design is emphasized in Dow's teaching and art making and draws parallels to the other artist-teachers highlighted in this text as they all attempt to create a system of learning for abstract imagery. Dow (ca. 1826–1978) laments the divide between decorative and representational art. Reclaiming decorative art as space-art, he writes:

> The elements of space-art art shape, tone and color, the whole visible world being revealed in these terms. Education in space-art follows the

analogy of music, and literature – beginning with structures of a simple order – a few lines, a few sounds, a few words – and proceeding onward by steady growth. Rhythm, subordination, symmetry, proportion, tone-values, color-schemes are fundamental to all the arts, at least by analogy. From this point of view Design instead of being classed as "decoration" is seen to be the very primer of art. (Dow ca. 1826–1978:3)

Dow emphasizes self-expression with the skill acquisition serving as an aid to this effort. The power of space is the key because it is related to all forms of art, including architecture, sculpture, and painting. The relationship between line, color, and proportion when emphasized propels artists to new heights. A systematic grammar, Dow enacted a strong self-reliance and commitment to learning in both the disciplines of art making and teaching. Because of this highly developed understanding, he developed new ways for understanding visual form, first in his art and then he developed a method to teach it. He broke with an outdated mode of artistic creation and teaching.

* * *

The academic education combined with discoveries in Japanese art provided Dow with a unique educational experience. His zeal for learning is an important component to who he was as a person. These characteristic shine in his artwork and his teaching. The individual interests he pursued for years are systematically organized in his 1899 text *Composition: A Series of Exercises in Art Structure for the Use of Students and Teachers*. The text, printed more than twenty times before the year 1940, achieved high praise by many of his colleagues by encouraging students to find new and different ways to express themselves (Hook, 1985). Dow clearly thought about his art making and teaching in a similar fashion. The orderly system Dow created and taught was highly influential in both respects. Mock-Morgan (1976) estimates nearly all other systems of art education for the following twenty years were based upon Dow's theories. Capturing the spirit of reality through his stylized system of visual grammar, Dow laid the tracks for abstract thinking in art education for generations. Many of Dow's students moved West and became heavily involved in arts and crafts communities in schools and colleges (Meyer, 1999). Known affectionately as a great teacher, Dow's students often overshadowed his importance, yet his teaching would not be possible without his active studio inquiries. A studio life that brought together a diverse number of research interests (East and West) from the academic to the modern, he is considered one of the most creative art educators of the 20th century (Meyer, 1999). As an artist-teacher, it is clear his art making fueled the great theories about which he was able to teach and write.

References

Chisolm, L. (1963), *Fenollosa: The Far East and American Culture*, New Haven: Yale University Press.

Dewey, J. (1934), *Art as Experience*, New York: Penguin.

Dow, A. W. (ca. 1826–1978), "Writings on teaching art (1908–1912)," in Arthur Wesley Dow papers, Archives of American Art, Smithsonian Institution.

Dow, A. W. (1899), *Composition: A Series of Exercises Selected from a New System of Art Education*, New York: The Baker and Taylor Company.

Dow, A. W. (1920), *Composition: A Series of Exercises in Art Structure for the Use of Students and Teachers*, Garden City, New York: Doubleday.

Dow, A. W. (1926), *Composition: A Series of Exercises in Art Structure for the Use of Students and Teachers*, Garden City, New York: Doubleday.

Enyeart, J. L., (2001), *Harmony of Reflected Light: The Photographs of Arthur Wesley Dow*, Santa Fe: Museum of New Mexico Press.

Green, N. E. (1999), "Arthur Wesley Dow: his art and his influence," in *Arthur Wesley Dow (1857-1922): His Art and His Archives*, New York: Spanierman Gallery, pp. 8–37.

Hook, D. (1985), "The Fenollosa and Dow relationship and its value in art education," in *The History of Art Education: Proceedings from the Penn State Conference*, Reston: National Art Education Association, pp. 238–242.

Meyer, M. B. (1999), "Arthur Wesley Dow and his influence on arts and crafts," in *Arthur Wesley Dow (1857-1922): His Art and His Archives*, New York: Spanierman Gallery, pp. 45–76.

Mock-Morgan, M. E. (1976), "A historical study of the theories and methodology of Arthur Wesley Dow and their contribution to teacher training in art education," Ph.D. dissertation, College Park: University of Maryland.

Mock-Morgan, M. (1985), "The influence of Arthur Wesley Dow on art education," in *The History of Art Education: Proceedings from the Penn State Conference*, Reston: National Art Education Association, pp. 234–242.

Moffatt, F. C. (1972), "The life, art and times of Arthur Wesley Dow," Ph.D. dissertation, Chicago: The University of Chicago.

Moffatt, F. C. (1977), *Arthur Wesley Dow (1857–1922)*, Washington, DC: Smithsonian Institution Press.

Ollman, L. (2000), "Arthur Wesley Dow: Democratizing Art," *Art in America*, 88: 11, pp. 62–67.

Sokol, D. M. (2000), "Arthur Wesley Dow: His Art and His Influence" (book review), *Journal of American and Comparative Cultures*, 23: 1, pp. 111–112.

Watanabe, K., (1997), "The influence of ukiyo-e woodcuts on the prints of Arthur Wesley Dow," M.A. thesis, East Lansing: Michigan State University.

Bauhaus Basics

The Bauhaus brings to mind a plethora of images and ideas. The term is often associated with boxlike modern design. Whether it be the actual products or the school itself, it is difficult to separate this aesthetic from the name Bauhaus. Tom Wolfe (1981) in his humorous critique *From Bauhaus to Our House* laments the influence it had on American architecture, especially when American schools and homes started to resemble factories and warehouses. Despite the bare, impersonal, or abstract architecture (glass box) associated with the Bauhaus, quite a bit of theory in art education is associated with the foundation and subsequent influence it had on 20th-century teaching. Many prominent artists were associated with the school, including Walter Gropius, Johannes Itten, Ludwig Mies van der Rohe, László Moholy-Nagy, Josef Albers, Wassily Kandinsky, Oskar Schlemmer, Paul Klee, Marcel Breuer, among a host of additional teachers, lectures, and students. These individuals were then associated with a diverse number of fields, including architecture, silversmithing, graphic design/typography, printmaking, sculpture, and furniture design—to name a few. It was these artists and their practice in the arts and crafts who illustrate the teaching artistry that differentiated themselves from the academy and the traditional fashion of organizing curriculum. To better understand the relationship these artists have with the artist-teacher concept, art school founder Gropius (1883–1969) and the foundation's course instructor Johannes Itten (1888–1967) are highlighted to demonstrate an aspect of the varied philosophy of these artists-teachers that contributed toward a Bauhaus pedagogy.

Walter Gropius

Gropius built an internationally known movement and art school between the years 1919 and 1928. Essentially taking over two unknown art schools—Weimar School of Arts and Crafts and the Weimar Academy of Fine Arts—Gropius fashioned an innovative

curriculum that progressed beyond the life of the school (Hoffa, 1961). In a period of only fourteen years, Gropius made a lasting effect on art and design education. In this new academy, all media were regarded as acceptable. The institution is not synonymous with Gropius or Itten, because the school continued after the departure of both individuals before its ultimate closure by the Nazis in 1935. However, both are important and essential for understanding the foundation. Gropius felt the compulsion to return to his architectural practice in 1928 after a few ups and downs, including the entire faculty resigning in 1924 (including Gropius himself) because of the harassment and impeded growth caused by the traditionally minded population and government (Hoffa, 1961). The school rebounded with a move to a new location (Dessau) in 1925 with most of the faculty and Gropius intact. The school moved to Berlin in 1933 (long after Gropius's departure) with Miles van der Rohe as director because of additional political trouble before closing its doors forever.

The Bauhaus building in Dessau was designed by Gropius and built in 1925/26. The building itself can be viewed as an example of the Bauhaus education. Divided into three different wings, it represents the educational focus of the school. The workshops, studio spaces, and the north wing all have particular spaces yet connect to one another. "There is no central view of the Bauhaus, but, for that, there are a number of entrances, which emphasize the building's various functions" (Baumann, 2007, p. 21). Even the word "Bauhaus" is a conceptually rich, which means to build or building a home or dwelling place. For Gropius, it was a house of architecture, one which he saw all arts integrated under the mother art (architecture; Moynihan, 1980).

As the founder of the Bauhaus and its longtime leader, Gropius wrestled with his own training as a student of architecture. He felt that the education offered at technical schools was not appropriate for the changing face of technology, so he reflected on art educational methods to reinvent design education (Wick, 2000). His recommendations called for cooperation between the artist and technician to progress beyond the stylistic and unrelated form of industrial products (Gropius, 1948, 1963a). These thoughts originate from his own understanding of education but also his architectural practice. In prefacing his text regarding the new architecture and the Bauhaus, he addresses the concepts from an analysis of his own work (Gropius, 1965). Recounting his own personal (artistic) development, he aims to educate the reader, stating "... the New Architecture is a bridge uniting opposite poles of thought, to relegate it to a single circumscribed province of design" (Gropius, 1965, p. 23). This was a personal perspective and an explanation of the benefits of New Architecture. Rather then borrow styles from the past, Gropius addresses new problems with the advent of technology. He felt the architect was more than a builder who focuses on methods but rather a master of space. Gropius (1965) speaks like an artist, as his design longs to satisfy the aesthetic in human soul. And this is all possible with the new technological resources (steel, concrete, glass) available to the architect in the early 20th century. Without the structural limitations, Gropius's vision

for architecture resulted in transparent/open/better lit spaces, a reduction in cost, larger windows, and flat rooftops, among a host of other innovations (Gropius, 1965).

The metaphor of a bridge is apt for understanding Gropius as an artist-teacher (Gropius, 1965, p. 23). Collaboration was an important aspect of Gropius's writings (Moynihan, 1980), the language implying the connection or combination of traditions and disciplines not associated with one another is called upon to explain his theories. This artistic philosophy of connecting traditions, disciplines and theories mirrors Gropius's educational philosophies embedded within the Bauhaus school. Bringing together a diverse faculty or combining artistic techniques—imaginative design with technical proficiency—are examples of Gropius's attempt to bridge distant enterprises in his laboratory/workshop (Gropius, 1965, p. 52). Gropius (1965, p. 51) writes, "The idea of a fundamental unity underlying all branches of design was my guiding inspiration in founding the original Bauhaus." This bridge also connects artistic experience within an educational context. Gropius's architectural experience and education greatly informed the foundation and continued management of the school.

> We can reach our aim only when arts, crafts and industries interpenetrate each other. Today they are widely separated from each other, so to speak, by walls. The crafts and also the industries need a fresh influx of artistic creativity in order to eliven the forms which have gone stale and to reshape them. But the artist still lacks the craft training which alone will safely enable him to shape materials into masterly form (Gropius, 1963b, p. 32).

The structure (of the Bauhaus) set in place by Gropius is important for those working in art education institutions today. The relevance of the Bauhaus is seen in almost every post-high-school art program in regard to theory and practice (Wasserman, 1969). In fact, some researchers feel the Bauhaus is the strongest influence on studio art education in the United States (Phelan, 1981). A recognized architect himself, Gropius studied in Germany and held a private practice, designing the facades for the Fagus Factory in 1911 and a model factory for the Werbund Exhibition in 1914.

Gropius's establishment of the Bauhaus, with its program of education in art conceived uniquely for the contemporary scene, was the direct outgrowth of his sensitivity to the potentialities and the problems inherent in the relationship of the arts to industrial economy (Hoffa, 1961). This sensitivity is the type of artistic quality present in designing buildings as well as curriculum. He noticed a problem, "a breach," with the past that needed to be connected (Gropius, 1965, p. 19). He felt architecture with the advent of new technologies was in a position to mend this divide. This was a new civilization breaking from the old traditions that required New Architecture. Similarly, the invention and construction of a built environment is the product Gropius created when establishing the Bauhaus. This falls in line with a basic understanding of an architect who designs systems

to meet the needs of peoples. The new solutions of the Bauhaus were designed for the new problems of the postacademy world (old traditions). Gropius's artistic perspective both personally and in relation to his surroundings was ultimately a reaction to create a new education for a new problem. Phelan (1981, p. 7) writes, "However, the Bauhaus was founded and developed its methodology over the years in response to the needs of modern art, and its offspring, modern design, which differ greatly from that tradition of Western art which evolved from the Renaissance." The problems Gropius encountered in his own education and with the advent of new technology were essentially pragmatic. He wanted an art education that would work for practical reasons—something the art of architecture is keen to address. The aesthetic of boxlike structures is practical, addressing all available space, as is the educational philosophy his school maintained. In this manner, Gropius and his views of art and education seem to intersect.

Wick (2000, p. 11) writes ". . .the phrase 'Bauhaus pedagogy' is too richly faceted-and the pedagogical practices of the artist-instructors active at the Bauhaus too varied-for it to make sense to search out the educational theory. . ." Wick's estimation of simplifying a complex system is akin to reducing the multiple philosophies of the Bauhaus to a single overarching theory that is ill suited to explain the differences of each teacher. This is precisely why the teaching methods of artist-teachers are as diverse as their artistic practices. The Bauhaus is a particular example of an institution holding a great number of artist-teachers practicing at a high level.

As the first director and the intellectual leader, Gropius's experiences informed the school arguably more than any other individual. His own educational background witnessed a divide between the encyclopedic information learned compared to the practical expectations from the field (Wick, 2000). Gropius's own studies of medieval masons' lodges had an effect as well (Wick, 2000). This was not just a return to handicraft but an emphasis on aesthetic education in a new manifestation of these lodges.

This designed educational system encompassed the great number of artists mentioned earlier. These artists and craftsman were not followers but collaborators with independent ideas who worked toward a common cause. Hoffa (1961) categorizes the recruits into two categories: artists of unchallenged creativity and skilled craftsman who were used to break down barriers and hierarchies within the arts. Collectively, they represent the Bauhaus.

> I saw that an architect cannot hope to realize his ideas unless he can influence the industry of his country sufficiently for a new school of design to arise... I saw too, that to make this possible would require a whole staff of collaborators and assistants: men who would work, not automatically as an orchestra obeys its conductor's baton, but independently, although in close cooperation, to further a common cause (Gropius, 1965, pp. 48-51).

The Bauhaus Curriculum

Elkins (2001) explains the innovative curriculum as a three-stage process that started with a preparatory class followed by specialization in an area of choice and eventually finished with assistant work to round out the curriculum. A screening process (enacted by faculty members) further separated each stage of the curriculum to ensure quality control and satisfactory completion of the objectives (Hoffa, 1961). The preparatory class lasted roughly six months and was divided into three topics, including two- and three-dimensional instruction for the senses, emotions, and mind. The specialization chosen by the student was then studied for three additional years. During this time, students choose to study under two masters as apprentices, a slight departure from the academic tradition. The final phase of the curriculum was when the student obtained a journeyman's certificate and worked as an assistant, such as at a local design company. The course is referenced by Macdonald (1970, p. 315) as "the most purposeful ever practiced in art education, planned to foster creativity, analysis and appreciation of art craftsmanship, and technology in order to produce the artist/craftsman/industrial designer." Gropius (1965, p. 78) comments that his students' "intellectual education proceeded hand in hand with their practical training."

Three Stages of the Bauhaus Curriculum

Basic Course/preparatory instruction
Six months
Elementary training in design and experiments with materials

Technical instruction
Instruction in a training workshop (stone, wood, metal, clay, glass,
color, or textiles)
Advanced study of nature, study of materials, space study,
color study, composition, study, study of materials and tools,
study of construction, and representation
Culminates with a journeyman's certificate from a trade council
and certificate of completion from Bauhaus

Structural instruction
Work–study arrangement with a local trade group
Culminates with master diploma

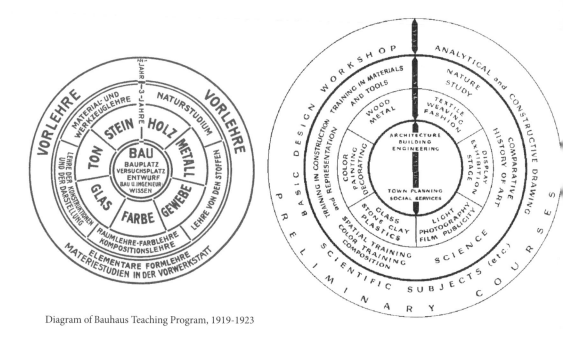

Diagram of Bauhaus Teaching Program, 1919-1923

... [T]he Bauhaus developed its methodology, which is closely related to the modern scientific method which is then applied to teaching the fundamentals of art making. However, what should not be overlooked is that this approach grew out of the needs of modern art itself. Traditional art training taught the artist how to make a work of art. The Bauhaus examined what was in it. Thus, the material of art-making was approached in a highly analytical fashion. (Phelan, 1981, p. 7)

The varied philosophies of education and approaches practiced by the diverse faculty of the Bauhaus contributed to the complex pedagogical goals of Gropius's school. Breaking the traditional barriers of art education, students were expected to attain a deep understanding of materials and processes. Without a hierarchical system, students could explore a number of correct answers or processes to solve artistic issues. This diverse system supported individuality and a different understanding of an art product. In these cases, the finished product must be a solution that worked. This is a pragmatic philosophy, akin to the original director's artistic practices as an architect. The great number of artist-teachers—including Johannes Itten, Josef Albers, Wassily Kandinsky, Paul Klee—did not necessarily agree with one another or with Gropius (Wick, 2000).

The teaching philosophies of the artist-teachers differed as much as their artwork. This is why separate monographs were published to explore the teaching methods of

the various instructors who worked within the Bauhaus (Goldstein, 1996). Itten, Albers, Kandinsky, and Klee are all noted figures in modern art history with independent personalities. However, the concept of the artist-teacher applies to each, especially because scholarship regarding their art-making practice is best understood through their teaching (Goldstein, 1996). Looking at lecture notes and classroom assignments allows historians to understand the thinking process of each these artist-teachers associated with the Bauhaus and how they constructed their theories: bringing the artist into the classroom, yet deciphering the teaching to understand the art.

Utopian Education

Wick (2000) emphasizes the ideal Gropius strived to realize. This goal was to be reached via aesthetic education. This was the starting point and would eventually revitalize society—from education to industry. Gropius touches upon this goal in a speech to students during a Bauhaus exhibition stating, "The coming years will show that for us artists the crafts will be our salvation" (Wick, 2000, p. 74). Wick (2000) credits Friedrich Nietzsche for pushing toward the new style he thought would adequately express the progression of modern life.

Johannes Itten

Itten could be seen as the unofficial early director of the school. He differed with Gropius on particular goals, but it was his basic or preliminary course upon which much understanding of the Bauhaus is based (Wick, 2000). Moholy-Nagy and Albers later refined the foundational course (Hoffa, 1961). However, as the first director of the preliminary course, his ideas had a lasting effect on the institution and its legacy. Itten's course essentially hoped to liberate students from convention, opening up their creative forces, to aid students' understanding of materials and career, and to expose students to the principles of composition—color and form—that would enable them to achieve success as artists (Wick, 2000). Itten "considered it essential, in teaching the means of artistic representation, to evoke an individual response in students of various temperaments and talents. This was the only way to generate the creative atmosphere conductive to original work" (Wick, 2000, p. 102). Although there was no official teaching plan, the curriculum morphed through the years. At the very beginning in 1919, the drawing and designing of ornaments and the exercises that usually accompanied them were part of Itten's preliminary course (exercises from Wallis's time) and were eventually dropped from the course of study as the school moved more toward unadorned functionalism (Wick, 2000).

Figural Composition, 1918
Johannes Itten
Lithograph on Heavy Woven Paper
Los Angeles County Museum of Art,
The Robert Gore Rifkind Center for
German Expressionist Studies
Photograph ©2009 Museum Associates/LACMA
M.82.288.101

Experience as an artist and teacher were important aspects regarding the maturity of Itten's curriculum. By the time Itten joined Gropius at the Bauhaus in 1919, he had already taught at the elementary level and had opened his own art school (Itten, 1963). Formulating a strong perspective on art education, his philosophies of art making infused his teaching practices.

Itten claims the foundation of design teaching was imbedded within contrasts (Itten, 1963). The theory was applied to studying light and dark, materials and texture studies, form and color theory, rhythm, and expressive forms (Itten, 1963). In studying each of these elements, they could be approached through the contrasting effects. Thus, to study texture, one could understand it by applying categories such as hard versus soft or smooth versus rough. These elements were to be seen and felt. Students were expected to know them and to experience them. The sensuous aspect of knowing is repeated and highlighted by Itten. This type of experience took the form of touching materials to understand textures. These deceptively simple exercises opened up entire worlds for students as they explored the extraordinary all around them. Famously, Itten instructed his students to taste a lemon before drawing a still life containing lemons (Itten, 1963). This deep way of knowing infused the art making and educational process.

Responsible for the creativity of his students, Itten held this position very dear. The imitative curriculum of the academy was impersonal. Beholding an intuitive knowledge was essential to recognize and facilitate the natural abilities of students (Itten, 1963).

> In music, the theory of composition has long been an important and accepted part of professional education. However, a musician may know counterpoint and still be a dull composer, if he lacks insight and inspiration. Just so, a painter may know all the resources of composition and color, yet remain sterile if inspiration be denied him. (Birren, 1970, p. 7)

This philosophy takes a page from Franz Cizek, the Austrian educator who is sometimes called "the father of creative art teaching," who allowed children to discover creative capabilities through a taking-the-lid-off approach (Anderson, 1969, p. 29; Smith, 1985). This philosophy informed Itten's proposal to Gropius to allow all students into the basic course who had an interest in art. In this course, Itten felt he could awaken sleeping talent (Itten, 1963). Knowledge of laws and principles were important to Itten; he felt they should not "imprison" but rather "liberate" students from indecision (Birren, 1970). Gropius granted this request and the basic course began. The refining/screening process would then narrow the progression of students. In addition, Itten held a student-centered philosophy, in which he appreciated the different temperaments and talents of his students (Itten, 1963), and believed in treating each child as an individual with different rates of growth and understanding. This philosophy draws a parallel with the progressive student-centered New York City artist-teachers referenced by Efland (1990) in his history of art education. Appealing to the student's creativity, the student is to find his or her profession and should be attracted to different types of design. Itten's skill arises as a facilitator who recognizes these talents/interests; he states, "I accomplish the unlocking of individual power through a definite way of teaching the means of design" (Itten, 1963, p. 10). Itten hoped to not hinder the native unconsciousness of the student. He never corrected mistakes, because he felt the teacher's correction to be inappropriate invasion into the development of the child (Wick, 2000).

Preliminary Course

In Itten's words, the three objectives of this preliminary course included (Itten 1963, p. 9):

> To free the creative powers and thereby the art talents of the students
> To make the students' choice of career easier
> To convey to the students the fundamental principles of design for their future careers

Itten stressed the importance of creativity in his teaching. "First, imagination and creative ability must be freed and strengthened. When this is accomplished, technical-practical requirements can be brought in and finally economic considerations of the market" (Itten, 1963, p. 10). The facilitation of creativity is often thought to include a teacher letting a student explore any art material the student desires and helping those students who have questions. The room has very few rules and a lot of chaos as students pursue a variety of different directions. Itten's statement demonstrates the difference between the "do whatever you like" philosophy and one that is calculated carefully. Creativity and experimentation were valued but solving a problem and contributing toward a goal were the end results of such a curriculum. This is something to keep in mind when looking at Itten's educational philosophy and his artwork.

Itten's classes customarily started with exercises designed to relax the mind and body before beginning the work of an artist, such as breathing, relaxing, and concentration exercises. This approach was unique to his foundational course. The role of Eastern philosophy figured into Itten's life and teaching when he started studying Persian Mazdaism and Early Christianity. These religious experiences were then incorporated into his teaching exercises. Kaneko (2003) explores the depths of Itten's fascination with Asian thought. Studying Sumi-e, a painting process using sumi ink and brush techniques, Itten devoted a great amount of interest in the East. This research manifested in Itten's course as spiritual preparation or creative practice (Kaneko, 2003). It seems that the spiritual essence, however, was of particular importance:

> It is not only a religious custom to start instruction with a prayer or a song, but it also serves to concentrate the students' wandering thoughts. At the start of the morning I brought my classes to mental and physical readiness for intensive work through relaxing, breathing, and concentration exercises. The training of the body as an instrument of the mind is of the greatest importance for creative man. (Itten, 1963, p. 11)

Itten prepared his students for classes by encouraging them to move their hands, arms, and legs around in space similar to stretching exercises. Paying attention to the movements of the body, Itten practiced the type of exercises one completes in an actors workshop. This type of exercise may seem silly to some (including Paul Klee), and many were resistant at first, but in the end it prepares one to physically realize concepts. Exercises were followed by activities like Sumi-e, or black ink painting where simplicity is the most outstanding characteristic. The practice of Sumi-e with its economy of brush strokes was thought to enhance spirituality, concentration, and sensitivity—something Itten hoped to facilitate (Kaneko, 2003).

Differentiating the roles Itten played is difficult, as each interest or activity connects to his roles as an artist-teacher. His teaching and art making were closely related. In *Design*

and Form, Itten (1963) explains how his diary served as a medium for exploring color and form. This was not just an investigation as an artist but an investigation of artist-teacher because these results informed both practices, which he duly acknowledges (Itten, 1963).

Wick (2000) believes the legendary status the preliminary course at the Bauhaus achieved is the result of Itten and his memorable personality. Similar courses existed at other arts and crafts schools, but Itten's background as a modern artist and progressive teacher combined to produce an unforgettable experience.

Artist-Teachers Within the Bauhaus

Examining Gropius and Itten as artist-teachers allows us to understand their relationship between their art practices and their educational roles differently. Gropius serves as a planner and Itten as a practitioner. Their artistic strengths as architect and painter feed these roles and are part of the success each had in their respective positions. "Therefore, the Bauhaus, while placing a traditionally high value on the idea of craftsmanship, shifted the focus on aesthetic development and art teaching to the solving of aesthetic problems. This paralleled developments in the art world" (Phelan, 1981, p. 7).

The framework of the school encompassed an attempt to remove the walls between art, architecture, craft, and design as well as the distinctions between art and art education through Gropius's curriculum (Macdonald, 1970). Gropius articulates how he hoped to liberate students from narrowly defined roles and instill creativity back into design in this statement: "Architects, sculptors, painters, we must all return to the crafts! For art is not a 'profession,' there is no essential difference between the artist and the craftsman. The artist is the exalted craftsman" (Goldstein, 1996, p. 261). These various theories of art and education eventually migrated to the United States as members of the Bauhaus accepted positions in American universities, such as Harvard University (Walter Gropius, Marcel Breuer, Siegfried Giedion), Yale University (Joseph Albers), the Illinois Institute of Technology (Miles van der Rohe), the Massachusetts Institute of Technology (Gyorgy Kepes), and Black Mountain College (Joseph Albers). It was through Josef and Anni Albers, however, that the link between the Bauhaus and university education is modeled.

Josef and Anni Albers

Josef and Anni Alber were significant artist-teachers teaching at both the Bauhaus and later the experimental Black Mountain College in North Carolina. Their story serves as a transition—as modern art education crosses the Atlantic to the United States. Both started as students in the Bauhaus before eventually marrying and teaching there. Progressing

through the educational objectives of the Bauhaus, they were well versed in the various philosophies. Josef and Anni adjusted from the student to teacher role very quickly. The legacy of the Bauhaus survives through the Albers, as they remained with school until its closing (Moynihan, 1980). This process repeats itself, as many of their students at the Bauhaus and later Black Mountain College and Yale University continued to work at schools across the United States, furthering the notions expressed in the Bauhaus.

Anni worked within the weaving workshop after receiving her education at the Bauhaus. Considered one of the greatest artists to work with fibers, she is a manifestation of Gropius's vision of the arts and crafts uniting (and Itten's law of contrasts). Honored with a show at the Museum of Modern Art in 1949, Anni's oeuvre includes many textiles, both practical and artistic. Designing tablecloths, wall hangings, and upholstery—to name a few—these items often held a strong geometric pattern and were often constructed with traditional and industrial materials. Later taking up printmaking, her modern education and experimental nature led her to create and philosophize on acceptable art-making traditions. Anni's (2000) process as an artist-teacher comes alive in her writing:

> The crafts, understood as conventions of treating material, introduce another factor: traditions of operation which embody set laws. This may be helpful in one direction, as a frame for work. But these rules may also evoke a challenge. They are revocable, for they are set by man. They may provoke us to test ourselves against them. But always they provide a discipline which balances the hubris of creative ecstasy. (Albers, 2000, p. 8)

As a teacher, Anni felt the useful/practical and the artistic must be considered (Albers 2000). Emphasizing the principles of weaving combined with industrial processes, she was a product of her education. Her embrace of traditional textiles produced on a loom was counteracted with an emphasis on mechanized weaving (Goldstein, 1996). When the Bauhaus closed in Germany, Josef and Anni Albers were recruited to teach at Black Mountain College in North Carolina, joining the ranks of an incredibly rich group of artist-teachers.

Black Mountain College was a newly formed experimental liberal arts school. Located in the Blue Ridge Mountains of North Carolina, the opening serendipitously coincided with the closing of the Bauhaus in Germany. John Andrew Rice, a maverick educator, recently resigned from Rollins College, founded the school with a group of like-minded colleagues (Horowitz and Danilowitz, 2006). A student of Dewey, Rice felt the arts should be the central aspect of the curriculum. The college was owned and operated by the faculty, who choose to teach what and however they liked. A college without grades, attendance regulations, or exams, it was similar to the Bauhaus because of its embrace of the experimentation. An experiment in education, the college combined many events in music, visual art, and drama (Macdonald, 1970).

At the Bauhaus, Josef Albers eventually took over the preliminary course from Itten and taught from 1923 to 1933. Reflective on his own education, a "creative vacuum" was part of his journey, as Josef found his own way through the school (Horowitz & Danilowitz, 2006, p. 18) and was best known for his obsession with color and materials in his art making and teaching. The series "Homage to the Square" is a direct representation of Josef's interest in color applied to the grid system. At Black Mountain, Josef taught a basic course in design, color, and painting. He ultimately saw his position as one of opening eyes, and the exercises he had students practice were often ideas he was exploring in his own work (Horowitz & Danilowitz, 2006). Never teaching the same subject matter twice, Josef was constantly looking for inspiration. Noticing what happens when two elements are placed next to one another is the type of relationships he valued, with an awareness of how color and formal relationships changed and transformed single elements into poetry. "At Black Mountain and Yale, Albers would frequently refer to the discrepancy between what he called 'physical facts'- the way lines, shapes, and colors existed physically- and 'actual facts'. . . the way these forms were perceived" (Horowitz & Danilowitz, 2006, p. 89). In both his art making and his teaching practices, art became more than materials. Warm colors could become cool and space could be developed with two-dimensional items. In this manner, the physical became psychic.

Not long after Josef Albers' arrival in the North Carolina, he began to receive teaching and lecturing invitations. Advocating the role of creative education, he found himself to be quite influential in the field of art education (Albers, 1963). His role of the artist within the college and university setting along with a growing interest in art education began to arise (Horowitz & Danilowitz, 2006). Albers' curriculum at Black Mountain was a progression of his ideas and experiences at the Bauhaus. Albers' eventual move to Yale University illustrates the continued change in art education. Upon his arrival midcentury, the school dropped "fine" from the school's name, and the painting and sculpture schools were renamed Department of Design (Horowitz & Danilowitz, 2006).

The artist-teachers of the Bauhaus begin with the initial effect of Gropius's bridge design and the foundational course developed by Itten. The legacy of Albers and his effects in the United States is an example of the artist-teachers' influential visual thinking processes brought into the classroom. From the Bauhaus to your house, the art educational theories still play a role in art education at all levels. Eventually criticized for creating a conceptually cooler and hard edge aesthetic, graduates eventually replicated the teaching methods without the initial zeal of the originators. A continuation of the Bauhaus was often talked about after its demise. Founding a Bauhaus School in France was an option but nothing significant developed. Instead, the philosophies survived through the teaching of many individuals working at schools and colleges around the world.

References

Albers, A. (2000), *Selected Writings on Design*, Middleton: Wesleyan University Press.

Albers, J. (1963), *Interaction of Color*, New Haven: Yale University Press.

Anderson, J. P. (1969), "Franz Cizek: Art Education's Man for All Seasons," *Art Education*, 22: 7, pp. 27–30.

Baumann, K. (2007), *Bauhaus Dessau: Architecture Design Concept*, Berlin: Jovis Publishers.

Birren, F., ed. (1970), *The Elements of Color: A Treatise on the Color System of Johannes Itten*, New York: Van Nostrand Reinhold Company.

Efland, A. (1990), *A History of Art Education: Intellectual and Social Currents in Teaching the Visual Arts*, New York: Teachers College Press.

Elkins, J. (2001), *Why Art Cannot be Taught*, Chicago: University of Illinois Press.

Goldstein, C. (1996), *Teaching Art: Academies and Schools from Vasari to Albers*, Cambridge: Cambridge University Press.

Gropius, W. (1948). Teaching the arts of design. *College Art Journal*, 7(3), 160-164.

Gropius, W. (1963a). The Bauhaus contribution. *Journal of Architectural Education (1947-1974)*,1888(1), 14-15.

Gropius, W. (1963b). The Bauhaus: Crafts or industry? *Journal of Architectural Education (1947-1974)*, 18(2), 31-32.

Gropius, W. (1965), *The New Architecture and the Bauhaus*, Cambridge: MIT Press.

Hoffa, H. (1961), "Walter Gropius Innovator," *Art Education*, 14: 1, pp. 12–28.

Horowitz, F. A. & Danilowitz, B. (2006), *Josef Albers: To Open Eyes: The Bauhaus, Black Mountain College, and Yale*, London: Phaidon Press.

Itten, J. (1963), *Design and Form: The Basic Course at the Bauhaus*, New York: Reinhold Publishing.

Kaneko, Y. (2003), "Japanese Painting and Johannes Itten's Art Education," *Journal of Aesthetic Education*, 37: 4, pp. 93–101.

Macdonald, S. (1970), *The History and Philosophy of Art Education*, London: University of London Press.

Moynihan, J. P. (1980), "The influence of the Bauhaus on art and art education in the United States," Ph.D. dissertation, Evanston: Northwestern University.

Phelan, A. (1981), "The Bauhaus and Studio Art Education," *Art Education*, 34: 5, pp. 6–13.

Smith, P. (1985), "Franz Cizek: The patriarch," *Art Education*, 38: 2, pp. 28–31.

Wasserman, B. (1969), "Bauhaus 50," *Art Education*, 22: 9, pp. 17–21.

Wick, R. K., ed. (2000), *Teaching at the Bauhaus*, Ostilfern: Hatje Cantz Verlag.

Wolfe, T. (1981), *From Bauhaus to Our House*, New York: Farrar, Straus and Giroux.

Hans Hofmann

Hans Hofmann (1880–1966) is widely recognized as an important contributor to the midcentury movement of abstract expressionism. This unique American movement, often referred to as the New York School, featured artists Jackson Pollock, Willem de Kooning, Mark Rothko, and Franz Kline, among others. Although stylistically the individuals involved differed from one another, the movement derived its name from the emotional intensity associated with the imagery (Daichendt, 2008). Achieving international success as a painter by the late 1940s and 1950s, Hofmann exhibited around the world with the advent of his popularity as an artist. Despite critical success as a painter, he is often remembered as a great mentor and teacher. Although many abstract expressionist artist taught to some degree, Hofmann's commitment to teaching stands apart. His development and practice of bringing art-making and artistic experience directly into the classroom is a distinct signifier of his role as an artist-teacher.

Hofmann's involvement in the arts started as a young man in Germany, studying and following early art movements such as Secessionism (a development of Impressionism), Neo-Secessionism, and Cubism (Sutherland, 1989). Working through these early modern art movements and philosophies himself, Hofmann discovered his own perspective and modern language. This progression, most likely full of frustrations and breakthroughs is the experience he could use for opening new vistas for aspiring artists seeking to understand the modern language of the abstract artist. Making a breakthrough allows one to make great art; reflecting upon it and articulating the discovery to students makes for great teaching. Embracing both is difficult enough; combining and reorganizing enterprises where they become indistinguishable is a creative act worth celebrating and modeling.

A contemporary of Matisse and Picasso, Hofmann did not hit his stride as an artist until much later in life. A full generation older than the other Abstract Expressionists, such as de Kooning or Pollock, he does not always fit nicely into the art historical category (Wilkin, 2003), but rather he builds from Matisse and Picasso, as his flattening of space and

experimental abstraction offer successes and failures. Of all the philosophies Hofmann encountered during his early years, Cubism appears to be the major force for seeing the world in new way. The application of abstraction to the real world is a language Hofmann developed through his entire life. Applying this to teaching becomes special. The experience he gained from the European avant-garde was carried forward to the classroom as theories like Cubism allowed Hofmann to abstract the real world, pushing his art making and teaching to new heights. As an idea was developed in his studio, students solved similar problems and acted as a laboratory, which Hofmann reapplied to his own paintings.

As an artist-teacher, engagement with the art world is essential. Contemporary artist-teachers read art journals, visit museums and galleries, and converse with others involved in creative enterprises. As a young painter, Hofmann engaged a number of influential artists in cafes, schools, and galleries, including Picasso, Braque, Léger, and Matisse (Sutherland, 1989). These experiences were important, as they allowed the young Hofmann to see and experience the life of an artist, something he later modeled for his own students. Without an engagement with the larger art field, it is difficult to speak a language of relevance.

Despite Hofmann's success as a painter, his role as a teacher sometimes out shined his artistic contributions. Teaching opportunities in California and New York drew him away from Germany. The first of many opportunities opened in the summer of 1930 to teach at the University of California, Berkeley, at the Chouinard School of Art in Los Angeles in 1931, and then again at Berkeley. In 1932 he accepted an invitation to join the Art Students League in New York City. By teaching in a number of institutions across the United States and Europe, Hofmann's educational philosophy was developed by his artistic practices. A teacher of artists, many students sought his guidance to learn the modern language he offered. Notable artists who studied with Hofmann include Burgoyne Diller, Ray Eames, Helen Frankenthaler, Red Grooms, Lee Krasner, Frank Stella, and Louise Nevelson. Although it is not prerequisite of an artist-teacher to train artists, the type of student attracted to Hofmann's philosophy speaks to his pedagogy of leading folks to a practical modern language for artists. It was not long before Hofmann opened his own school of art in New York City in 1933, appropriately named The Hans Hofmann School of Fine Arts, located at 444 Madison Avenue. (After several relocations, Hofmann's school settled in Greenwich Village, at 52 West 8th Street.) Simultaneously facilitating creativity and discipline, Hofmann's classroom served as an area of investigation for teacher and student alike.

As a European in the United States, Hofmann brought a modern aesthetic quite different from the traditional American art academy. The academic style or influence was passé to Hofmann. Instead, he desired freedom in his art and teaching. Newbury (1979) interpreted this unique perspective as instructing rather than training or directing students. Modern life and thought advanced beyond the Renaissance techniques of perspective, and Hofmann sought new rules for the modern language. This language included developing and exploring spatial tensions, plasticity of the two-dimensional canvas, and using color as an expressive agent (Sutherland, 1989). This development consumed Hofmann's thinking

process. This is evident because his artistic growth benefited the development of his teaching philosophy. Working through many of the early modern movements and styles, Hofmann drew upon a wealth of art-making experiences that he brought into the classroom.

Hofmann the Artist

Hoffman's art, although abstract, was rooted in the real world. His compositions progressed over his lifetime from a postimpressionistic style to the semiabstract and the geometric abstract planes associated with his later work. He was born a year before Picasso and lived a decade longer than Jackson Pollock, an illustration to demonstrate the many art movements he lived through (Flam, 1990). Still life work from the 1930s is the best representation for displaying a cross section between the real object and abstracted shapes and colors. Combining geometric shapes derived from actual objects with bold hues, Hofmann's canvases started to vibrate, as the juxtaposition of size became the focus in the 1940s. Shape, color, and plane are constant touchstones in describing Hofmann's aesthetic, as one attempts to engage the flat surface. Hofmann's oeuvre of painting demonstrates the importance of the natural world, yet his abstract compositions delineate from the real world with nods to the figurative and landscape painting traditions. For close to fifteen years Hofmann did not paint but instead drew constantly as he claimed to sweat Cubism out (Greenberg, 1961). It was in the mid 1930s that he began to paint again and in the 1940s when he finally committed himself to abstraction (Greenberg, 1961).

This progression in style is characteristic of Hofmann's insistence on the importance of simplification in abstraction. Despite simplifying the form, a reading and universal message could still be experienced. The canvas or picture plane was a two-dimensional surface requiring an alternative approach for engaging with nature. Hofmann speaks of art making like magic:

> The artist's technical problem is how to transform the material with which he works back into the sphere of the spirit. This two-way transformation proceeds from metaphysical perceptions, for metaphysics is the search for the essential nature of reality. And so artistic creation is the metamorphosis of the external physical aspects of a thing into a self-sustaining spiritual reality. Such is the magic act which takes place continuously in the development of a work of art. (Hofmann, 1967, p. 40)

Elements of line and hue reacted to one another in a mystical fashion. Depending upon their placement, the meaning and reaction occurs. The artist could develop sensitivity for these relationships but in Hofmann's case, cubism appears to play a major role in abandoning academic art education. As his philosophy progressed beyond formal

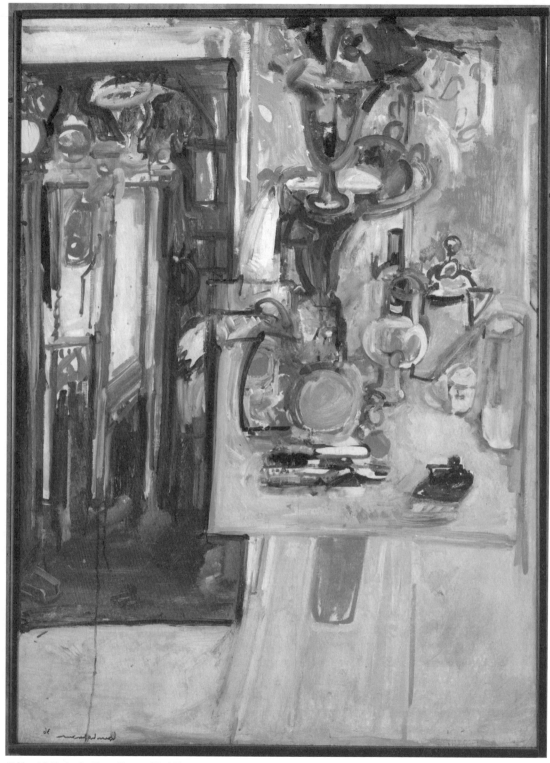

Table with Teakettle, Green Vase and Red Flowers, 1936
Hans Hofmann
Oil on Plywood
University of California, Berkeley Art Museum and Pacific Film Archive
Gift of Hans Hofmann

relationships, Hofmann used the formal element of line to create and isolate shapes. These forms began to represent expressions of rhythm and movement (Sutherland, 1989).

Hofmann (1967) stresses the importance of the plastic creation in his painting. Plasticity, according to Hofmann, is the transference of three-dimensional qualities and experiences to a two-dimensional surface. However, the plastic creation also involves expression. This two-dimensional plane must also communicate the real-world experiences in an emotive language. A combination of expression and space, Hofmann did not expect the theory to be learned quickly:

> The layman has extreme difficulty in understanding that plastic creation on a flat surface is possible without destroying this flat surface. But it is just this conceptual completeness of a plastic experience that warrants the preservation of the two dimensionality. (Hofmann, 1967, p.43)

Hofmann addresses space through poetry:

> Space and the Picture
> One cannot see space-
> one can only sense space-
> Since one cannot see space-
> one can also not copy space-
> and since one senses space only
> one must invent the pictorial space
> as the finale of a pictorial creation.
> Therefore one must be inventive in using
> the pictorial means:
> the Line, the planes, the points
> these are the architectural means
> with which to build up space as
> experienced-
> experienced by the senses
> and not only perceived by physical vision
> because vision and space experience
> together
> create a inner vision
> in the junction and by relation of a multiple physical
> experience
> with a psychic reaction

> (Hofmann, 2008)

Hofmann's theory is understood best in comparison to the traditional art methods advocated by the academy. To achieve depth on a two-dimensional surface, an academician would advocate the use of shadows through tonal gradation. By adding tints and shades to hues, one could represent dark to light. In comparison, Hofmann's depth was created on the two-dimensional plane, which did not mimic space. Hofmann states:

> My aim in painting as in art in general is to create pulsating, luminous and open surfaces that emanate a mystic light, determined exclusively through painterly development, and in accordance with my deepest insight into the experience of life and nature (Kuh, 1990, p. 128)

Although success came late, he was recognized as a painter of importance from critics and the art field (Greenberg, 19610. The first Hofmann retrospective was held in 1948 at the Addison Gallery of Art in New York City. At the age of 68, Hofmann was primarily known as a teacher, and through this exhibition many of his works were seen for the first time (Sutherland, 1989). However, it was not until the 1950s when Hofmann's strongest images representing his theories emerged.

Hofmann the Teacher

Hofmann began teaching in 1915 in Munich and ended his teaching career in New York in 1958. A constant feature of the curriculum was his knowledge of the modern art world and its permeation into the classroom. The art and artists who influenced Hofmann extended beyond his philosophies of art making. The gallery and museum exhibitions featuring outstanding examples of modern art were an extension and integral aspect of his pedagogy (Cho, 1993). Cho (1993) claims these students would visit exhibitions of Leger, Van Gogh, de Chirico, Lipchitz, Calder, Gorky, and Kandinsky. Through extending his classroom into (New York) city, artists were introduced to the masters of European modernism. The exciting exhibits that continued in the 1940s and 1950s were integrated into his teaching.

By no means did Hofmann reject the masters of the past. In fact, Michelangelo and Rembrandt are both cited as using a push and pull theory to accomplish monumentality and universality in their work (Hofmann, 1967). The forces at work in the masters, although not abstract, produce experiences that are physical and spiritual. Cézanne is also singled out as an artist who uses color to push and pull forces across the two-dimension canvas. His images then pulsate and exhale a liveliness that displays sensitivity to these decisions.

Modern techniques—including cubist space, Fauvist colors, and assemblage—were all incorporated into Hofmann's teaching (Cho, 1993). A merging between traditional and self-expression, Hofmann students were encouraged to traverse individualistic styles.

This is apparent when comparing past students (Louise Nevelson and Larry Rivers). While demonstrating or lecturing on the modern art movements, Hofmann desired his students to see. It was a classical format with a new philosophy.

The frustration of balancing both teaching and art making is a contemporary issue that plagued Hofmann as well. He states: "I don't think my long years of teaching have hurt my work too much. They have only taken up my time. I taught for so long—too long" (Kuh, 1990 , p. 125). Although teaching was a vital outlet it also hampered his production at times. Hofmann brought the studio into the classroom, but it appears the classroom sometimes took precedence over teaching, a dangerous balance that can darken and cause the spirit of the artist-teacher to drain.

A Philosophy of Teaching

Hofmann was a one-man academy. Bringing his own experience as an artist into the classroom, his education and practice are both highlighted in his teaching processes. Hofmann's art practice is tied very closely to his own education in this respect. Hofmann's later images are highlighted, as they signify the pinnacle of his painting philosophy, but his early painting provides evidence for his growth and developing thinking process.

The growth he experienced as an artist and the intangible qualities aided his development. Progressing through a number of styles, Hofmann was placed in a unique situation to push students into the modern art world at a much quicker rate compared to the lengthy process he progressed through on his own.

> "When Hofmann criticized a drawing, he sat or stood in the very position from which the student observed the model and made his points directly on the student's drawing. Sometimes he "really got into it" – then the drawing would undergo a storm of corrections taking as long as ten minutes, and the end result was a complete Hofmann drawing. Sometimes, to make a point about shifting planes or to clarify space relations, he would ask the student's permission to tear the whole paper in pieces which he then reassembled with tape and thumbtacks. When a student painted in class, Hofmann, undaunted, would ask for the brushes and the palette and would paint directly onto the student's painting. It was unusual for anyone to object to these drastic procedures. We had been well indoctrinated to regard the process, not the product, as primary" (Kahn, 1982, p. 22).

As many teachers realize, learning a concept or process on one's own can be a cumbersome and lengthy process, yet also rewarding. As one teaches himself, he can encounter a much more complex understanding of the concepts or processes studied.

Experimenting and probing are part of this process as Hoffman's canvases demonstrate examples of successes and failures (Wilkin, 2003). As Hofmann experimented with the modern language of painting, he developed an intimate understanding of the subject. Teaching refines ideas and the teacher is the one who benefits the most from the practice (Anderson & Wark, 2005). Through the process of gathering materials, designing, and teaching, the instructor constructs the information before dissemination. The results are evident, as Hofmann continued to be sought by American artists hoping to also understand his discoveries. "Painting has many problems but the foremost is the synchronized development of both form and color" (Hofmann, 1957, p.54), which was a notion he aimed to understand in the created realities on canvas. These incompatible developments could be interwoven to create a synthesis (Hofmann, 1957).

"Push and pull" was an expression by Hofmann that described an important aspect of controlling the surface of the picture. Expanding and contracting forces were prompted by the push and pull theory as a dynamic energy presented itself as the planes react to one another. Hofmann's arrangements of multicolored geometric shapes control the two-dimensional space as plates of color shift and shimmy. Basic forms compose the majority of the forms he uses. Referred to as planes, these squares, spheres, and geometric shapes are linked to the basic building block of nature (Newbury, 1979). This experience is successful when the planes are in constant tension and thus relating to one another. Lines also aid this process as it moves in and out of the plane. They create planes and add to the movement as the individual elements interact.

This philosophy developed over many years, and his willingness to share and model it within the classroom signifies Hofmann's teaching as an art process. The forces of push and pull were of central concern in his artwork and his teaching. Writing about it and practicing the philosophy further refined it to a spiritual understanding:

> The forces of push and pull function three dimensionality without destroying other forces functioning two dimensionality . . . To create the phenomenon of push and pull on a flat surface, one has to understand that by nature the picture plane reacts automatically in the opposite direction to the stimulus received; thus action continues as long as it receives stimulus in the creative process. Push answers with pull and pull with push . . . Exactly the same thing can happen to the picture plane in a spiritual sense. (Hofmann, 1967, p. 44)

"Search for the real" a phrase and title of Hofmann's 1967 text was used to test the ideas from his analysis of the picture plane. It serves as evidence of the real formal relationships and real world Hofmann observed and abstracted on canvas. Writing several essays and continuing his teaching practice despite moving locations and countries is significant. The tenacity and resilience of Hofmann's message illustrate his commitment and belief in

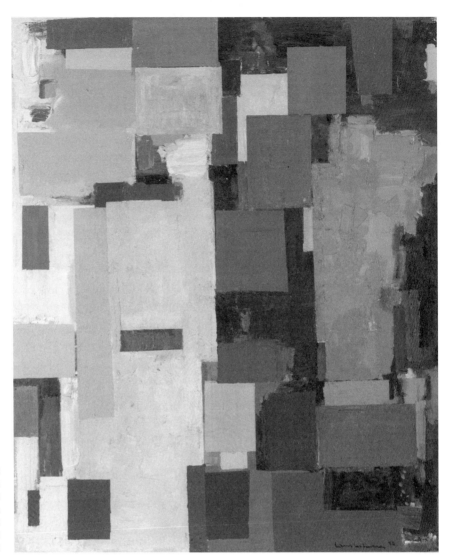

Equinox, 1958
Hans Hofmann
Oil on Canvas
University of California,
Berkeley Art Museum
and Pacific Film Archive
Gift of Hans Hofmann

his educational philosophy. His hope was not to confine but rather to free students armed with knowledge. Rather then copy nature or explore it as a scientist, Hofmann desired his students/artists to communicate through their artwork a deeper level that examines the way nature effects our sensibilities (Newbury, 1979). This stimulation was intellectual, adding a conceptual layer to abstract painting. It was a belief that the picture communicated something rich and meaningful beyond harmonious arrangement of colors.

Negative space or distance between planes also contributes toward the experience. The rules and guidelines are not linear and appear emotional to someone outside the experience. It is a difficult process to measure, yet noticeable and qualitative. Best described as experiential, the creation of three dimensions on the two-dimensional

plane is a struggle for every student artist. Hofmann states:

> Being an artist and being a teacher are two conflicting things. When I paint, I improvise, speculate, and my work manifests the unexpected and unique. I deny theory and method and rely only on empathy or feeling . . . In teaching, it is just the opposite. I must account for every line, shape, and color. One is forced to explain the inexplicable . . . (Seckler, 1951, p. 64)

Despite the inherent differences between art making and teaching, Hofmann (1967) believed art is ruled by an order. While the creation of this order is quite different than facilitating it, a similar philosophy permeates his thinking process. Beyond a style, Hofmann hoped students would understand his philosophy for how a painting worked. A lifelong learner, Hofmann's patience and experience are important aspects of his teaching.

The Artist-Teacher

Hofmann's greatest strength as a teacher and the factor that led so many aspiring artists to his classroom was his ability to bring the studio into the classroom. This ability differs in relation to artistic practice. Sutherland (1989) writes that Hofmann's growth as an artist paralleled his growth as a teacher, and that he was an artist-teacher because of his willingness to bring the art-making experiences into the classroom. The discoveries made in the studio were something to be shared. The life of the artist was not divorced from teaching but rather enhanced teaching and vice versa. Art was ruled by an order and Hofmann believed one could teach this harmony and order. Wilkin (2003, p. 16) writes:

> The pictorial dynamism that Hofmann strove for in his work and strove to elicit from his students was not merely a personal conception of Cubist structure, but a visible metaphor for the opposing forces-real and metaphysical, spiritual and pictorial, emotional and practical- that animated existence and made humanity human.

The Hofmann household was, according to Wilkin (2003), akin to walking into one of his paintings. Bright and bold colors were affixed to objects and parts of the house. The subject matter for his paintings was his context for living. Demonstrating a commitment to color and it effect on the senses, the color of the floor in contrast and relation to a chair or rug quite possibly had the same effect on Hofmann as a painting.

The forces between Hofmann's art making and teaching were very real. Pulling his thinking back and forth, the mixed emotions and experiences involved with teaching combined with the complex decisions involved in composing paintings represent a

juxtaposition of intentions that complement one another and in the case of Hofmann, both his teaching and art making affected a number of viewers and students.

Having a teacher who also modeled the process of being an artist is an important attribute. Students in Hoffman's school did not graduate with an accredited degree. Instead, they left with a notion of what is a modern artist and an increased sensitivity for quality.

* * *

Balance was instrumental for Hofmann's progression as an artist-teacher. Teaching encompassed a majority of his early career. The time spent with students and his instruction was important for personal development as an artist. Working through ideas with students and encouraging them to find their voice, Hofmann further developed his own art as well. Nothing refines ideas and thoughts better than teaching and explaining them to others. The process of teaching pushes individuals to think through curriculum in a critical fashion that otherwise may be overlooked in independent study. Several aspects of the Hofmann's pedagogy highlight an ongoing process of self-critique for art making and teaching.

Hofmann states:

> Art teaching has a meaning for America, and should be more general and more significant. The problem of civilizing this enormous country is not finished. The teaching of art must be directed toward the enrichment of the student's life. The teacher must be a guiding personality for the student, and develop his sensibility and his power for "feeling into" animate, or inanimate things, with sympathy . . . The problem of art teaching is not limited to the problem of artistic development itself, but includes the problems of how to produce artists, comprehending teachers, art understanding in general, and art enjoyment in particular. (Hofmann, 1967, p. 56)

Hofmann thought of himself as a painter who had to teach to practice his ideas independently (Wilkin, 2003). Interestingly, except for a few short tenures in California and New York, Hofmann's teaching experiences were also independent. His schools were not part of a larger degree-granting institution. The independent nature he desired for his painting career was also reflected in the organization of his schools. The fact that good teaching requires a great deal of time and effort to prepare and expend in the classroom, it is easy to understand Hofmann's desire to devote more time to his craft. However, it is impossible to ignore the influence this teaching had on his art making. A combination of intellectualism and emotion, Hofmann's artwork is powerful on many levels (Pearl, 2006). The ideas explored in the studio also manifested in his teaching; the studio was his school, and he brought that sensibility to his students as their teacher.

References

Anderson, T. & Wark, N. (2005), "Why do teachers get to learn the most? A case study of a course based on student creation of learning objects," http://www.usq.edu.au/electpub/e-jist/docs/Vol7_no2/FullPapers/WhyDoTeachers.htm. Accessed November 22, 2009.

Seckler, D. G . (1951), "Can painting be Taught?: Hans Hofmann, " ARTNews, 50: 1, pp. 39-40, 63-64.

Cho, J. M. (1993), "Hans Hofmann and Josef Albers: the significance of their examples as artist-teachers," New York: Teachers College, Columbia University.

Daichendt, G. J. (2008), *Revisiting Pollock: Engaging Art through Attribution and History*, Azusa, CA: Azusa Pacific University.

Greenberg, C. (1961). *Hans Hofmann*. Paris: Editions Georges Fall.

Flam, J. (1990), "The Gallery: Hans Hofmann Retrospective," *Wall Street Journal*, 14 Aug, p. A14.

Hofmann, H. (1957), "The Color Problem in Pure Painting—Its Creative Orgin," in F. Wight (ed.), *Hans Hofmann*, Berkeley: University of California Press, pp. 51–63.

Hofmann, H. (1967), *Search for the Real*, Cambridge: MIT Press.

Hofmann, H. (2008), *Hans Hofmann: Poems and Paintings on Paper*, New York: Ameringer Yohe Fine Art.

Kahn, W. (1982), "Hans Hofmann's Good Example," *Art Journal*, 42: 1, pp. 22-23.

Kuh, K. (1990). *The Artist's Voice: Talks with seventeen Modern Artists*, Cambridge, MA: Da Capo Press.

Newbury, D. S. (1979), *Hans Hofmann: Master Teacher of Painting*, Chicago: School of Loyola, University of Chicago.

Pearl, J. (2006), *Hans Hofmann: The Unabashed Unconscious: Reflections on Hofmann and Surrealism*, New York: Ameringer Yohe Fine Art.

Sutherland, S. (1989), *Hans Hofmann: A Painter's Teacher*, Montréal: Concordia University.

Wilkin, K. (2003), "Hans Hofmann: Speaking through Paint," in *Hans Hoffman* Rev. ed., New York: George Braziller, Inc., pp. 11–38.

CHAPTER EIGHT:
PREPARING ARTISTS

Basic Design in the Classroom

Richard Hamilton (b. 1922) and Victor Pasmore (1908–1998) are notable artists working in the 20th century. Both enjoyed success as artists, but they are also significant leaders in the Basic Design movement. As artist-teachers, they are examples of bringing artistic studio life into the classroom. Raising the importance of critical intelligence in art making, they broke with many technical-based art education theories (Packer, 1998). Based in Newcastle, they are relevant for their preparation of art students during the mid-20th century, which included a series of loosely organized principles for art education inspired by the Bauhaus and European Constructivism (Yeomans, 1987). However, despite their similar objectives as teachers, they could not be more different from one another in both their art-making and teaching styles. This diversity symbolizes what is possible when artists embrace their unique thinking processes in the classroom.

Hamilton is best known as a British pop artist and for his studies of life, culture, and machines. His 1956 collage entitled *Just What Is It that Makes Today's Homes So Different, So Appealing?* is considered one of the earliest examples of pop art. Analytical, distant, and self-effacing, Hamilton's teaching style was anything but personal and could be considered postmodern (Yeomans, 1987). In contrast, Pasmore is better known as an abstract artist who rejected the natural world in his compositions. A charismatic teacher full of personality and energy, he often modeled his art-making process in the classroom. A force as a teacher, his approach was direct and closely associated with modern art education (Yeomans, 1987). Seeking inspiration from within, Pasmore's inspiration was at odds with Hamilton's observations of culture.

Despite their aesthetic differences, both were vital contributors toward the Basic Design movement in England in the 1950s and 1960s. Following a line of innovative artist-teachers, the movement represents a distinct change in art education. Led by Pasmore and Hamilton—along with Tom Hudson, Harry Thubron, William Turnbull—their theories moved from technical preparation to a course of study involving formal

131

analysis and an open-ended experimental approach that illustrates teaching as an aesthetic activity (Yeomans, 1987, 1992, 2005). Additional contributors to basic form studies working in British art schools were Barbara Hepworth, Lynn Chadwick, Bernard Meadows, Reg Butler, Robert Adams, Wilhelmina Barns-Graham, John Wells, William Gear, Alan Davie, and Ben Nicholson (Macdonald, 1970). Their roles as artist-teachers were influential in recognizing and leading this movement.

Basic Design Movement

Pasmore and Hamilton taught at the University of Newcastle-on-Tyne between 1954 and 1966. It was during this time they developed a foundation course that represented many of the Basic Design movement ideals, including the conviction that arts could be objectively understood in a formal manner. Not a movement in a traditional sense, rather it was a collection of theories and teaching methods working toward developing an experimental foundational education in the arts—a course designed to be a common core for all the arts, regardless of discipline. Yeomans (1987, p. 186) outlines the changes in art education proponents of the Basic Design movement sought in the 1950s:

> The disintegration of the old classical and naturalist tradition
> The social demand for an end to separation of the fine and applied arts
> The introduction of art activity in schools as a creative counterpart
> to the traditional systems of education

Many involved in the movement felt the traditional technical courses of art education were not appropriate for the conversations occurring in the 20th-century art world. This is akin to the bridges Gropius hoped to mend, which were greatly divided in the 19th century (art and design versus applied arts). The Basic Design philosophy was open minded and owes a debt to Itten's foundation course at the Bauhaus that was to "liberate students from second-hand traditional information, and to make them learn basic principles from direct analyses and their own direct experience with materials" (Macdonald, 1970, p. 365). Yeomans (1987) writes at length about the movement and states members were aware of the Bauhaus literature, which was available in fragments. However, this influence is a contentious point because members of the Basic Design movement would deny such an influence (Yeomans, 1987), especially because Pasmore felt the Bauhaus was becoming an academy, claiming it was too idealistic, sterile, and limited compared to the fluid and less predictable outcome he desired from his teaching (Yeomans, 1987).

The Basic Design movement is poignant because it demonstrates a continuation of artist-teachers working in England under a particular tradition in line with the Bauhaus. Although the authors of the Basic Design movement would likely deny such an association,

they would not have developed their program without the foundation set by the Bauhaus (Yeomans, 1987). The differing philosophies of the Bauhaus are also present within Basic Design teaching, as there was no common teaching philosophy and the curriculum was left to the discretion of the individual teachers (Yeomans, 1987). The design method, differentiating itself from a traditional technical artist production, approaches teaching in a different manner. The Bauhaus was "design adapted to the needs of the new industrialized society" (Carline, 1968, p. 264), and the Basic Design movement follows a similar method of abstract analysis for artists. Yeomans (1987, p. 176) explains, "[I]t was a kind of reversal of the Bauhaus situation where artists devised a foundational course for craft and design students. In this instance, it was a case of artists devising a similar course for artists." Context continually changes the way art is taught, yet the strategies employed by proponents of the Bauhaus and the Basic Design movement appear to acknowledge teaching as an aesthetic activity, albeit for different justifications.

Drawing many similarities, the Basic Design movement represented a shift from a technique-based instruction and teaching to an intellectual quest that valued the idea and thought processes of artists similar and unique from its Bauhaus predecessor (Yeomans, 1987). "The course is aimed at developing modes of thinking which will induce a self-critical attitude in the student. He must learn to question the significance of every mark he makes" (Hamilton, 1983, p. 174). In this new art education, the process was valued more than the end product. As a movement, it spread to include secondary schools and higher education thanks to exhibitions, political policy, and graduates becoming teachers (Macdonald, 1970).

Most of the artists associated with the Basic Design movement were part-time instructors. Because there was a lack of opportunities to share ideas, there was not a central philosophy but rather strategies that were the responsibility of each individual instructor. The lack of a consistent philosophy is a characteristic of education after the academy—a philosophy practiced yet not always understood in the 21st century. The context of Newcastle was appropriate for such experimental teaching to take place. Compared to other university art departments, the faculty had quite a bit of autonomy, which allowed them to practice their progressive pedagogy. This allowed a break from traditional techniques and ushered in an education apt to the developments in modern art (Yeomans, 1987). As the artist practiced, it was also a topic of study.

The philosophies expressed during this movement in Britain are critical, because these artists themselves regarded their teaching processes and methods as a direct extension of their studio life. Yeomans (2005) captures the importance of this studio relationship:

> The studios were laboratories and the spirit in which the teaching was carried out was more important than content. Walter Gropius, who firmly established the principle of putting leading artists in the workshops and studios, stated that what defined the Bauhaus was its "atmosphere," and

for that reason the Bauhaus could never be replicated. So it was with the early Basic Design courses and for the same reason they cannot be repeated or replicated. (p. 209)

The ideas and concepts of artistic practice were applied in courses to provide a creative atmosphere. A good example involves Richard Hamilton's admiration of Marcel Duchamp. Duchamp's intellectual challenges fueled Hamilton's own embrace of ready-made objects in his art making. Hamilton, like Duchamp, rejected the sensual or physical aspects of art. They both preferred art to be a product of the mind. Hamilton then applied this line of thinking to problem-solving activities in the classroom. His assignments would suppress style or touch and only enact the mind as an exercise (Yeomans, 2005). This might include cutting out magazine imagery and using the pictures for metaphor and analogy (Yeomans, 1987). This is different from exercises at the Bauhaus that would focus on texture or color studies. Hamilton subsequently had his students practice these exercises as intellectual dilemmas.

Basic Design Course

The Basic Design course was a process, one in which traditional boundaries overlapped with one another. Macdonald (1970) writes that a class might include a short lecture or a demonstration based upon an issue or theme. This would be followed by an exercise. Proposing problems or propositions in which the results or conclusion were open ended was typical of these exercises. Some might be about invention or about the acquisition of technical information. Class would conclude with a critique or an organized discussion. However, even the course itself differed among the faculty who taught. Overarching goals of a basic course would include the following:

Free students from previous art knowledge

Relearn a comprehensive and orderly knowledge from direct experience

Learn analytical features of visual elements/grammar

Understand the structure of forms through drawing

Train students to engage the masters critically through the use of
elements of their compositions (structure, tone, texture, color)

Documentation of the process is essential (Macdonald, 1970). Without such notes in a sketchbook or notebook, the discoveries are forgotten. Keeping notes stresses the importance and value of the process.

The first aim of our course is a clearing of the slate. Removing preconceptions. People come to art school with ready-made ideas of what art is. We have to do some erasure. Then we have to build up a sense of values. We try to put across the idea that any activity should be the outcome of thinking. That is one of the common preconceptions- that art is not something you think about but something you feel. What we do is to introduce problems which can be solved intellectually; the graphic quality is not so important. (Hamilton, 1983, p. 179)

Richard Hamilton

Hamilton holds a revered place in contemporary art as an artist, teacher, curator, and advocate for the arts. The subject of two major retrospectives at the Tate Gallery (Francis, 1992; Marharaj, 1992; Morphet, 1992), he was prolific in the variety of interests he held. An accomplished painter, Hamilton also taught at several schools. As a contributor to the Basic Design movement, his visceral approach to art making and teaching is a marker of artist-teacher diversity.

Hamilton received a formal education at the Royal Academy Schools in London during the 1930s and the Slade School of Art during the late 1940s. This formal education was supplemented with positions in design studios and workshops.

Hamilton was determined that art should openly embrace the reality of its own period. He saw no reason why it should fail to reflect – and where possible assimilate – either the striking mass imagery or the technological discoveries of the age. (Morphet, 1992, p. 14)

Hamilton's early work is figurative, realistic, and stylized, insisting he is a traditional artist valuing both skill and technique (Morphet, 1992). As an artist who embraced new types of media, he held a conventional painting practice (Morphet, 1992). An early figure study by Hamilton contains soft geometric planes encompassing the figure through tonal changes. Rendering a three-strong three-dimensional figure, geometric shapes define the human body. Receiving an education that valued objective drawing, Hamilton wrestled with providing a balance for his own students. As a pop artist, he used secondary sources in his art and teaching. However, Hamilton also had an abstract education at the Slade School of Art. During this tenure, his work became more abstract as he explored the minimal elements of complex information systems such as a machine or a philosophy through painting or printmaking. Commenting on Hamilton's elusive style, Field (1974) states:

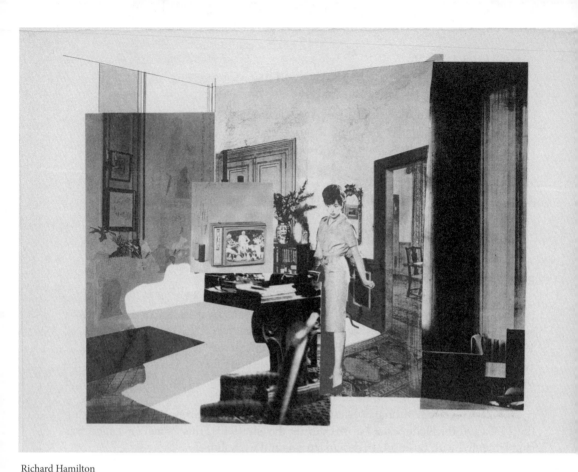

Richard Hamilton
Interior
1964-5
on paper, print
©Tate, London 2009
© 2009 Artists Rights Society (ARS), New York/DACS, London

"Hamilton wishes to articulate the void that separates objects, and within this field of optical flux where events are continuous if not always rational, Hamilton is free to establish new and meaningful relationships among objects of the two dimensional world of representation" (p. 2).

This aspect of his education most likely fueled much of his philosophy of teaching. Route learning was not the objective; rather, Hamilton sought to provide a way of thinking through open-ended and experimental activities for his students. Releasing the potential of the student was the goal rather than providing a systematic series of techniques and methods for making art (Yeomans, 1987).

Aware of his predecessors (unlike Pasmore), Hamilton was a scholar and read all the available Bauhaus literature. In doing so, he was influenced by the art and teaching work of Paul Klee. Evidence exists in Hamilton's early paintings that display a resemblance to Klee's work. He also used Klee's writings to counteract much of the academic education/training he received (Yeomans, 1987). Hamilton used Klee's (1968) teaching treatise *Pedagogical Sketchbook* in his own teaching. Klee, a teacher within the Bauhaus School, was an influential draftsman and color theorist, and his influence continued through Hamilton. The Dada artist Marcel Duchamp also supremely influenced Hamilton. Organizing a retrospective of the artist, Hamilton's art bears many conceptual ideas linked to the influential artist. Hamilton was disturbed by many of the inward or empty manifestations created through Abstract Expressionism—something Pasmore embraced—especially because the movement's popularity diminished the recognition and significance of Marcel Duchamp (Morphet, 1992). Hamilton linked his own thinking process to Duchamp when he states that a single work does not mean very much (Birnbaum, 2003). A painting by itself does not make sense; because of this, the context must be carefully manipulated. Objects need to be ordered to make sense and ideas must be sequenced.

Hamilton's teaching practice was based upon the rational thought processes he valued in all his endeavors. Results from class activities must not be based upon free expression but rather the growth of ideas.

> The tasks I set my first year students are designed to allow only a reasoned result. Rarely is a problem presented in terms which permit free expression or even aesthetic decision. The student is prompted to think of his work as diagrams of thought processes- equipment which will enable him to derive further conclusions. (Hamilton, 1983, p. 169)

In assigning a form and movement exercise, Hamilton expects students to develop a visual flow from one end of the paper to the other. To accomplish this goal, a logical progression of thought is required to place the energies as different shapes and positions develop through their placement (Yeomans, 1987). An interesting Hamilton (1983) assignment includes observing microphotographs of sea urchin eggs. Comparing an egg divided by its own internal forces to one divided by external forces, students focus on the generating forces and how they may be represented differently visually. From drawing to collage exercises, in the end, students hopefully possess a language for creating art. This was a language that included a vocabulary and a method. "There is virtually no work by Hamilton in which the "front" subject is not strongly related (or subjected) to some kind of structure, for example a systematic physical process or clear intellectual programme" (Morphet, 1992, p. 20). His teaching mirrored the intellectual world of his studio. A mix of abstraction and objective exercises, Hamilton's work was conceptual as was his teaching.

Victor Pasmore

On the other end of the artist-teacher scale, Pasmore presented students with problems. Visceral and emotional, Pasmore was an expressionist to the core. Pasmore held a "This is what I am, take it or leave it" mentality (Bell, 1945, p. 16). Embracing Abstract Expressionism, Pasmore sought a classroom atmosphere that embraced the intuitive and emotional aspects of creating art. The perceptual reflection was significant, as students under Pasmore learned about form and color from their own constructions.

His process was akin to a laboratory experiment that students were expected to develop a method for solving it. Open ended in design, there was no correct way to make a two-dimensional drawing or painting into a three-dimensional sculpture, but the study of abstract form was thought to be a lifetime's worth of work (Yeomans, 1987). Drawing his ideas on the blackboard, Pasmore modeled being an artist and clearly demonstrated his process of thinking visually. In these instances, students did not blunder through their own trials; instead, they witnessed the differences between good and bad form from Pasmore. Pasmore would then expect students to explore form in a similar manner. Paper piles would eventually cover the floors as students experimented with form while Pasmore critiqued and encouraged their designs (Yeomans, 1987). Spontaneity and intuition were critical factors in Pasmore's teaching, as each class would progress differently. Valuing the mystical and spiritual expressions that radiated through art was akin to Abstract Expressionism and Pasmore's pedagogy. Through exercises like these, Pasmore facilitated individual creative abilities and a development of their own grammar of form.

As an abstract expressionist, Pasmore worked large. He developed through a traditional art education, working from nature. This tradition was eventually discarded to take on subject matter from within. In a retrospective exhibition review, Edelman (1991, p. 167) writes: "His experiments with supports and mediums and his freewheeling mixtures of painting and drawing demonstrate his conviction that dialectical forces activated his work." Edelman (1991, p. 167) continues to commend Pasmore's "continued . . . search for equivalents- form, line and color- that would parallel but not imitate nature." This interest carried over to his teaching as well. Students report being encouraged to work on a large scale very quickly. Working from the floor, many of the traditional aspects of creating were discarded for expressing form from within. Facilitating this experimentation, Pasmore found teachable moments by recognizing quality work when it was created. This was part of the aesthetic education students received, but it was only after creating. A mix of spontaneity and expression, Pasmore facilitated a visual language unique to each student. Described as a man with impeccable taste, he developed his students' aesthetic sensibilities to form from these exercises (Yeomans, 1987). "The idea of content-as-form, information-as-image was coupled with the belief that the active visual intelligence could make up for any deficiency of technique . . ." (Packer, 1998, p. 15).

Traditional art education was outdated according to Pasmore. Art schools promoting life drawing were obsolete and were not relevant for the modern artist (Yeomans, 1987). Pasmore's teaching was a new beginning for students and not a list of exercises to complete. "Pasmore's basic course was an extension and development of his own creative preoccupations and he unashamedly admitted that he used his own students as guinea pigs in exploring aspects of abstract form" (Yeomans, 1987, p. 178). If students were not appropriate for this type of study, he would recommend them elsewhere. In fact, Pasmore

Victor Pasmore
Yellow Abstract, 1960-1
Oil on board
Tate Museum, Purchased 1961
© Tate, London 2008

once told a student that he stood to learn more from visiting the local museum rather than from enrolling in his class (Yeomans, 1987). Emphasizing an artistic language, Pasmore continually pushed his pedagogy as a formal method for understanding abstract art.

* * *

The difference between Hamilton and Pasmore is evident despite their common core to modern art education. Whether its perceptual or intellectual, they both brought their individual studio life into the classroom. The systematic and orderly study of texture and the principles of design progressed to visual language in the Basic Design movement. This fragmentation of thought is a precursor for much postmodern art education but draws a parallel with aesthetic education. In fact, the term "aesthetic education" is sometimes used to emphasize the importance of visual education, something both Hamilton and Pasmore valued (Feldman 1970).

The difference between modern and postmodern art education is played out in the differences between the two philosophies of art education present in Hamilton and Pasmore. The bold and internal process of Pasmore is similar to modern ideals, whereas Hamilton's attitude is very different, as he encouraged reflection of contemporary life, rejecting formalism for allegory and metaphor. Hamilton's conceptual work does not propagate a style or a recognizable aesthetic. The conceptual agenda is thus present in his assignments and changes according to the problem or agenda. The Basic Design movement continued outside the walls of Newcastle as more foundational courses developed in other universities and secondary schools (Yeomans, 1987). Yeomans (1987) credits Pasmore for the wide dissemination of the thinking process involved in the Basic Design course. However, once the curriculum became standardized in England it lost the substance that sustained its relevance. Appearing in high school classrooms, the context and special qualities became a formula. The Basic Design course or courses continue to be a foundational prerequisite for many advancing toward a degree in fine art. However, they are quite distant from the creative context that fueled them midcentury.

References

Bell, C. (1945), *Victor Pasmore*, Harmondsworth: Penguin Books.

Birnbaum, D. (2003), "Richard Hamilton," *ArtForum*, 42: 4, pp. 141.

Carline, R. (1968), *Draw They Must: A History of the Teaching and Examining of Art*, London: Edward Arnold Ltd.

Edelman, R. G. (1991), "Victor Pasmore at CICA," *Art in America*, 79: 4, pp. 166–167.

Feldman. E.B. (1970), *Becoming Human Through Art: Aesthetic Experience in the School*, Englewood Cliffs: Prentice Hall.

Field, R. S. (1974), *Richard Hamilton Graphics*, Edinburgh: Scottish Arts Council.

Francis, M. (1992), "London and Dublin: Richard Hamilton," *The Burlington Magazine*, 134: 1074, pp. 616–618.

Hamilton, R. (1983), *Collected Works*, London: Thames and Hudson.

Hamilton, R. (1956). *Just What Is It that Makes Today's Homes So Different, So Appealing?* Tübingen, Germany: Kunsthalle Tübingen,

Klee, P. (1968). *Pedagogical Sketchbook*, London: Faber & Faber.

Maharaj, S. (1992), "A Liquid, Elemental Scattering: Marcel Duchamp and Richard Hamilton," in *Richard Hamilton*, London: Tate Gallery, pp. 40–48.

Macdonald, S. (1970), *The History and Philosophy of Art Education*, London: University of London Press.

Morphet, R. (1992), "Richard Hamilton: The Longer View" in *Richard Hamilton*, London: Tate Gallery, pp. 11–26.

Packer, W. (1998), "That Very English Bogey Man: For a While Even More than His Contemporaries, Victor Pasmore was the Epitome of the Modern Artist," *Financial Times*, 16 Jan., p. 15.

Yeomans, R. (1987), "The foundation course of Victor Pasmore and Richard Hamilton 1954–1966," Ph.D. dissertation, London: Institute of Education, University of London.

Yeomans, R. (1992), "The Pedagogy of Victor Pasmore and Richard Hamilton," in P. M. Amburgy, D. Soucy, M. A. Stankiewicz, B. Wilson, & M. Wilson. (eds.), *The History of Art Education: Proceedings from the Second Penn State Conference*, Reston: National Art Education Association, pp. 72–78,

Yeomans, R. (2005), "Basic design and the pedagogy of Richard Hamilton' in M. Romans (ed.), *Histories of Art and Design Education: Collected Essays*, Bristol: Intellect Books, pp. 195–210.

CHAPTER NINE:
REDEFINING THE ARTIST-TEACHER

Reflecting on the Concept

"Teaching a Plant the Alphabet" by John Baldessari (1972) illustrates both complexity and silliness. The short film depicts a motionless potted plant on a stool while the artist holds up a series of flashcards depicting different alphabet letters. Progressing from A to Z, the artist-teacher creates a work that is illogically educational. The film sequence emulates route- and subject-based learning. Flashcards typically intended for memorization are wielded to provoke a response from the viewer witnessing this bizarre interaction. Similar to many artistic theories, the experience is ridiculous yet telling. As art making continually changes because of new thinking, the way art is taught must also change. Outdated forms of teaching will be as effective as trying to teach a plant the alphabet. As postmodern art education continues to shift, there will be constant and necessary deviations as issues of importance develop. Understanding education from the perspective of the artist, however, provides a center of gravity for theses deviations and allows artist-teachers to comprehend the seemingly illogical nature of teaching art.

The history and development of the artist-teacher traces back to the beginning of artistic creation. In every art-making context, a method for passing the skills or traditions of creating was established to ensure future practice. From the craftsman to the contemporary artist, the artist-teacher continually reinvents himself or herself as culture, context, and goals change. Throughout history, art and education were combined in a number of different ways. Efland (1995) takes a wide view and organizes teaching art into four historical categories: mimetic, pragmatic, expressive, and formalist. Mimetic concentrates on imitation. Models are used to copy or imitate to learn the desired objectives. Pragmatic values both art and education as subjects to be learned through constructing knowledge with the subject. Through experience with art, reality changes learners and they add this to their view of reality. The expressive category values the expressive or emotional perspective of the student. Imagination and expressive aesthetics

contribute toward learning activities. The formalist perspective acknowledges that works of art attain their status of quality through an organizational system. Vocabularies, concepts, and principles of design accompany this category of teaching. The categories by Efland (1995) represent four diverse ways art teaching can be explored. However, when artist-teachers embrace their artistic practice in the classroom they can explore teaching in an *unlimited* fashion and combinations. As art making changes and evolves, so does teaching.

Redefining

Reflecting on the term "artist-teacher" is troubling. The compound phrase represents the merger of two professions, that of art and education. The field of art education continues to grow and bridges this divide when preparing art teachers for grade schools and high schools across the country. Despite the all-encompassing categories of art educator and art teacher, professionals in the field of art education continue to propagate the use of the term artist-teacher in journals and graduate programs. However, the artist-teacher also extends beyond the typical borders of art education (or perhaps the borders of art education are wider). College professors teaching a range of media, visiting artists, museum educators, and artists who see their work as educational also adapt and use the term to their liking. The broad use and multiple meanings in these instances leads one to rethink the meaning of the term "artist-teacher." Artist-teacher is a common ground in these diverse professions and is the central core to the very large field of art education. Its importance cannot be understated,

The Role of Modernism and Postmodernism

The two perspectives with the biggest effect on art education are modernism and postmodernism (Neperud, 1995). Both perspectives are important to understand because they affect art and teaching practices. The values an artist places on context, objects, aesthetics, and history has roots in these thinking processes and will change the way one teaches. The search for a universal set of visual qualities defined much of the accepted wisdom of modernism. Postmodernism questions the assumptions held by these modernists and raises issues in relation to social contexts, race, gender, sexual orientation, and multiculturalism. It is considered a break with modernism without a return to premodern thinking (Williams, 2009).

The advent of scientific objectivity greatly affected the methods artists used to teach. As modernism progressed, a language of modern art developed similar to science. In addition, a growing focus on individuality was present. Through this process, formalism

became an established measuring stick for judging quality aesthetically (Parks, 1989). Many types of formalism developed from the 19th-century British Schools of Design to the Basic Design movement, each seeking a solution for understanding and teaching art. Hamilton's break with these conditions sets in motion a pluralistic art education tradition that celebrates ambiguity and eclectic approaches to art education. Embracing ideas set by Duchamp, Hamilton engages cultural conditions affecting the structures of art making. Modernist received much thought from those in positions of power, including critics, historians, and philosophers. A postmodern view of truth is a complex web of perspectives that is constructed by the artist or student (Neperud, 1995). There is no single truth in postmodernism; rather, it is a collection of truths that can contradict one another. Proponents of postmodernism seek a conceptual vocabulary for critiquing the visual, psychological, institutional, and economic conditions in power (Williams, 2009).

> The contemporary era of art education is affected by momentous social and ideological changes that strike at our conceptualizations of art, of teaching and learning, and of curriculum development. Young children still search after meaning through depicting their world, just as graduate art students search for idiosyncratic imagery, hoping to make sense of their world. The traditional imagery and valuing of art no longer provide the universal "truths" that once provided stability in teaching about art. The methods used to help students to create and understand art are being questioned more now than ever before. (Neperud, 1995, p. 1).

Postmodernism may not be a good philosophy for living out a daily life. Truth and order help us understand the world and interact in a safe manner. In regard to teaching art education, however, it is a powerful tool that embraces the concept of the artist-teacher. Postmodernism values local artistic practices and the individuality of the art teacher (Neperud, 1995). The artistic process is a tangled web of personal experiences and interests. Similar to the individualist philosophy of making meaning, the artist is empowered in the postmodern era to explore issues at will. As artists attempt to understand art, they construct issues of importance and a way of understanding art, and learning about a range of issues that may surface. These may include an emphasis on technique, formalism, history, politics, or problem solving among a host of other concepts. They can all be viable goals when the artist embraces them in the studio and then in the classroom. The postmodern artist-teacher does not necessarily disregard modernist theories or practices. In the postmodern era, the artist-teacher decides appropriate content, understands that classroom context influences curriculum, includes multiple voices, and interprets instructional information through his own artistic thinking process.

Education

The professionalization of the education field was essential for the artists to recognize their teaching practice as equal to their art practice. Since the 19th century, artists have used the term artist-teacher to describe their own practice while historians have adapted the term to illustrate the important contributions these artist-teachers made to their respected fields. The addition of art history and a variety of complementary studies have broadened art education at all levels (Yeomans, 1987). However, once an innovative method for teaching is discovered, one often attempts to replicate and distribute that pedagogy for wider distribution. Art education history is witness to this philosophy failing again and again. Instead, embracing the particular context and culture of learning is vital for artists who hope to teach. Reflecting on one's own education and art making are essential components. The variables are many, but the artist-teacher molds the classroom into an exciting place for learning. Applying someone else's theories will not circumvent the unique aspects of the individual teacher nor the classroom. There are many practicing art teachers at all levels teaching academic, modern, and postmodern ideologies. The problem arises when art-making and teaching process/philosophies do not overlap. Rejecting formal properties in the studio yet embracing them in the classroom is a disservice for all involved. Understanding and reflecting on one's philosophical basis will allow thinking in all areas to be clear.

Despite the complicated nature of teaching art, it is important to remember that art comes first. Initially, the product, technique, skill, or language is created and recognized as valuable. Then various methodologies are developed to teach an aspect of the trait (ranging from technique to creativity) or sometimes to teach something outside the immediate scope of the art field. Sometimes art is used to teach math or an abstract concept such as patience. The field of art education would be amiss without the production of artists. However, the rich teaching practices and discoveries accompanying the field of education in the 19th century created a context for the artist-teacher.

Hickman (2005) emphasizes the unease he felt when his art training did not coincide with his teaching practice.

> I often felt a slight unease with much of what has been written about art and art education in that I have not been able to relate it to my own personal experiences of art and art making. I have seen my own practice, as a student of art and as a producer of art, as being parallel with, but separate from, my work as an art educator. (Hickman, 2005, p. 71)

This unfortunate dilemma is a common tale in the teaching profession. The failure to interweave the two traditions—art and education—in a meaningful way has created art teachers who see the roles of artist and teacher as incompatible. Frustration overcomes

those that feel art teaching is far removed from the exciting aspects of creating objects of aesthetic significance (Hickman, 2005). However, this should not be the case if art education stresses the importance of being an artist, thinking like an artist, producing artistic products, and carrying these activities over into the teaching field. One must think and be an artist first. The teaching methodologies are secondary. Once an individual moves toward thinking and being an artist, his or her teaching can embody this special way of thinking that makes arts education valuable.

Characteristics of the Artist-Teacher

Reflecting upon the many successful artist-teachers in this text, there are overarching pedagogical characteristics they share in their practice as artist-teachers. These include the following:

> Artist-teachers are artists first. This refers to their educational and life pursuits; all the art teachers came into the teaching field through an interest in art or art production.
>
> Teaching should be a direct extension of studio life.
>
> The production of art works is central to understanding the profession of teaching art.
>
> Classrooms should be modeled on the practices of artist and designers.
>
> Teaching is an aesthetic process: artists-teachers manipulate classroom techniques, materials, and characteristics similar to the artist's manipulation of the elements and principles of design.
>
> Artist-teachers apply artistic aptitudes—drawing, painting, performance—in educational contexts—classrooms, boardrooms, planning sessions, mentorship opportunities, teaching processes, research practices—to enrich the learning experience, for example, exploring lessons in a sketchbook.

Individually or combined, these characteristics are independent of a particular philosophy of art; depending upon the vantage point of the artist, the teaching strategy changes. Modernist art educators concerned with form and how it communicates are apt to teach from this perspective. In contrast, the conceptualist or nonobjective painter would be amiss to offer a course in life drawing. The artist-teacher at the basic level is an embrace of the studio thinking process in the classroom.

Redefining

In redefining or, in this case, defining the artist-teacher, the characteristics form an accurate description of an artist-teacher pedagogy. Only through reflecting on individual processes was the researcher able to dissect the many aspects of teaching artistry. Because the concept of the artist-teacher embraces two fields, the genius of the term may rest in the middle ground where the traditional understandings of education and progressive art making meet. Defining it or reflecting on it through history captures something elusive, often unnoticed in the contemporary classroom. The characteristics are by no means definitive but represent a starting point, with qualities that encompass one person but are present in many artist-teachers working in the contemporary field. Reflection is the key when analyzing the exchange and interchange between art and education. Only after the experience ends can one reflect on that time, event, and place to construct how one enterprise imbeds in the other. This happens at all levels of education, from planning to implementation, and it seems foolish to credit the interchange to a mystical experience. It is something we can learn from and encourage artists to embrace when traversing the educational landscape.

The in-between space was a void, and our understanding of the term must be loose for it to develop in new educational settings. Deconstructing these outdated terms allows contemporary art teachers to redefine what they do and how they do it. New educational problems and artistic processes are constantly at the forefront. The academic process has been reversed, and artist-teachers are now using a different concept and foundation to build their theories. Twenty-first-century artist-teachers who work within this void will form different combinations and strategies for how an artistic enterprise informs their educational pedagogy. The space needs to remain empty for this artistic process to take place. However, there is an awareness of this space called the artist-teacher—regardless of its fluidity.

* * *

The profession of art education comes with a rich and complicated history. From 19th century industrial design programs to today's contemporary art education research degrees, the goals and standards in the field of art education have changed dramatically. The professionalization of the field of education however has had the most detrimental impact on art instruction. The separation of art theory, art history, and studio art from the field of art education is a result of art education being a sub-discipline of education and not the studio art department. The field of art education did not exist until teacher preparation schools were conceived and should be a subject of study and not an alternative to studio courses. I am greatly concerned that today's art education programs hinder more than enhance quality learning and teaching in the classroom as the artist has been

removed from many of the programs in universities and colleges. The result is graduates who are over theorized and who understand their subject in a shallow manner. They are armed with a host of teaching strategies and theory to facilitate an activity they don't practice or understand in a meaningful way.

The field of visual arts is also to blame. Education is an important discipline yet students who study visual art at the highest level (MFA students) receive no training or education in teaching. These future schoolteachers and professors then repeat the same pedagogical errors of their predecessors. A greater balance is needed in graduate programs that offer visual arts degrees as these future teachers inherit an occupation of teaching art they know nothing about.

The emphasis on education theory has trumped the art in art education. The divide gradually grew as art education solidified itself as a discipline in the 20th century. The endeavor of specialization is fruitful and frustrating. At its very best Art Education is a rich field of inquiry that knows no bounds yet at its worst it has separated art teachers from the rest of the art field including art history, studio art, and other critical enterprises. The art education degree has become a sub-discipline of education and has lost the very essence that makes it a powerful subject. Through a variety of initiatives the role of the artist has been raised and smothered because of the complications the two roles hold for one-another. The goals of the artist are seen as contradictory with the goals propagated by teachers and educational institutions. For these reasons many in the field of art education are hostile towards the notion of the artist-teacher. But this is precisely why we need the artist!

Clement Greenberg felt that superior or quality art always comes from tradition (Goldstein, 1996). Teaching his brand of formalism himself for a short period at Black Mountain College, the outspoken critic's thoughts deserve recognition. Regardless of whether you agree with Greenberg, one could learn much from him because he taught what he knew and believed. The very best teachers embrace who they are and what they do best. When I began my teaching career, a wise dean shared a similar notion when she encouraged me to teach from my interests. This was helpful advice as a young professor. Yet, it is good advice for any teacher. If you embrace your passion in the classroom, it will only strengthen your practice. A conceptual understanding of the artist-teacher embraces the experiential aspects of making art. The artist-teacher values this and brings this into his or her teaching. So why do you teach art? The artist-teacher recognizes the unique, rewarding, and multifaceted qualities that are present in art-making experiences. The experiences are as diverse as the artists. Thus, the possibilities for teaching art are endless. Through teaching art, the world is opened to students, as arts teaching and learning is an inclusive experience. This is the great strength of art education!

References

Baldessari, J. (1972), *Teaching a Plant the Alphabet*, New York, *Electronic Arts Intermix (EAI)*.

Efland, A. D. (1995), "Change in the conceptions of art teaching" in R. W. Neperud (ed.), *Context Content and Community in Art Education: Beyond Postmodernism*, New York: Teachers College Press, pp. 25–40.

Goldstein, C. (1996), *Teaching Art: Academies and Schools from Vasari to Albers*, Cambridge: Cambridge University Press.

Hickman, R. (2005), *Why We Make Art and Why It Is Taught*, Bristol: Intellect Books.

Horne, H. H. (1916), *The Teacher as Artist: An Essay in Education as an Aesthetic Process*, New York: Houghton Mifflin.

Neperud, R. W. (1995), "Transitions in art education: search for meaning" in R. W. Neperud (ed.), *Context Content and Community in Art Education: Beyond Postmodernism*, New York: Teachers College Press, pp. 1–22.

Parks, M. E. (1989), "Art Education in a Post-Modern Age," *Art Education*, 42: 2, pp. 10–13.

Wick, R. K., ed. (2000), *Teaching at the Bauhaus*, Ostfildern: Hatje Cantz Verlag.

Williams, R. (2009), *Art Theory: An Historical Introduction*, 2nd ed., Oxford: Wiley-Blackwell.

Yeomans, R. (1987), "The foundation course of Victor Pasmore and Richard Hamilton 1954–1966," Ph.D. dissertation, London: Institute of Education, University of London.